D1624919

WILLIAM GLACKENS
and The Eight

The artists who freed American art

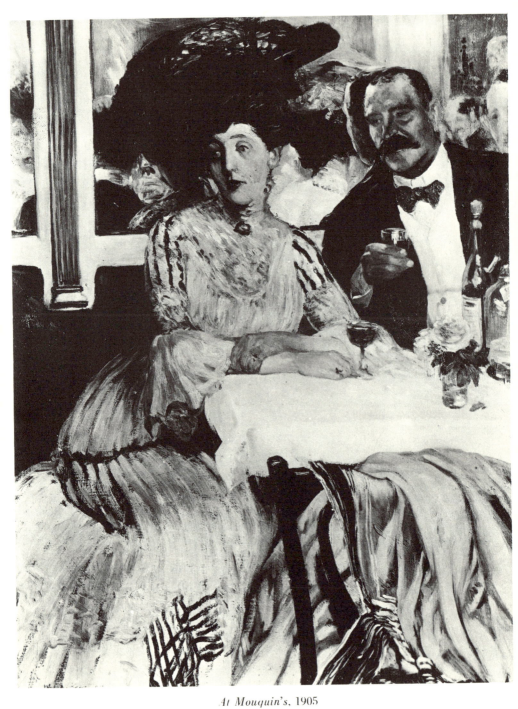

At Mouquin's, 1905

ART INSTITUTE OF CHICAGO

WILLIAM GLACKENS

and The Eight

The artists who freed American art

IRA GLACKENS

Horizon Press *New York*

Library of Congress Cataloging in Publication Data

Glackens, Ira, 1907-
 William Glackens and the Eight.
 Rev. ed. of: William Glackens and the Ashcan
Group. 1957.
 Includes index.
 1. Glackens, William J., 1870-1938. 2. Painters—
United States—Biography. 3. Eight (Group)
4. Ashcan School. I. Glackens, Ira, 1907-
William Glackens and the Ashcan Group. II. Title.
ND237.G5G56 1983 759.13 [B] 83-18468
ISBN 0-8180-0139-9
ISBN 0-8180-0138-0 (pbk.)

Manufactured in the United States of America

-≫-≫-≫-≫-≫

CONTENTS

-≫-≫-≫-≫-≫-≫

OTHER BOOKS BY THE SAME AUTHOR

YANKEE DIVA: Lillian Nordica and the Golden Days of Opera

POPE JOAN: The English Girl Who Made It—
 An Unorthodox Interlude

A MEASURE OF SLIDING SAND, a novel

POOR MAD VALERY and *other poems*

DID MOLLY PITCHER SAY THAT?—The Highlights
 of American History (in preparation)

➤≫-➤≫-➤≫-➤≫-➤≫

This book is not about art but about artists. The only criticisms in it are a few quotations from the contemporary press, included because they belong historically to my father's story or that of his friends, or are particularly astute or particularly foolish.

My father was a man of few words, and in order to portray him at all it seemed necessary to fall back on his letters. And I have tried to tell something about his friends. They were a delightful and colorful group, and it was my privilege to have been brought up among many of them.

A number of the anecdotes are set down from remembrances of my mother's stories, for fortunately she was a voluble *raconteuse*. The accounts of Ernest Lawson and May and James Preston are edited from manuscripts left among her papers, with additions from the writer's recollections and those of others.

In the days described, artists had a great enjoyment of life and were less theoretical than they seem to be today. The artists I knew did not sit about discussing their souls or deciding they were in their Nude Period and could paint nothing but nudes. They painted whatever came along that seemed paintable, and greatly enjoyed it. They took art seriously, but themselves less so. The world appeared in consequence a more vital place.

It should perhaps be said that the painters of the Ashcan School were not painting for social comment, or for political propaganda, or to reform the world. Their concern was only with reality, with life.

Their battles to free art from officialdom (which they decisively won) had nothing to do with the manner in which they painted. For this reason the Romantic Arthur B. Davies, the Impressionist Ernest Lawson, and the Postimpressionist Maurice Prendergast, belong with the others; their association in the group called "The Eight" was, as Edgar Preston Rich-

ardson has so well put it, "one of the heart," for they all equally believed that the artist must be free to paint as he pleases.

This principle of theirs is now securely implanted in our culture, though today realism is out of fashion again and art has withdrawn from life to a large extent. Perhaps some day it will rediscover its own roots.

I. G.

Conway, New Hampshire
June, 1957

-»»-»»-»»-»»-»»

ACKNOWLEDGMENTS

My thanks are due to many people for their warm co-operation in this book: to Miss Antoinette Kraushaar of the Kraushaar Galleries for encouraging me to undertake it, and for her innumerable and invaluable favors; to Miss Rosalind Irvine, Associate Curator, the Whitney Museum of American Art, for her enthusiasm and unfailing aid; to the *New York Times* and the Hartford *Times* for permission to print copyright material from the files of those papers; to the New York *Herald Tribune* for permission to print part of Guy Pène du Bois' tribute to Ernest Lawson; to the New York *Sun*, Inc., for permission to print extracts from the New York *Sun*, the New York *Evening Sun* and the New York *Herald*, including the cartoon on page 107.

I wish to thank Miss Violet Organ for permission to print letters from Robert and Marjorie Henri, for her gift of three letters from my father to Robert Henri, and for making available the caricature on page 16.

My thanks are due to Margaret Lawson Bensco for permission to print her father's letters and a portion of one from her mother; to Mrs. Charles Prendergast for permission to print letters from Maurice and Charles Prendergast; to Mrs. George B. Luks for permission to print a letter from George B. Luks; and to Mrs. Albert C. Barnes for permission to print the letters of Dr. Albert C. Barnes. None of these may be reprinted without the consent of the owners of the material.

I am deeply grateful to the many museums and private collectors, and to the trustees of the Barnes Foundation, who have given me permission to reproduce paintings and other material in their collections, none of which may be reproduced without the permission of the owners.

I wish to thank my cousins John V. and Dorothy Glackens Coxe for the text of the letter from Lafayette to Daniel L. Glackens; Mrs. Walt Kuhn and Miss Brenda Kuhn for permission to quote from Walt Kuhn's

History of the Armory Show; Garrett Price and *The New Yorker* for permission to reproduce the cartoon on page 237; the staff of the Frick Art Reference Library and the staffs of the Periodical Division and the Art Division of the New York Public Library, whose aid seemed to go at times beyond the call of duty; my father's old friend James Preston for much information; and Miss Wanda Whitman for her invaluable aid with the manuscript. My wife Nancy Glackens has come to my rescue whenever required.

None of these people is in any way to blame for the shortcomings of this book.

I. G.

WILLIAM GLACKENS
and The Eight

The artists who freed American art

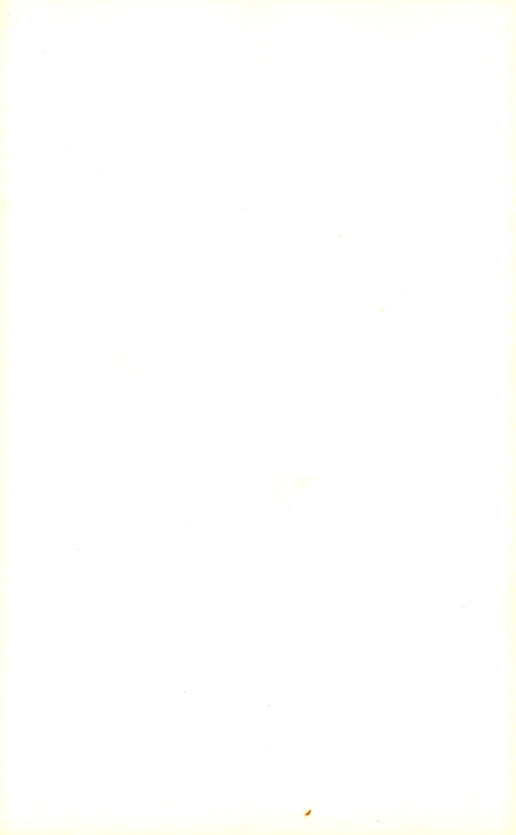

CHAPTER ONE

One day I was looking through family papers in search of information about my father William Glackens. There were several questions to be answered. When had he gone to Paris, what year, to buy paintings for his friend Dr. Barnes? What canvases had he bought? When had he been a staff artist on the New York *Herald*—before or after he drew the war in Cuba for *McClure's*?

I remembered once seeing a bundle of letters and amusing sketches and caricatures by father's old friends, Robert Henri, George Luks, John Sloan. Where was it? And then the historic Armory Show, for which father selected the American entries—perhaps there would be clippings about that.

At least a catalogue of the exhibition called "The Eight," held in 1908, might be unearthed. Only one or two copies are known to exist (there is one in the New York Public Library) and it is considered a rare collector's item, for that now-famous little exhibition of paintings by my father and his seven friends, held in a sort of defiance of the National Academy of Design, was a sensation. It is credited with having broken the nose of that artistic dictatorship and thrown wide the portals of freedom for artists, who ever since have been able to paint how and what they please, and often to get their work hung, whether the Academicians like it or not.

But the search was disheartening until I came upon a promising little notebook with "W. Glackens" stamped on it in gold (doubtless a gift). Here at last there might be clues, and perhaps answers to puzzling questions.

The notebook seemed to contain only names and addresses of models ("Miss Mignon Fyella, 593 West 154th St. Has yellow dress") and lists of paints to be ordered from his old dealer Rabinowitz ("6 rose madder,

12 ultramarine"). Then came a cryptic message with numbers. I deci-
phered the following:

> Put in yeast midnight Jan. 11
> Bottled 9:30 A.M. Jan. 16
> Makes fermentation about 105 hours
> Mean temperature 66
>
> Put sugar in most bottles—note difference.
>
> *Note.* Those without had a good head after
> several weeks' standing.

Father's ale! But nothing whatever about the Armory Show.

There was also father's wine. I used to help him at the bottling when
this event concurred with a week end home from boarding school, where
we never did anything that was as much fun as bottling wine. The lengths
of rubber hose, the vats, the boiled corks, all ranged in the cellar of our
house in West Ninth Street, are as vivid a memory as that of father
before his easel. The grapes were usually Zinfandels.

Once father came home happy in having found a great treasure in
Washington Market: not the usual Zinfandels, but the classic *plante noble*,
Cabernet Sauvignon. The little insignificant-looking grapes—each was a
jewel in his eyes. It was due to their modest appearance that they had
been left unpurchased by less knowing home viticulturists. The resulting
wine was in time a great success, for father was very careful and scien-
tific in these serious matters.

A prosperous friend, with a most reliable bootlegger, gave him a case
of champagne. Like all true oenologists father preferred still wine to
champagne, but one did not cavil at a case of champagne, especially
during Prohibition. He opened a bottle for dinner. The label was beauti-
ful, the cork popped, smoke seemed to curl from the mouth, and the wine
bubbled in the glass. But one sniff and sip—

"Charged prune juice!"

The *Régime Sec* finally ended, and father could go out after the day's
painting, when the light began to fade, and visit his wine merchant and
talk to him of wines and perhaps buy a bottle or two. He never acquired
wine by the case, and this was partly due to the lack of an adequate
storage place in the house.

"I wish we had a wine cellar," was his frequent moan.

My mother, whose aim in life was to please him, determined to provide one.

We had a general handy man named George, an ex-sailor, who lived at his own request in our cellar, where he had made a little bower, like the bunk in a ship, in an abandoned coal bin. George was very strong and healthy—except when he came home drunk, his face bashed in and covered with blood, and this occurred frequently. "I met a friend," was his invariable explanation. Mother used to warn George solemnly against his friends. It was George who proposed to tunnel a wine cellar under our back yard, breaking through the stone foundations. The house, built about 1830, had solid foundations, but George began to tunnel. The tunneling went on for months. Special dirt removers had to be contracted to carry out through the areaway all the dirt, rubble and brickbats that George had removed, and to cart them away in trucks.

The wine-cellar project was to be kept a profound secret from father, partly to surprise him on his birthday, and partly to prevent him from stating that such a thing could not possibly be done and the whole house would collapse if it were tried. Mother herself, who had strong apprehensions, feared something of the sort, but George said, "It won't happen at all. You're a regular Calamity Jane!"—which silenced her.

Neighbors used to stop mother in the street and ask her what new repairs were going on at Number 10. But father, famed for his observant eye, sat every morning in the front window, as relays of workmen carried bushels of debris out the basement door right beneath him, and read the morning paper. He was so used to mother and her continual projects that he apparently neither wondered nor noticed. It was then mother said she could introduce a small-sized man right in bed and father would never notice.

The great day arrived on which George was to have the honor of presenting father the key to his new wine cellar. It had been fitted up with honeycomb metal shelves, an air vent, door, table and thermometer. My sister Lenna and I had provided some bottles of wine so that the shelves would not look too bare.

The presentation of the key was made at the end of breakfast.

George, who like father was a native of Philadelphia, was always particularly anxious to please him.

"Mr. Glackens," he said, "we have been making improvements in the cellar. Would you please inspect them? Here is the key."

Father took the key with his usual unquestioning calm, and we all trooped after him. He did seem surprised that day, as well as pleased and a little sheepish.

He ranged the so-called champagne on a conspicuous shelf, his theory being that if thieves did break in they would be sure to steal those gaudy and phony bottles, and thus possibly leave untouched his Montrachets and Chateau Haut Brions. That prune juice came in handy at last; he had never thrown it away.

In 1891, when he was twenty-one, William Glackens landed a job as an artist-reporter on the Philadelphia *Record,* and his career began.

In those days the process of photoengraving and reproducing of half-tones had not been perfected, and the event now depicted by the news camera was then "drawn on the spot by our special staff artist."

The city editor of the *Record* was an extraordinary boy of eighteen named Ned Miller, who burned himself out young, for one day he committed suicide. William, to whom this must have been a first sobering shock, left the *Record* in 1892 and joined the staff of the Philadelphia *Press,* and there found an old schoolmate, John Sloan, a colleague in the art department. Also on the staff were George B. Luks, a one-man circus, and Everett Shinn, who had known Sloan when both were working on the Philadelphia *Inquirer.* There were others in the art department, but these four artists whose lives and careers came together then were ever afterward linked, and the friendships were never broken.

John Sloan and Everett Shinn have left accounts of what life as an artist-reporter on a city paper was like in those days, but as for father, I heard him tell only one story:

He was sent to the scene of a murder which had taken place in a barn. The barn had been locked by the police, and the only possible means of entry was through a small, high window. Since William was small, he was boosted onto someone's shoulders, wriggled through the window, and landed in a pool of the victim's blood.

For the purpose of making a likeness of the victim in his reconstruction of the violent scene, he had also to call at the undertaker's parlors to view the remains. The undertaker obligingly demonstrated that the lady's eyes were blue.

Fires, strikes, accidents, trials, suicides and murders were the order of the day for the artist-reporters.

5

There were also less trying events to depict. In those days newspapers were more given to "stunts" than they are now, and when the colossal statue of William Penn was put in place on the top of the Philadelphia City Hall, W. G. was obliged to spend the night on the brim of Penn's hat, for exactly what purpose it is difficult to say.

But newspaper illustration was a means to an end. W. G. wanted to paint, and he began to attend night classes at the Pennsylvania Academy. John Sloan was also studying there, urged to do so by his friend Robert Henri, a teacher in the Women's School of Design, who had spent much of his time for the past ten or eleven years in Paris.

When Robert Henri returned from Europe with all the glamour such a background could impart, and walked through the antique class at the Pennsylvania Academy, where the toiling students drew and erased the Venus de Milo and the Dying Gladiator, to the life class, which lay beyond and was only for the chosen few, awed whispers were heard, "Henri! Just back from Paris!" as though he were one who had seen God.

Having studied at Julian's and the Beaux-Arts, one acquired a prestige that was doubtless specious, but Henri's position was not really due to this academic background, but to his own personality. Henri had the great gift of inspiring, and his theory that life was the foundation of art was the rallying cry of the group of young men who gathered about him. Popular painting at this time, and for a long time to come, had nothing to do with life. But the seething life about them was the very thing that Henri's young friends were trained by their profession to observe.

Henri's studio was at 806 Walnut Street. For a time, when he taught classes in the morning and W. G. worked on the paper in the afternoon, they shared it, and John Sloan took it over when Henri returned to Paris.

Once a week "the gang" met here, and the evening was devoted to discussions, games, beer and Welsh rabbits, and sometimes skits. The skits were written by a member of the group, C. N. Williamson, and he was probably the author of "The Widow Cloonan's Curse" and "The Poisoned Gum-Drop," the only ones whose titles have been preserved. Photographs of one of the performances survive: John Sloan, as the heroine, and Robert Henri lie dead on a railroad track to which they have evidently been roped by the villain. In another photograph William seems to be offering an entr'acte *divertissement,* clad in a little white dress and a tiny hat.

AN EVENING AT 806 WALNUT STREET

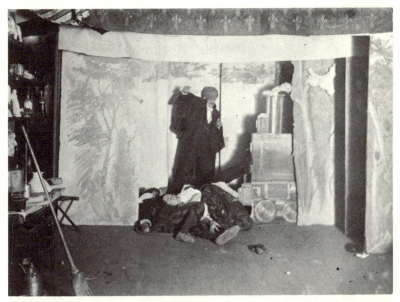

Robert Henri and John Sloan tied to the railroad tracks

W. G. presenting an entr'acte *divertissement*

Not satisfied by the classes at the Academy, these young men organized "The Charcoal Club," which met twice a week in a photographer's studio. Here they could work from the nude model, and Henri gave criticisms. It is said that there were forty members, more than there were at the night classes at the Academy, and probably a better time was had here too, for work went on late, and beer was required when the artists felt exhaustion creeping over them. Those who lived out of town missed

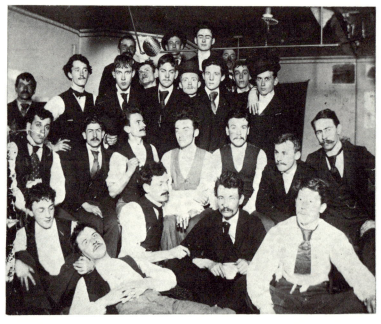

An Evening at Overbrook, c. 1894. W.G., extreme left. Robert Henri holding cup.

the last train home and had to sleep among the scattered drawings and empty beer bottles until the cold, gray dawn. But The Charcoal Club did not last long.

James Preston was another Academy student and habitué of 806, and among the girl students were Florence Scovel, who later married Everett Shinn, and Alice Mumford, who became a portrait painter. Being young ladies, however, they missed all the fun.

The young men found time somehow for even more diversions. A favorite excursion was to Overbrook, where a Frenchman ran a restaurant and made his own wine. Seemingly it mattered not that the only

lady present was the proprietor's daughter, who sat watching her father's customers with a pet goose in her lap—perhaps for protection.

Between assignments W. G. could sometimes hurry home for a meal, for the Glackens family was living at 2027 Cherry Street, where they had lived since little Willie was five. His father, Samuel Glackens, worked in the office of the Pennsylvania Railroad, until he retired on a pension. Samuel was one of six children and his father, Daniel Logue Glacken, was a native of County Donegal, Ireland. When Daniel reached America, about 1818, he added an "s" to make "more euphonious" a name said to mean "little hand" in Gaelic. Daniel was then about twenty, and family tradition says that his mother followed him to his ship and begged him to stay in Ireland. But he sailed away, never to return.

In America, Daniel Glackens married Sara Ovenshine of Pottstown, Pennsylvania, whose ancestors were political refugees from the Palatinate, but got here in time to fight in the Revolution. Daniel declared that all his six children were "ignorami" and that none of them had ever cracked a book. He was said to know Latin and Greek and higher mathematics. He became a master printer, for in 1833 one Stephen D. Maillory "by his own free will and accord put himself apprentice" to Daniel L. Glackens "to learn his Art, Trade and Mystery." The indenture further stipulated that the apprentice "his said master faithfully shall serve, his secrets keep, his lawful commands everywhere gladly obey," while in return Daniel was obliged to supply "two pairs of shoes in each year and sixty-two and a half cents each week, payable weekly," as well as to provide for him "sufficient meat, drink, apparel, lodging and washing, fitting for an apprentice."

W. G. was not the first newspaper man in his family. In 1825, at the time of Lafayette's triumphal visit to America, Daniel had founded a newspaper in Pottstown, called *The Lafayette Aurora*. He sent copies to Lafayette, who wrote to thank him and wish him success, although, the General cautiously added, were the enterprise not literary but political . . . "however devoted I am to the freedom of the press, and persuaded that when applied to public men it is, in its Security, a necessary safeguard for free institutions, I would observe that in my peculiar situation, I would be sorry to see my name proposed to certain attacks of men on different sides, although all patriots and my personal friends."

The Lafayette Aurora continued publication until 1833, when Daniel

and Sara moved from Pottstown to 108 South 22nd Street in Philadel-
delphia. Their four sons lived with them, and Samuel was still there when
Daniel died in 1875.

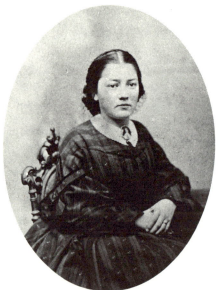
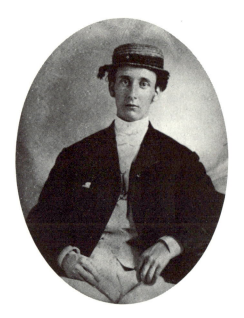

Elizabeth Finn Glackens Samuel Glackens

Samuel by then had three children of his own, Lou, Ada, and William,
the youngest, born at 3214 Sansom Street, Philadelphia, on March 13,
1870. Samuel had married Elizabeth Finn, whose mother, Elizabeth Cart-
wright, was said to be the daughter of an English bishop. But this may
not be true, for the family seems never to have held any religious
observances. Grandmother adored her eldest son Lou, the only child
whose picture she bothered to have taken, and hardly any information
about William's childhood has survived. Once he had a new coat with
brass buttons. "See my buttons," he said proudly to his schoolmates, and
his oldest friends usually called him Butts.

He was graduated from the Central High School in 1889. There are
statements in print that he was called upon to make drawings on the
school blackboard, and that about this time he made all the illustrations
for a dictionary, but he never spoke about such things himself.

After high school, W. G. rode to Florida in a boxcar with some companions, one of whom knew a brakeman on the railroad. But the only surviving result of the adventure was a small study in oils of a palm tree. He went with a friend on a boating expedition on the Delaware, and wrote up the trip in a fine, careful hand with elaborate pen and ink illustrations. This composition is modeled on the stately style of 1888, and the drawings are exactly like those of the then popular Arthur B. Frost.

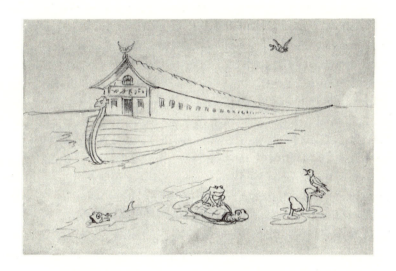

Noah's Ark. Sketch by Louis M. Glackens.

Lou Glackens also had remarkable talent for drawing (both brothers drew in the cradle) and for years Lou was on the staff of *Puck*, the old comic weekly published in New York. My sister Lenna and I adored him because when he came to our house he drew us pictures for hours at a time; his drawings of elves, gnomes and Noah's Ark with the antics of the animals within were part of our childhood. Full of humor and imagination, they flowed from his pencil like water from a tap. Like Shakespeare he never blotted a line.

Lou once illustrated a Horatio Alger story for a periodical. There was a tramp in the story, and Lou dressed him in old, tattered clothes. The editor objected, saying his was a family paper and his readers would never stand for such a disreputable-looking character. So for the entire

serial Lou obligingly depicted the tramp in a silk hat and morning coat.

Lou never married—it was said he had been jilted in his early days—but he was the adored companion of all the children in any neighborhood he inhabited. "Where's the little man?" they would come to the house to ask. In his later years, when *Puck* folded, he had a few jobs drawing for the moving pictures. He drew the first animated cartoons, and his genius and imagination were made for this very thing. He would have been a great success if he had not been born too soon.

Lou had a whimsical fancy which made his work markedly different from William's, rooted in realism. A *Puck* cartoon, published at the time Castle Garden at the Battery became the New York Aquarium, illustrates this. Lou drew a picture of an old, old man looking at the fishes, who were all dressed in little bonnets and shawls in the style of 1850: for him, the Aquarium would always be Castle Garden, the place where he had heard Jenny Lind sing.

Eventually Lou had to go home and live with his family. To live in Philadelphia was a dismal fate for one who had sat up drinking with Steve Brody, the famous bridge-jumper, and was on familiar terms with the great Harry Houdini, but his letters excoriating what he considered the backwardness and stupidity of his fellow Philadelphians served to relieve his feelings. "William Penn got their number in 1683," he wrote, when they had insisted on putting up a large market right in the middle of a fine vista he had planned. Lou sent us a drawing of Market Street on a Saturday afternoon. Crowds of people were hurrying along in crinolines and beaver hats, presumably to indicate that these articles were still thought to be the latest mode in Philadelphia. For the holidays he sent a picture of a graveyard: an arm holding a wreath with the legend "Merry Christmas!" was thrust out of a grave.

Indeed it seemed as though attending funerals was the only activity in Philadelphia. With depressing frequency, and always in the bleakest weather, we were summoned to attend the funeral of a relative. On more than one occasion, when we found ourselves swept by polar winds on the platform of the Thirtieth Street station, it was discovered that none of us could remember the number of the house where the obsequies were to take place. "Drive along such-and-such a street," were then father's instructions to the cabman, "until you come to a hearse!"

On one occasion distant relatives, who only met at such times, ex-

claimed at how much father resembled their own absent son. Afterward, when we stepped into the long black undertaker's limousine to be borne to the cemetery, grandfather and grandmother both began unexpectedly to sputter. It was the only time either one was ever known to express the slightest indignation. "Looks no more like Our Will!" one muttered, and then the other, as soon as we were off and driving through the endless Philadelphia streets. It was a sort of keening; it took on a rhythm. *"Looks-n'more*-like-*Our Will!"* and every little while an explosion, *"That blunk-headed thing!"* We proceeded to the graveside to this refrain. My grandparents were like indignant wrens. All sorrow at the loss of a relative was happily blotted out by the quite unconscious slander of comparing *their Will* to "that blunk-headed thing."

My grandfather died suddenly after a hearty breakfast at the age of ninety-two, having survived his wife and his two older children. His was the most serene of natures. The fact that he spoke very little was hardly noticed because of the peaceful and friendly aura that seemed to waft about him with the smoke of his cigar.

His wife filled the silences with continual chatter, in which Ada joined. Both W. G.'s parents were little people, and in my childhood grandmother reminded me of a chipmunk. She had bright observant eyes and was continually inspecting everything about her. When she entered an unfamiliar room her glance darted into every corner; nothing escaped her. Hers was a natural intellectual curiosity. She never criticized anything. If you gave her a book to read, she began with the title page, and having digested that, turned to see where the book was printed and what was the date of the copyright. When all these matters were noted she started to read the book.

Father inherited his father's silences and his mother's observation, and from both of them a calm acceptance of things as they are and a complete willingness to live and let live. His talent and Lou's came from an untraceable source.

Lou already was listed as an artist in the Philadelphia City Directory when W. G., on his newspaper job, achieved that distinction too. His life was a busy one. In addition to his other activities, he was painting mornings in the Walnut Street studio, and at the Academy, in Thomas Thouron's class, he executed a mural ten feet long, entitled "Justice," which is still to be seen in the Auditorium.

In the spring of 1895 all this came to an end. W. G. relinquished his
job and embarked on the great adventure: he set sail for France on a
cattle boat. His destination, of course, was Paris.

W. G. in the studio he shared with Henri at 1919 Chestnut Street, Philadelphia,
c. 1894.

CHAPTER THREE

Robert Henri was in Paris again that year, in a studio at 49 rue Mont-parnasse. W. G. lived first at 203 Boulevard Raspail, but found a studio at 6 rue Boissonnade and moved in on October 1, 1895. His lease provided that he pay the landlord, M. Petit, eight hundred francs annually, or one hundred sixty dollars.

The rue Boissonnade runs from the Boulevard Raspail to the Boulevard Montparnasse, at the junction of the Boulevard Saint Michel. The café of the Closerie des Lilas stood here on a corner (it still does), and here W. G., Henri and a young Canadian painter used to meet at the apéritif hour. The Canadian was James Wilson Morrice (1865–1924). When the weather was good they went on sketching expeditions together, particularly to Charenton and to the hamlet of Bois-le-Roi on the borders of the Forest of Fontainebleau. W. G. did not enter any of the schools, for which he seems to have felt only contempt. The Pennsylvania Academy was the first and last art school he attended.

Morrice, Henri and W. G. were congenial companions, for their points of view about art were similar. Morrice had been a close friend of another American artist, who returned to the United States before Henri and W. G. reached Paris. This was Maurice Prendergast, whom Morrice had met while a student at Julian's Academy. As it turned out, Prendergast's later career was to be closely associated with Henri and Glackens.

In the spring of 1896, Henri and W. G. and Elmer Schofield went on a bicycle trip through Northern France, Belgium and Holland. Schofield was another of the cronies at 806 Walnut Street who was in Paris that year. The three sketched, ate, and drank the wine of the country, and according to Henri's letters home they evoked peals of laughter from the Dutch. Their American cycling clothes appeared ludicrous to the peasants and doubtless were.

In Brussels they visited the curious Wertz Museum, and Henri described that morbid artist's huge canvases, glimpsed through peepholes, as "gruesome and philosophical." Since these works of art depict piles of rotting coffins with rats running in and out, and similar subjects, Henri was correct. But the Rembrandts and Halses in Holland were alone worth the trip.

Caricature by Robert Henri

Later that year W. G. returned to America to earn a living again. His colleague George Luks had moved to New York and was occupying the position of "premier humorist artist" on the New York *World*. Through Luks, W. G. got a job to do comic drawings for the Sunday supplement. At the same time he began to work for the New York *Herald,* and within six weeks he had given up the Sunday *World* and worked exclusively on the *Herald* staff for the next nine months, or through September, 1897.

For a while he and Luks shared a studio. It was in an old brownstone and the floor below them was occupied by a dealer in ladies' trimmings.

The tenants' names were posted on a series of signs in the entry and callers on the artists read with pleasure:

LUKS & GLACKENS

FURS & FEATHERS

W. G. never returned to Philadelphia except for short visits to his family. All his old cronies were either in New York or soon arrived: Henri, Sloan, Luks, Shinn and Preston.

The art director of the *Herald* was an amusing young man named Harry Grant Dart. He and W. G. struck up a friendship that was lifelong. Harry Dart could not open his mouth even on the most solemn occasion without saying something to chuckle over. The fact that he spoke a little as though he had been stung on the tongue by a bee probably helped.

Likewise in the art department of the *Herald* was a young New York artist, Ernest Fuhr, whose work consisted chiefly in making perfect pen-and-ink copies of portrait photographs to be reproduced as line cuts, and illustrations for long, sentimental serials that ran in the Saturday edition. If Harry Dart was talkative and lively, Ernest Fuhr was quiet and modest. He and W. G. likewise became lifelong friends. Later Fuhr illustrated for the magazines, and painted. He and W. G. exhibited together more than once.

During W. G.'s days on the *Herald* many momentous things were going on. In January, 1897, occurred the Seeley investigation, and Harry Dart dispatched W. G. to make drawings of it. A gentleman named Seeley had given a party in a private room at Sherry's, and to entertain his guests had hired a young dancer named Little Egypt. She was supposed to be a gypsy, but unkind people added that she had been born in Brooklyn.

Into the midst of this gay private party a police captain burst uninvited. He had come to see just how nameless the orgy was; and now the investigation centered around Captain Chapman's actions and rights, or the lack of them, and (more important) on just how many veils Little Egypt wore, and whether or not one really could glimpse her bare skin when she did her *danse du ventre*. These important questions had the city, and presumably the whole country, on tenterhooks. W. G. drew, in all their pompous self-importance, the solemn men with great cowcatcher moustaches who were connected with the case, and also for good measure

drew Little Egypt herself, who, appearing in court fully clothed, made a very tame impression.

The Seeley investigation, however, brought her fame. Her name became a sort of generic term for "belly dancer," and soon every rural fair in the land advertised "Little Egypt"—each, of course, the original and only—among its attractions.

In February came Senator Lexow's investigation of the sugar trust. The sugar kings were John E. Searles and Henry O. Havemeyer. Mr. Havemeyer was angry in court. Accusations, threats of contempt, subpoenas, flew thick and fast. W. G.'s drawing depicts Senator Lexow on the bench, lawyers, clerks and the chief witnesses—all portraits.

In March he and Harry Dart journeyed to Washington to cover the inauguration of William McKinley. They collaborated on two enormous drawings: the ceremony on the steps of the Capitol, and the great parade. Both these drawings of course included large crowds of people. About the parade, "The column is swinging around the northeast corner of the Treasury Building," the *Herald* informed its readers, and of this there was no doubt. There was the Treasury Building complete, draped in bunting, and also the Department of Justice, and passing below, a great display of cavalry. There were more than forty horses in this drawing, and some of them were turning a corner, and consequently foreshortened. Hundreds of soldiers were marching, hundreds of people watching. The drawing was spread across two pages.

Both drawings appeared in the New York *Herald* the next day.

On April 28 Harry Dart and W. G. produced together an even more astonishing *tour de force*. On that day Grant's Tomb was formally turned over to the municipality by General Horace Porter, president of the Grant Memorial Association. President McKinley was there to deliver an address on the steps of "the beautiful and massive memorial pile." The drawing of this event is signed "Glackens and Dart." But the drawing of the parade that followed was spread from the top of one page to the bottom of the next, and showed a contingent of the U. S. artillery which included no less than twelve gun caissons, three men seated abreast on each, and each drawn by four horses. They were seen "approaching the Plaza," and an inset depicts "President McKinley and Vice President Hobart on Their Way to the Tomb" in an open carriage. The *Herald*'s readers were treated with lavish generosity.

In such cases the artist could make quick sketches upon the spot, but above all he trained himself to memorize the scene. Then he hurried back to the office, sat down at his drawing board, and went to work. Sketches were helpful reminders, but in W. G.'s case the entire scene, down to individuals in the crowd, was etched on his memory and transferred to paper in time to make the next edition. To add to their difficulties, these staff artists worked against a daily deadline. But when the reproduction of halftones was perfected, all this ended, along with the chance for anyone ever again to acquire such training.

Everett Shinn stated that W. G. could make a drawing of a fire engine almost detailed enough to construct one from, after merely seeing it go by in the street. Many years later, at Bellport, Long Island, in the heat of summer, May Wilson Preston was heard to lament the necessity, for a story she was illustrating, of taking a special trip to New York to see what a New York lamp post looked like. W. G. made her a careful drawing of a typical New York lamp post and saved her the trip.

W. G. to Robert Henri:

[No date—circa early 1897]

MY DEAR HENRI

I am about to write a letter! I thought that before this I would be in Philadelphia; it was most unfortunate that I missed you when you called at my place. I saw Reddy[1] Thursday night and he is very enthusiastic over what he saw of your pictures, and tells me that you are to have the big room at the Academy this winter with about 40 or 50 canvases.—Now is your chance, they treated you very shabbily last year and now they are going to make up for it. Of course you will own the exhibition. I am extremely anxious to see what you have done in the past year, Reddy appears to have been especially struck with a gray day effect in front of the Bal Bulier. I think I remember that one but probably it might be another. I would like to exhibit myself if [I] could expose half a dozen or eight at once, it strikes me as being scarcely worth while to send one or two and have them balance the front windows like last year.

The exhibitions over here are atrocious but you can see good things in the loan exhibitions. Davies[2] no longer sends to the Society notwithstanding invitations. By the way, did you see him before he left? You know he has gone to

[1] E. W. Redfield
[2] Arthur B. Davies

Spain and whether he has returned or not I don't know. He had a remarkably
fine exhibition here this Spring; he gets better every year.

How did you leave Morrice and Wilson the wandering Jew is back. God
how he must enjoy sea voyages.

Have the Friday nights developed again? Reddy has disclosed to me how
you skin Sloan out of the rent every month poker playing.

I think I shall probably be over in Philadelphia pretty soon. Until then or
until I hear from you

<div align="center">au revoir</div>

<div align="right">Your friend</div>

New York Herald <div align="right">GLACK</div>

The "one or two" pictures referred to, which balanced the front
windows, were in effect, according to the Academy's catalogue for 1896,
three: "At Mouquin's," "Central Park in Winter," and "Battery Park."
Of these, only the last is identifiable, and it was lost in a fire in 1950. "At
Mouquin's" has disappeared, but the title indicates that the painting now
in the Art Institute of Chicago, produced in 1905, was not the first of this
subject.

The last of W. G.'s drawings in the *Herald* appeared in September,
1897, and after that he free-lanced for the magazines, particularly
McClure's, which sent him to Wisconsin to illustrate an article on a log
drive. On his return he again began to do drawings for the Sunday *World*,
as well as for the magazines. But he never gave up painting, or trying to
get his work shown.

W. G. to Robert Henri:

<div align="right">Jan. 22, 1898</div>

DEAR HENRI

Don't bother yourself in the least about my "*execution.*" I can understand
very readily that they [my pictures] could never go in an exhibition—a mixed
exhibition that is. And especially in a place where you were unfortunate
enough to have been a so called student. So it was down with the "Mud"
school was it?

To put you down they put you up—a paradox.

I should have been very glad to be on the line[3] of course, but I doubt very

[3] At eye level, in the best position, not hung near the floor nor "skied." Henri's one
accepted picture received the last treatment.

much even then if I could have thoroughly appreciated the honor. You see I aim too high.

Let me know when you are coming over. I still keep open house.

Your friend

139 West 55th St., New York W. Glackens

W.G. at the age of twenty-eight

The reference above to his "execution" is inexplicable, for in the Academy catalogue for 1898 no less than five paintings by W. G. are listed, all of which were French subjects this time: "The Wine Shop," "La Quadrille," "Terrace du Café d'Harcourt," "The Fête Night" and "Horses Bathing in the Seine." In fact W. G. succeeded in exposing more canvases than did Robert Henri, whom he so looked up to. Henri had but one canvas in the exhibitions of 1896 and 1897 at the Pennsylvania Academy, and two in 1898. W.G.'s score was three, two, and five.

Whatever the explanation of this curious puzzle, W.G. seldom revealed himself as he did in this letter, or admitted that he did have a wish to exhibit his work, or cared whether it was shown or not. But then he was only twenty-eight.

The winter of 1897–1898 was a fateful one, with tension over Cuba steadily mounting. On February 15 the U.S.S. *Maine* blew up in Havana harbor, and by April 24 we had forced Spain into declaring war on the United States.

Just two weeks later W. G. found himself in Tampa as special correspondent for *McClure's Magazine*. Detailed instructions by letter from the manager of *McClure's* art department defined his job as "to go to Cuba with the American troops" and send "illustrations telling the story of the departure, voyage and arrival and subsequent work and fights of the U. S. troops in Cuba." In Tampa he was to find *McClure's* correspondent and editorial representative, Mr. Stephen Bonsal. "Whatever Mr. Bonsal and yourself decide, then do, but keep in mind what we want from you is the story of the U. S. troops going to and in Cuba."

The writer went on to say, "Of course, I forgot to tell you something which is so naturally implied that with all the bustle and hurry of your departure it was forgotten—about your being our exclusive correspondent and all the stuff you make on that trip is ours. Send it along in any shape it may be—we will use it either in the magazine or in some other way." One other way was explained: arrangements had been made with the managing editor of the *World* for W. G. to go, when necessary, on that paper's "special boats." In return the *World* would be given "some of your drawings. Whenever you have any rough things done quickly send them along and I will pass them along to the *World*."

From here on it is possible to follow W. G.'s adventures from the drawings that survive. They fully demonstrate, among other things, that he did exactly as he was told—recorded the "departure, voyage and arrival and subsequent work and fights of the U. S. troops in Cuba." He sketched the landing of the troops at Daiquiri, he was present at Bloody Brook and San Juan Hill, he witnessed the surrender to General Miles and

23

the raising of the American flag over the governor's palace at Santiago. All these events survive in his living drawings of them.

John Sloan told, long after, what he remembered as W. G.'s account of the repulse of the Rough Riders at the foot of San Juan Hill. They stuck at the foot of the hill, and it was not until a Negro regiment went up that they followed. "Glackens," said Sloan, "said he was lying on the ground with his face pushed into the mud, but he raised his head to yell 'Cowards!' at those fellows and then put his face back in the mud."

This story, or one somewhat like it, I heard differently; the reader may choose. As I remember, it began with the difficulty that, as my father was the only *McClure's* correspondent in Cuba, without headquarters or any sort of arrangements for his survival, he was supposed to scramble for food at the regular Army canteens. This W. G. either would not or constitutionally could not do. But at San Juan Hill a correspondent cried out, "Save yourself! We are under fire!"

W. G. replied, "Beans!" He had found a plate left by a fleeing soldier. While the others dashed by he raised his head from the mud, cried out cheerfully "Cowards!" and returned to consuming the beans.

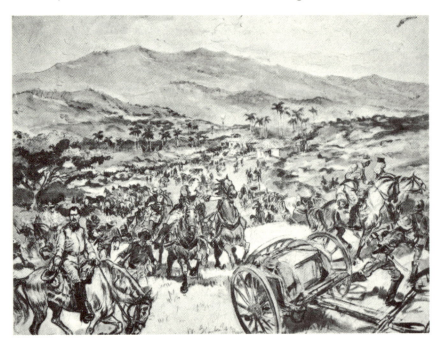

El Pozo. Just before the engagement. July 1, 1898.

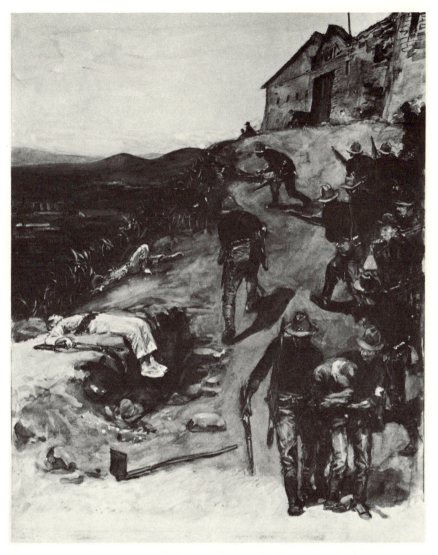

The Night after San Juan

W. G. nearly starved in Cuba until he ran into his good friend Harry Grant Dart. Dart and Tom Millard, likewise a *Herald* correspondent, invited him to the *Herald* mess and thus was another casualty of the Cuban campaign averted.

On the transport returning to the U. S., W. G. came down with a severe attack of malaria. He feared that he was going blind.

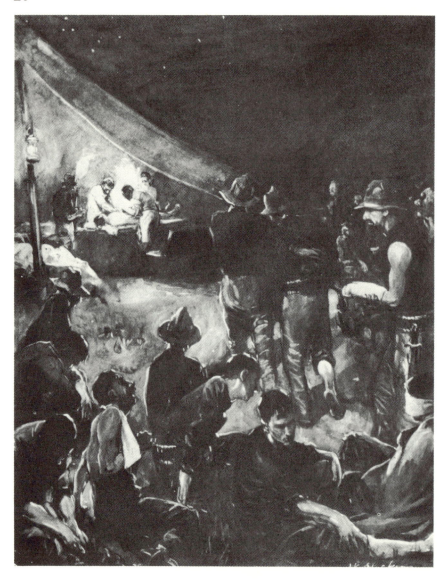

Field Hospital. July 1, 1898. (The Night after San Juan)

When he reached home he found that the war had ended so suddenly (the peace protocol was signed August 12) that many of his drawings were not received until hostilities had ceased, and then the editorial policy was not to publish much about the war; it was old hat. Thus many of his drawings were not used, and not paid for. For it seemed that, in spite of

the explicit letter, which was much more explicit about what *McClure's* wanted than what it would give, the arrangement was that only drawings used would be paid for.

"We got the best of you there, Glackens," he was cheerfully told— always an easy thing to do to W. G.

He seems to have borne no resentment. If he felt any, and he must have for a moment, it soon evaporated. He never could hold unpleasant thoughts. They simply dropped out of his mind, and he went on to new things. He had had high adventure in Cuba, his art had advanced under the inspiration of great and historic events; and perhaps his experience with editors would be of value for the future.

But W. G. never worked as an artist-reporter again, although he continued to illustrate for the magazines. In 1900 he settled in a studio at 13 West Thirtieth Street. Mouquin's Restaurant at Twenty-eighth and Sixth was only two blocks away, and he frequently dined there. This part of town contained many of the publishers' offices. McClure's was on East Twenty-fifth Street and Scribner's at 153 Fifth Avenue.

In the November, 1899, issue of *The Art Interchange* ("An Illustrated Guide for Amateurs with Hints on Artistic Home Decoration") in a series of "Representative Young Illustrators" by Regina Armstrong, there appeared an interview with W. G. "He says that he is a painter," Miss Armstrong reported, and further:

He is somewhat of a revolutionist in Art, and thinks that artists of the present day have not much to say, but devote their efforts toward an effective expression. He believes that the old masters were the only ones who really knew how to draw—and that they drew flat—that high lights are vulgar, and that if one goes boldly and directly to express an idea he is at once assailed as clumsy. He considers Whistler and Manet as the two great black and white artists of the century. He admires the character work of Charles Keene, and DuMaurier for the real values and original art he displayed.

On the whole, Miss Armstrong seems to have reported correctly. She added, "He works rapidly, but is often dissatisfied with results and sometimes will do a drawing over eight or nine times. . . . He wants to do 'big work,' portraits, murals and church decorations."

If this was W. G.'s ambition in 1899, he changed his mind in short order. He would never paint a commissioned portrait. He painted only

one mural, and that a great battle scene symbolizing Russia, for a war drive in 1918. Impossible to imagine W. G. painting "church decorations."

The one portrait he attempted (other than family or friends) was of F. Hopkinson Smith, a minor writer at the turn of the century, whose too-bland and charming novels were once on every living room table. Mr. Smith was something of an artist himself, but how he came to pose for W. G. is not known. One of his books was *The Wood Fire at Number 3*, which referred to 3 Washington Square, and perhaps the sittings occurred when W. G. was living at that address. Mr. Smith was critical of his portrait while it was being painted, and pointed out to the artist that he had a "high light" in one eye, which must not be overlooked. He held his head at an angle that would catch this important light, so that the artist could see what he meant. The next time Mr. Smith arrived, with spats and cane, to pose, the picture was painted out.

The rule against portraits to order was not violated by the portrait, painted about 1899, of Ferdinand Sinzig the pianist, one of the most colorful characters in the entire circle of W. G.'s friends. A tall, elegant German with distinguished manners, brooding eyes and a dark, drooping moustache, Ferdinand was the son of the director of a conservatory in Wiesbaden, and a true Bohemian. His first job in America was shoveling fish for the Promised Land Fish Fertilizer Company, at Promised Land, Long Island. When he graduated to teaching the piano, he was required also to tune the instruments—"take the dampness out of them," as their owners expressed it. Next he held the chair of music in a college in the West, but when W. G. first knew him, Ferdinand was giving piano lessons in New York. He seemed to have had plenty of time for visiting his friends, playing for them beautifully, and introducing them to the modern French composers, Debussy and the rest, who were then unknown in America. Describing the use of discords at a lecture, he played seven notes of the scale and left off the eighth note.

"Everyone in the room would know what that last note would be," Ferdinand explained. Then, catching W. G.'s eye, he added, "Everyone with one exception."

"That's me," W. G. hissed unnecessarily.

Sinzig's German wife Louise was a dressmaker. During a musical evening in the Sinzigs' 19th Street flat, coffee placed on the stove by the hospitable hostess sometimes began to bubble at the wrong moment. If

Louise showed anxiety, Ferdinand, executing an arpeggio, would remark, "Louise, *let* it boil!"

And when Louise referred to her husband's activities as his "breadless art," Ferdinand told her, "We have the finest music, Louise, and the finest asparagus."

If problems of marketing arose, Ferdinand would say in a lordly way, "Get the best, Louise," whether or not there was the wherewithal in the house to do it. This became a family excuse often used to justify a minor extravagance. But Ferdinand's greatest achievement in his adopted language was a phrase that could be taken to describe so many of the results of human endeavor: "the crowning absurdity of misplaced effort." (Ferdinand was of course a star frequenter of The Grapevine, that little café on Sixth Avenue near Tenth Street where the famous conversations could grow equally animated over world events or the root of a word.)

One rainy day when the model had been sent away, W. G. painted a sketch of Ferdinand before the open fire, a study in dejection. When Louise saw it she laughed for five minutes. Ferdinand could not imagine why. "Just see," he pointed out, referring to the *profil perdu,* "there isn't any face there!"

"There is enough there to say *lots,*" was his wife's reply. Perhaps Louise should have been an art critic.

But when she first beheld W. G.'s full-length portrait of her husband, her reaction was, "Oh Ferdinand, did you have on those old pants?"

In April, 1901, W. Glackens first exhibited his work in a group show in New York. No catalogue of this exhibition has come to light, but the curiously shy announcement has been preserved:

You are cordially invited to view a few pictures by Mr. William Glackens, Mr. Ernest Fuhr, Mr. Alfred H. Maurer, Mr. Robert Henri, Mr. Van Dearing Perrine, Mr. John Sloan, and Mr. Willard Bertram Price in an exhibition at the Allen Gallery, 14 West 45th Street.

As was to happen for years to come, the New York *Evening Sun* liked W. G. and gave him intelligent criticism. The critique was written by Charles FitzGerald:

At Mr. Allen's, 14 West 45th Street, an interesting exhibition has been opened . . . the more interesting because the pictures are mainly the work of

painters seldom seen at the regular annual shows, and especially because
among these painters are two or three of the too-small number of our younger
men whose work is at all interesting. The attention paid to the larger exhibi-
tions of the year is commonly out of all proportion to their value: as a rule
they are little more than repetitions of last year's. It is often to small exhibi-
tions like this that one must look for indications of what the future is likely
to bring forth. . . .

It would be easy enough to dismiss a modest collection like this with a
sneer and it will probably be treated in this way by many visitors. The dis-
covery that a painter has been influenced by Manet or Degas or Whistler has
so extraordinary a fascination for some people that it quite blinds them to any
personal merit in his work. It is a curious circumstance that frank plagiary of
some other artist is generously overlooked, however flagrant it may be. Mr.
Glackens is one who has undoubtedly studied Manet, but surely this cannot
discount the intrinsic value of such studies as that of the dancer that hangs
opposite to the door of the entry, and the admirable scenes at Charenton, in
a dance hall, and in a park. It is very well to carp at such things, but in picking
out failings and shortcomings here and there we risk overlooking the positive
qualities of the work. Now in Mr. Glackens the positive is an interest in the
life around him and an observation that are rare enough to deserve attention.
Where among the perennials of our regular exhibitions are we to look for a
more lively interest in humanity?

Mr. Glackens has undergone that trial of newspaper and magazine illus-
tration, which ruins most artists, but he proved to be one of the rare excep-
tions, and today he is one of the very few illustrators in this country whose
work deserves serious consideration. In this field he stands out as an artist of
pronounced individuality, and the work that he shows here reveals him as a
painter, too, of more than ordinary ability.

This was W. G.'s first serious criticism. For a young artist who was
just thirty-one it must have been gratifying, for surely he read it. In later
years when he received clippings about himself in the morning mail, he
used to start to read them, but then he would be distracted by the steam-
ing coffee or a plate of eggs and bacon. The clipping was laid aside, and
when it came time to clear the table, it got swept up with the crumbs.
W. G. by then was up in his studio painting.

About the time of the show at the Allen Gallery, W. G. met Alfred H.
Maurer, whose work was exhibited with his. Alfy Maurer was small, dark,
lively, full of vigor and enthusiasm, and on a visit home after several

years in Paris. He won first prize at the Carnegie International that year, at the age of thirty-three, and was an artist of whom great things were expected. He and W. G. became close friends.

New York in the early 1900's was a pleasant place in which to live. Time for relaxation was still permitted, wherein good conversation amid agreeable surroundings was considered the necessary nourishment and inspiration for creative work.

W. G., Jimmy Preston and their old friend from Philadelphia days, Frederick Gruger the illustrator, were in the habit of dining at Mouquin's, where they stayed until 2:00 A.M., closing time. Then they repaired to Shanley's, three blocks away, at Thirtieth Street and Broadway, which stayed open all night, and finished off the evening with deviled kidneys washed down with cream ale. This ritual occurred night after night. To make certain that good digestion would "wait on appetite," as Macbeth says, when they left Shanley's they visited an all-night drugstore hard by and consumed a patented beverage called Zoolac.

CHAPTER FIVE

By the time W. G. met Edith Dimock of Hartford, Connecticut, he had
for several years been attracting notice for his illustrations, which were
much admired by artists and critics alike.

It used to be said in Hartford, "The Dimocks are very rich and very
queer and they live in the largest and ugliest house in town." This was
only partly true. Ira Dimock was a prosperous silk manufacturer and in-
ventor, but not a great tycoon. As for the queerness, the Dimocks were a
family of individualists, which certainly should not be considered queer
in New England. Perhaps the queerest thing about them was Edith's early
ambition to become an artist; such a thing had never happened in the
family before.

The house they lived in was indeed large, and probably ugly, and
had been built on expectations, about 1880, by Cornelius Jeremiah
Vanderbilt, a son of the old Commodore. It was perched on a hill, then
known as Vanderbilt Hill, overlooking Farmington Avenue, just across
the boundary in the incorporated township of West Hartford. Surrounded
by eleven acres of lawns, pastures and gardens, it stood in lonely isolation
and was a landmark celebrated for miles around. In cold weather it took
a ton of coal a day to heat it.

The house was painted chocolate brown and had wide verandas, a
porte-cochere, a conservatory, mansards, gables, bay windows, dormer
windows, turrets, spires, carpenter's Gothic curlicues, stained glass and
a cupola that terminated five stories above the ground and overlooked
the Talcott Mountains to the west and the whole Connecticut Valley. In
fact it was so bad architecturally that it was *good*.

The interior belied the exterior, for it was both spacious and hand-
some. There was a great wide central hall where it was reputed "a man

could drive a horse and buggy right in and turn around." There were drawing rooms to the right and left: "the Old Gold Drawing Room" and "the Pink Drawing Room." The former had a beautiful Louis Philippe chandelier, all airy crystal balls, and the latter had "Ariadne and the Panther" in Carrara marble in the bay window. The furniture was upholstered in pink brocade with hundreds of little buttoned navels and included a central piece composed of three seats set in a spiral, like a corkscrew. The walls, too, were upholstered in pink brocade, and the ceiling was painted (by artists imported from Italy by Jeremiah) with stars or garlands of flowers or cupids on rosy clouds—I cannot remember which. Perhaps all three.

In this room W. Glackens and Edith Dimock were married.

The family consisted of Mr. and Mrs. Ira Dimock, their sons Stanley and Harold Edwin, and their daughters Edith and Irene. Edith, known in the family as "Teed," was the eldest living child, and Irene the youngest.

There was also an old maid cousin of Ira Dimock's, Ella L. Fiske (the family said she added the "e" to her name to make it look more elegant) who ran the house and had bossed the children for years.

The Dimocks were said to sit reading, each in a separate room.

Ira Dimock, however, spent much of his time on the train going to New York to buy raw silk for the Nonatuck Silk Company, later the Corticelli Silk Company, of which he was president, or to Florence, Massachusetts, to inspect the company mills. If a shipment of raw silk arrived in New York from the Orient, he was on the milk train from Hartford, and when he left the offices, having bought up all the silk, could tip his hat to the Cheney brothers, who were just hurrying up the steps to buy it. He lived on coffee and doughnuts in station restaurants and thrived on the fare.

For recreation of an evening he kept maps of distant wars which he followed by means of carefully placed pins, or got out his drawing board and invented a new piece of machinery, or wrote letters to the Hartford *Courant* and the Hartford *Times*. His subjects ranged from the brutality of football and the cruelty of bullfights to the Mexican Situation and the common house fly as a carrier of disease. No one was ever more down on the common house fly than Ira Dimock. Giving egg-laying statistics, he offered cash prizes to the school children of Hartford if they would com-

pute how many offspring and descendants a single house fly could produce in a year—"if," as he expressed it, "the mother bird attends strictly to business."

Ira Dimock was born in Tolland, Connecticut, in 1827 and had a hard early life. He had lost two sons, Arthur, who died suddenly at six, and Irving, who died of typhoid fever contracted at the infamous Camp Alger during the Spanish-American War. He said, "I am eighty today, and I would be glad to begin life over again barefoot if I could have the boys back." When he was ninety, his wife died. He did not wish to survive her, so he resigned the presidency of the Corticelli Silk Company, arranged his affairs, went to bed, and followed her—all within ten days.

His wife, Lenna Demont, was a Londoner, considerably younger than her husband. She had a sense of humor and a musical laugh and dressed with great style. In London the Demonts were Unitarians and belonged to the group of prosperous upper-middle-class intellectuals and liberals who read the *Westminster Review* and discussed John Stuart Mill's *The Subjection of Women*. Though she led a retired home life, Edith's mother was a born feminist. She loved her daughters and all little girls, and wanted them to have all the privileges enjoyed by boys. In fact her prejudice in favor of girls was so strong that when neighbors produced their fifth consecutive daughter, she took pains to call and congratulate them on having *another girl!* She loved her husband and her sons too, but would tolerate no belittling of her sex. It was this maternal influence, undoubtedly, that made Edith an ardent suffragist later on.

Once Mrs. Dimock called on Father Hughes, a Catholic priest who lived on the corner of Church Street in Hartford, to corroborate the references he had given to a maid seeking employment. The priest approved the applicant but made the mistake of adding, "Of course she is a woman, with all a woman's frailties. . . ."

Mrs. Dimock drew herself up. "Mr. Hughes," she said (she was a freethinker, and he no father of hers!) "I have been married sixteen years today. My husband is the best of his sex. *But I haven't noticed any wings sprouting yet.* Thank you, and good morning."

Yet Mrs. Dimock was not so emancipated that many of the fears and beliefs of the age did not trouble her. "Edith, if you should ever be *talked about*, I should die!" she said. There was no mention, and probably no thought, of its making any difference whether the "talk" were true or not.

Merely the chatter of idle tongues was, in those days, enough to bring death to the fond parent of a daughter.

But Edith was allowed to study art, whatever the family misgivings.

Ella L. Fiske of course did not approve, though in her youth she had painted pansies on plush. But as long as the class was in Hartford and William M. Chase the teacher—he came once a week from New York to give criticisms—her apprehensions were calmed. William M. Chase was about the only artist who passed muster with Ella Fiske. Dapper and elegant with his goatee and slashing brush, Mr. Chase prided himself on never getting a speck of paint on his clothes. But one night on retiring he discovered a smudge of Prussian blue on his toe, and warned his pupils against the use of that pigment.

Edith however finally announced she wanted to go to New York and study in the New York School of Art, where the Master spent more of his time.

What anguish now was suffered by Ella L. Fiske! Ella's fancy rioted in artists' misdemeanors. In her imagination they spent their entire time in nudity and revels. Edith said of her later, "By day she worried, and by night she dreamed." Soon she dreamed that Edith was involved in a scandal with J. Carroll Beckwith, who also was one of the teachers at the New York School of Art. J. Carroll Beckwith was pushing sixty.

Ella felt that Edith's actions, even in her own dreams, were somehow Edith's fault. "You were unrepentent!" she accused her. "All you said was, *'He can draw!'* "

Edith had indeed been allowed, several years before, to study for a brief time at the Art Students League, and her passion to become an artist had survived even that.

"In a room innocent of ventilation," she wrote, "the job was to draw Venus (just the head) and her colleagues. We were not allowed to hitch bodies to the heads—yet. The dead white of plaster of Paris was a perfect inducer of eye-strain, and was called 'the Antique.' One was supposed to work from 'the Antique' for *two years.* The advantage of 'the Antique' was that all these gods and athletes were such excellent models: there never was the twitch of an iron-bound muscle. Venus never batted her hard-boiled egg eye, and the Discus-thrower never wearied. They were also cheap models and did not have to be paid union rates."

In the Chase School (as it was usually called) all was different. Wil-

liam M. Chase had a new approach to teaching. He did not begin by discouraging his pupils. Kenyon Cox on the other hand never did anything else. "You're a very pretty girl," he could snarl. "You should take up knitting!"

But William Chase said, "My pupils think so much of my word I couldn't think of discouraging them." And, "If you like to paint, that's the best reason to do it." He had his pupils make a quick sketch every day.

Now in the school Edith met a fellow student, May Wilson Watkins, a young widow who had shortly before returned from studying in Paris, and was already securing a few jobs to illustrate for the magazines. They soon set up housekeeping together in the old Sherwood Studios at 58 West Fifty-seventh Street, close to the school.

May Wilson had a beau, an artist and illustrator like herself. He was James Preston, whom she had met in Paris, and when James came to call one day early in 1901 he brought along his friend William Glackens. A Hartford friend of Edith's, Lou Seyms, had likewise come to New York to study art, and she lived with Edith and May. They had merry little dinners, the five of them, and even had someone come in to cook and serve—Lena Marchesi. Her spaghetti could not be surpassed. Moreover a capon, already roasted, was sent down from Hartford every week. If the family supposed that these roasted capons were consumed by Edith, May and Lou in cloistered seclusion, they could not have been more mistaken.

Finally Edith's mother, accompanied by Miss Ella L. Fiske, arrived in New York to inspect her daughter's studio. On the wall of the place, which had been taken furnished, hung a rattlesnake skin which no one had bothered to remove. On seeing it, Miss Fiske shuddered.

"You don't like it?" asked May with her winning smile. And, snatching it off the wall, she obligingly threw it out the window. The two ladies returned to Hartford somehow reassured.

Edith, May and Lou watched for W. G.'s illustrations in every new number of *Scribner's*. They were lively and real, too devoid of sentimentality to please a generation brought up on spun sugar. Yet at this time, the beginning of the short Golden Age of American illustration, there were a number of fine rising illustrators, and their work was much noticed and written about; it was deemed worthy of critical attention. Only the public complained.

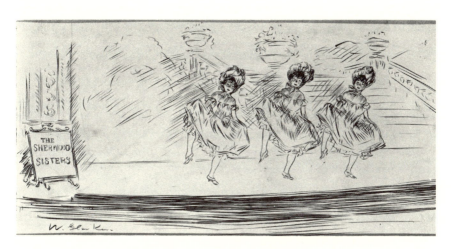

"The Sherwood Sisters" (Collection of Mr. James Preston.)

When William illustrated a vaudeville story for *Scribner's,* he added as a headpiece a sketch of three girls dancing the cancan. The sign at the side of the stage which announced the act said, "The Sherwood Sisters." It appeared in the issue for September, 1901.

James Preston and W. G. had a standing invitation to the Sherwood Studios every Sunday night, when the capon was consumed. Lena Marchesi, a native of Turin, was always on hand to see that there were other dishes beside the capon, for the Sherwood Sisters were not in the least domestic.

At a later period Lena often arrived in Ninth Street to see the Glackenses. These were Prohibition days, and she always brought a bottle of her own excellent Zinfandel—at once dry, fruity and spicy—and for Edith a bouquet from her little garden. The artist often bore these bouquets to his studio to paint.

Sometimes on her visits Lena went into the kitchen and prepared a favorite luncheon dish, one of her own.

Many years later Lena developed heart trouble and died. The whole Glackens family attended her funeral in her little house at Flushing, Long Island, and there was her flower bed, the roses and marigolds making it into a bower in the otherwise drab street. No one who knew her could ever forget Lena, her spirit, her chuckle, her genuine humor, her warm heart. As no book about William Glackens could be without a recipe or

two, here, to keep her memory green, is her luncheon dish, a fit monu-
ment to kings when properly made:

EGGS LENA

1 can tomatoes 1 onion

Cook on moderate flame one-half hour or until thick. Remove onion. Melt
one or more tablespoons butter in a skillet. Add one tablespoon of tomato for
each egg to be cooked. Break eggs into skillet and stir all rapidly together with
a fork until light and fluffy. Add salt and pepper to taste. Heap on platter,
garnish with points of toast and serve.

CHAPTER SIX

In the early summer of 1903 W. G. was busily engaged on the Paul de Kock illustrations, on which he had been working on and off for a year or more, and these are among the finest he ever did. In reading the stories themselves, as well as other stories W. G. illustrated, it is a matter of wonder how what was often such thin and empty material could evoke such living images. The illustrations have so powerful a life of their own that the text that called them into being can be completely dispensed with.

Charles Paul de Kock (1794–1871) was a minor French author who "excelled in descriptions of lower middle-class life in Paris," as the *Century Dictionary* informs one. His stories, written mainly between 1820 and 1850, were considered pretty spicy around 1900, and this must have been the reason that the Frederick J. Quinby Company projected a fabulous English translation, the edition to be limited to one thousand numbered sets. W. G. was approached to do the illustrations, and through him John Sloan, George Luks, James Preston and others also received commissions to illustrate the many volumes. But the whole project was unlucky. The company failed, the publisher went out of his mind, and the illustrators had a hard time collecting their money.

W. G. hated illustrating. Later E. told how, glued to his drawing board hour after hour, he did the same subject over and over, tearing up the drawings in disgust or throwing them aside until the floor was carpeted with them, and starting over again, cursing. Sometimes E. rescued the beautiful discarded drawings that floated around the room like autumn leaves.

Among the tales was one that caused extra trouble. The story involved a woman caught by her husband with another man. W. G. depicted the scene with the other man, in his nightshirt, sprawled on the floor. But the Quinby Company evidently felt that this was going too far. The

39

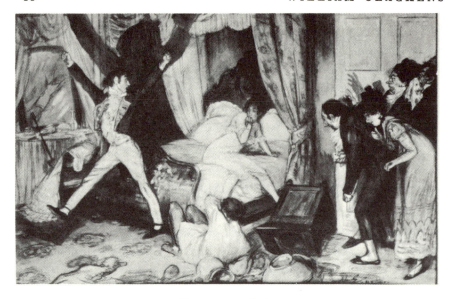

The suppressed plate

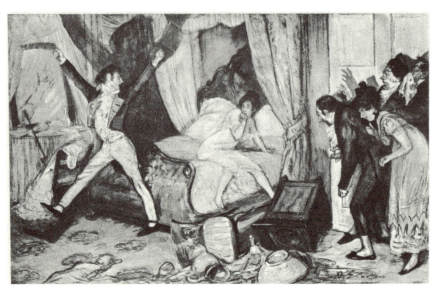

The revised plate

drawing was altered by substituting an overturned chair for the other man. So, in the published version, the raving husband and the gaping crowd pressing in the door are gaping and raving at having found the lady with a chair.

At this time the Dimocks were in New London, Connecticut, where they had long spent their summers, and E. was dutifully with them. On July 7, W. G. wrote her:

I took a ferry to the Palisades and spent an hour being blown about on the top of them. I sat in a summer garden on the very edge of the cliff where one could see all over the world almost, and drank a great glass of that same beer (they make it on Union Hill) we had at Van's that day.[1] I invoked your spirit and we had a fine time all by ourselves . . . it was the next best thing to having you there.

And across the bottom of the letter was a sketch of his tête-à-tête with the imaginary Edith.

"I invoked your spirit . . ."

[1] The artist Van Dearing Perrine

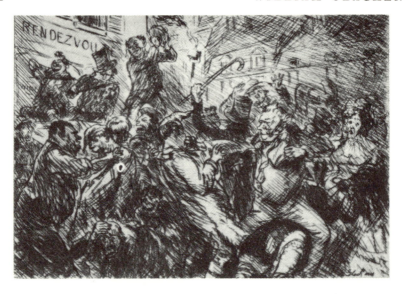

"By Jove! Everybody was fighting, and I did like the others."
(Etching from *Edmond and His Cousin*)

Edmond rose and walked about the room. (*Edmond and His Cousin*)

The reason that these two had let so much time slip by without mu-
tually discovering the state of their feelings lay mostly in W. G.'s reticent
nature; he was unable to say what he thought. He was dazzled by E.'s

Left. "Mademoiselle, I should like to see your mark." (*Scenes of Parisian Life*)
Right. The greatest happiness a grisette can experience is to make the conquest
of an actor. (*The Grisettes*)

sociable, informal manner and bright wits, which put him at his ease and
at the same time encouraged him to maintain his comfortable silence. In
fact he had in the course of his busy life never encountered anything at
all like the Sherwood Sisters. They must have been collectively a totally
new experience for so silent and retiring a young man.

Not only was he unable to say what he thought, he was totally unable
to say what he didn't think, and this inability sometimes placed him in
awkward situations.

Behind the scenes at the theater he was presented to the celebrated
actress Julia Marlowe.

"What do you think of the play, Mr. Glackens?" she asked brightly.

The play was *When Knighthood Was in Flower,* in which the actress
scored one of her greatest popular successes. But the question was a bad
one. W. G. sought vainly for a word, and flushed.

Miss Marlowe came at once to his aid. "I know it's trash," she ad-
mitted.

It was E. who likewise came to his aid, and helped him unloose his

tongue. Though far from reticent, and emancipated in many ways, she had a Victorian background, moulded by her mother and Ella L. Fiske; or, so she declared later, she would have spoken up much sooner!

"You have a delightful way of carrying off things in a quasi light style," W. G. wrote her, "and it is that I like so much. One never becomes embarrassed." And he referred in another letter to "my miserable shyness." But E. could not break down his reserve.

He invariably called her "Miss Dimock" until in despair she warned, "If you call me that again, I will kiss you in front of everyone." This threat had the desired effect.

W. G. planned to go to New Hampshire for a week, and later in the summer to Newfoundland for a month. Everett Shinn and his wife had rented a house in the vicinity of Cornish, New Hampshire, and W. G. wrote from the Kingsbury Old Tavern, at Plainfield, nearby, on July 20:

I am in a dismal spot. We have a burial ground to the right and a fifth rate mountain to the left and it has been raining ever since I arrived. I have to take the mountain on faith as it is wiped out with rain clouds.

The happy times at the Sherwood came back in this doleful setting with great nostalgia.

There is a devil of an artistic set here, it would make you weep. The Davidge and Shinn factions are sort of outcasts. Mrs. D. says she is afraid they are too tough for the elite.[2] God help the Sherwood Sisters if they were here. I believe they would burn you at the stake. Nothing but serious minded aesthetes permitted here. Pleasant jocularities not allowed.

As far as I can make out everyone passes the time in running the other one down. But enough of this, I still have faith in life, and these poor beggars up here couldn't survive art. Shinn's house looks very well and is quite a size. ... The lack of even a scratch from you has left me quite desolate. I wonder if you have sent a letter to thirtieth street.

When he returned to New York he reported:

Not much of the milk of human kindness in Cornish. Everyone roasts the other, garden, house and family. New York is a blissful abode of angels in comparison.

[2] Mrs. Clara Potter Davidge conducted the Madison Art Gallery. W. G. exhibited there in 1912.

On August 12 W. G. set out for his real vacation. Newfoundland was not after all to be the destination, but the small French island of Saint-Pierre off its southern coast. W. G.'s companion on the Saint-Pierre trip was his friend from *Herald* days, the artist Ernest Fuhr. They sailed from Boston, and on the seventeenth W. G. wrote from the Lorne House, Halifax, "Tomorrow Tuesday we take a packet boat for St. Pierre." The name of the hotel seemed to him appropriate; he said his feet had taken him up the hill and straight to its door.

Soon he reported from Saint-Pierre, "This is a funny place I am in . . . a wilderness of rock. There is only one mail every two weeks and I have just thirty minutes to catch it." That was on the twenty-third, and two weeks were to elapse before the return packet to Halifax. From Halifax on September 11 he wrote again; it appears that "the miserable French packet boat" caused the travelers to miss their connections to Boston; they had to wait until Saturday for the next boat, presumably a two or three days' wait. It was probably on this account (though he did not mention it in his letter) that they ran short of funds, though the Albion where they put up this time was in Sackville Street "near the Steamboat Landings," with "Terms $1.50 a day." Fortunately one of them had "something pawnable"—probably a watch—and with the proceeds they managed to eat on the way back to New York, though they had to eat sparingly.

They had been three weeks on Saint-Pierre, and W. G. produced one painting from the trip—"Cap Noir, St. Pierrre," a wilderness of rock.

But E. was still out of town. W. G. wondered how he was "to go on always living in the stupid Mouquin's and Francis restaurants"; he was horribly bored, and he admitted, "It is because you are not here."

E. came down in October, with her Hartford friend of lifelong standing, Grace Dwight. With Frederick Gruger to make the fourth they went on several sprees; W. G. took E. to dinner; and she returned to Hartford.

In Philadelphia on November 27 he had grown very despondent. "A scrapple-filled cynic with an acute attack of nostalgia—that's Willie. The nostalgia is your fault. The scrapple and cynicism are products of Philadelphia."

He need not have been so gloomy. E. came down from Hartford again in December, and they planned to announce their engagement. "When you went through the gates and got on your train Glacky's black dismal

holiday season commenced. What a miserable invention it all is, these holidays."

He had caught grippe at Thanksgiving. "My deepest and most heartfelt curses are leveled at Philadelphia. The home of grippe, typhoid and small-pox." But he could not really be unhappy. "I wonder what your family will think of it all when you tell them? I must hunt around for another studio; poor old 13 West must be abandoned."

By New Year's Eve he was better, but still unable to go out. He could dwell on the rosy future, and felt elated:

I am going to have dinner sent over from Shanley's tonight. I am going to make a sort of banquet out of it as I have an enormous appetite. You must understand that you have an invitation. I suppose Bill [Frederick Gruger] will be the only guest, and probably he won't turn up, but I'm not going to let that interfere with the gaiety of the occasion. If I can succeed in keeping pastel butts and paint rags out of the food I am sure everything will run smoothly. Tomorrow night Bill and I are having our New Year's dinner chez Preston. So Teedie dearest you have no occasion to be alarmed about me. My great regret is that you couldn't be here to eat off the model stand with me tonight.

But Edith at home was faced with breaking the great tidings. Though she could not help quailing, on New Year's Eve she took the plunge.

There was a moment of stunned silence at 744 Farmington Avenue,

broken by her mother. "Oh, Edith!" she wailed. "We thought that *you* would never marry!" Edith never understood exactly what this statement meant.

It so happened that the Iroquois Theatre fire in Chicago, in which 602 people perished, had occurred the day before, and the papers were full of the tragedy that morning. E. said that the two disasters—the Iroquois Theatre fire and her engagement—were henceforth linked in the family mind.

Ella L. Fiske was literally struck dumb. She never opened her lips for the remainder of the day.

Hers was an anomalous position. Though actually only a remote relation, she had long been a member of the family, a situation not uncommon in the Victorian era. Mrs. Dimock had for some reason abandoned running her own home, and let Ella take charge. But when it came to momentous family matters, Ella of course had nothing to say. This was very difficult for one of her temperament. She never could realize that the family freedom was a matter of preference, not ignorance of the Correct Thing. She was a hen in a lark's nest.

Doubtless Ella would have liked the Dimock girls to marry European noblemen, preferably Englishmen no lower than dukes. When Edith announced her engagement to a *New York artist*, the blow was almost more than she could bear. And the shock was to be repeated some years later when the second Dimock girl, Irene, became engaged to Charles FitzGerald, a newspaper critic and an Irishman from Dublin. The Fitz-Geralds had a crest, to be sure, but it was kept in the dark and Ella did not learn about that, and when she did it was small comfort. The crest had a boar on it, with the motto: "Shanet a Boo," which Irene told Ella meant "Irish bacon forever!" Poor Ella suffered a good deal.

But Irene's marriage was in the future. At present the family had trouble enough; and still they had not learned all. Edith announced that she did not wish to have a fancy wedding.

Here her mother rebelled. "The Pratts have invited us to *three* weddings," she pointed out. And so it came about, in order to repay the Pratts, that Edith was obliged, as she expressed it, to be the goat. "But I won't wear a veil!" she declared firmly.

Ira Dimock said only that he wished to meet the young man and learn something of his *morals*.

The next day was New Year's, and Ella L. Fiske felt obliged to break her silence.

"Happy New Year, Edith," she managed to articulate in a strangled voice. "I *hope* you will be very happy."

W. G. received the news by special delivery that the cat was out of the bag, and he wrote:

I read your letter with much satisfaction. I think it is only quite natural that your father would like to know a little about me and my *morals*.

Tomorrow I shall write him all I can about myself on that subject, I wish it were some other. It's a dreadful ordeal and puzzle to know what to say and worse to know how. I hope it will be satisfactory but I have little hope for the penmanship. [Ira Dimock set great store by penmanship, and wanted everyone to write a fine, copperplate hand.]

I have sent word to my family. The man's end of it is so easily done that I can't help marveling at your courage. We will have the priest mumble whenever you say.

So W. G. arrived in Hartford to ask Ira Dimock for his daughter's hand in the time-honored fashion. Edith went down to the station to meet him, the train was five hours late, and this too outraged Ella L. Fiske. She said, using her favorite word, "Is it *rulable* for a young unmarried woman to meet a man at a railroad station?"

When the two silent men sat closeted, there seemed no necessity to explain matters. Finally Ira Dimock broke the deadlock.

"Edith would have made a fine stage comedienne," he observed with a sigh. "As if I didn't know that," W. told E. later.

The rest of the family was probably resigned, but not Ella.

"Edith," she asked one day suspiciously, "do you *kiss* William?"

"Certainly!" said Edith.

Ella's eyebrows rose.

"I should *think*," she said, "that you would leave *something* until *after* marriage."

As the years went by, Ella was to grow very fond of W. G., and later of Irene's husband Charles FitzGerald, but it never occurred to her that either of them was a person of the slightest consequence.

The wedding was set for February 16, 1904, Edith's twenty-eighth birthday.

Back in New York, W. G. was faced not only with house-hunting, but with "exposing" his paintings. An exhibition at the National Arts Club of works by him, along with others by Henri, Luks, Sloan, Davies and Prendergast, opened early in January, 1904.

Charles FitzGerald defended W. G.'s painting, "Ballet Girl in Pink," which had been adversely commented on, in his columns in the *Evening Sun* on January 23:

A ballet dancer according to the rules ... is essentially a thing of frills and frivolity, and because Mr. Glackens has chosen another aspect, removed from the footlights, pensive and in repose, we are seriously asked to believe that he has missed the essential qualities of his subject and that the fine painting is discounted by his failure to borrow the spectacles of a Carnier-Belleuse.

The picture will be remembered. It is the one that the hanging committee of the Society [of American Artists] consigned to a side gallery last year. At the Club it has been treated after its deserts and holds the centre of the wall opposite the entrance to the first room. Of the four full lengths that Mr. Glackens sends this seems to us the most consummate at all points. As a painting pure and simple it was unrivalled at last year's exhibition, but it is now seen in a decent light for the first time. If its merits do not declare themselves to the eyes even of the most casual observer we hardly know where to send him for legible testimonials of its author's worth. Perhaps the admirable landscapes, the East River, the Big Rock and the rest will serve the purpose. Among our famous landscape painters who excite the warmest annual enthusiasm how many can show such vigor and sureness of vision, such ability in the business of painting? There is nothing here of the vague compromise that we are accustomed to even in many of the more serious of them, no fumbling of awkward facts, none of the bribes to "taste"; the painting is of the school of Manet in its frank decision and forthright power.

The "Ballet Dancer" was painted about 1901 in the studio at 13 West Thirtieth Street, and long hung in the G.'s' apartment at 29 Washington Square. Since then, it has had a checkered career.

But the *Commercial Advertiser* felt differently about the whole thing. "A most lugubrious show," it said, and complained of its prevailing "unhealthiness." "The dreary, the sad and the bitter" seemed to be in evidence. So far removed from life had art become that any return to it was an unpleasant shock, at least to the *Commercial Advertiser*. The *New York Times*, however, was unusually excitable for that staid sheet. Charles de Kay called the paintings "Startling Works by Red Hot American Painters," and stated that "discussions convulse the Art Clubs over the status of the young Come-Outers." Prendergast was then forty-eight and Arthur B. Davies forty-two.

Neither the *Times*, nor the *Commercial Advertiser*, nor the art columns of other papers, was prepared for the bombshells which were to burst in four years, in six, and come to a great explosion in far-off 1913.

That January was a very trying time in the Dimock home: gloom had settled upon Hartford, and E. escaped back to the Sherwood until the family could recover from its state of shock over the dismal news of the engagement. E.'s younger brother Edwin, who was a student at Yale, wrote her, "In a few minutes I am going up to Hartford and if I can improve anything up there it shall be done but of course you didn't suppose that anyone you could possibly fancy would fill mother's ideal of a whiskered person without faults, or come up to Ella's plans for you— Lord knows what *they* are."

The inevitable problem of finding a suitable studio for two seemed insoluble. Earlier W. had written that, though he hadn't had a chance to look around, "we can always make some temporary arrangement if I can't get just the right sort of place." But when E. returned to Hartford at the end of January, no place had been found.

Then on February 4 W. wrote in great haste to say that May Preston had succeeded in landing a front studio at the Sherwood which she had generously given up. It had only one little room besides the anteroom, but the studio was good:

I have hunted all over town for a decent place, I have advertised, and

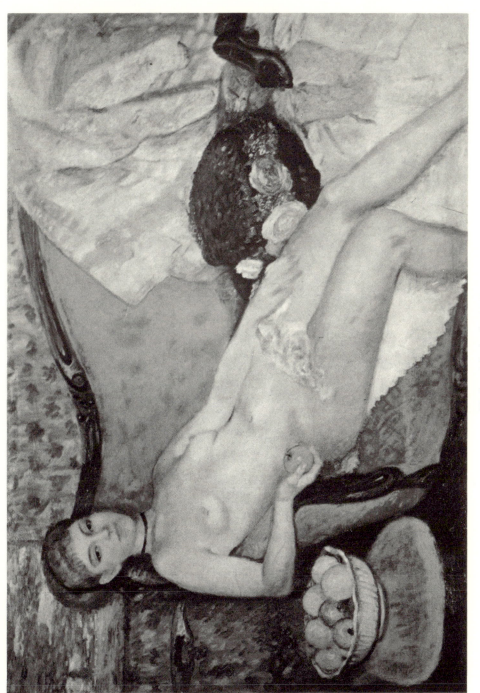

Nude with Apple, 1910

IN THE COLLECTION OF THE BROOKLYN MUSEUM

Robert Henri: *Portrait of William Glackens*, 1904

Robert Henri: *Edith Dimock Glackens*

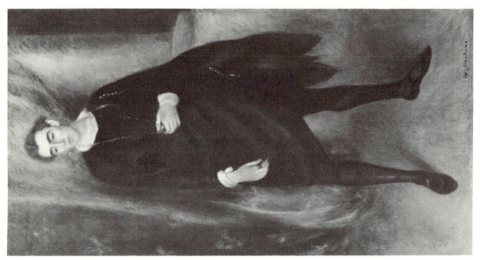

Walter Hampden as Hamlet

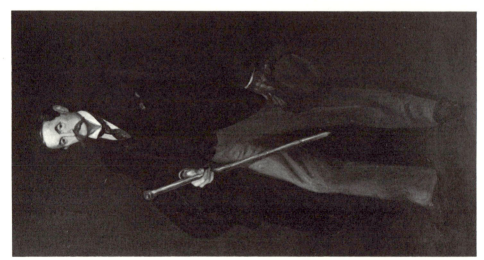

Ferdinand Sinzig, c. 1902

Outside the Guttenburg Race Track, 1897

PRIVATE COLLECTION

La Villette, 1896

CARNEGIE INSTITUTE, PITTSBURGH

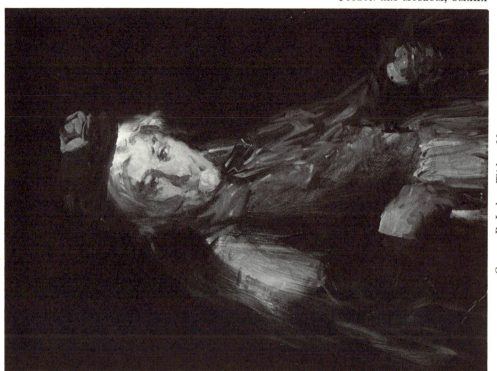

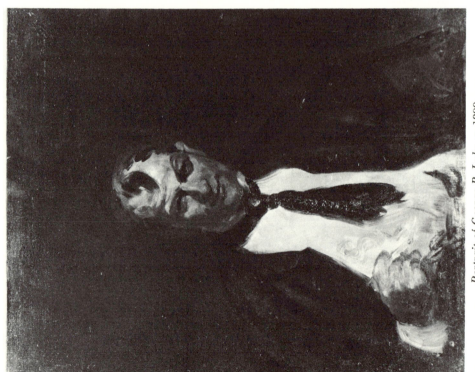

Hammerstein's Roof Garden, 1902

The Drive—Central Park, 1904

J. H. WADE COLLECTION, CLEVELAND MUSEUM OF ART

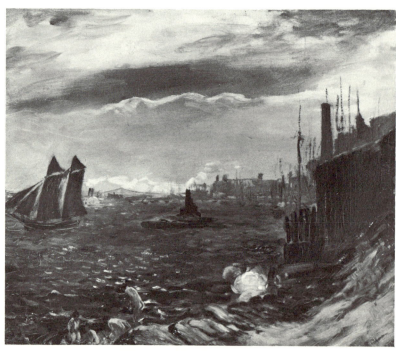

East River from Brooklyn, 1902

PRESTON MORTON COLLECTION, SANTA BARBARA MUSEUM OF ART

Portrait of Charles FitzGerald, c. 1903
PRIVATE COLLECTION

Portrait of the Artist's Wife, c. 1905

devil alone knows what all I did to find something that would do—utter failure, couldn't find it. Felt almost like giving up art.

Can't say how many of the family besides father and mother etc. will come.

I wouldn't be at all surprised if "Babe" would come along. George (Luks) was up to see me this afternoon, he had been celebrating the day before.

Doubts began to assail him about the guests. "They are all looking on our wedding as a good chance for a lark. I hope they don't get too noisy or too drunk."

A special Pullman on the 9:02 A.M. train to Hartford had been chartered by Ira Dimock for the wedding guests, and all those invited eagerly accepted. W. warned:

————will probably take advantage of that invitation. A free ride, no presents, a show and something to eat were too much for her. . . . I had on my long coat today to see how I looked—sort of a stuffed Paddy effect, but I guess I'll do. I shan't bring any top hat as I will not have to go out in it.

Wouldn't it be awful if all that carload were frozen up or came five hours late as I did? We wouldn't have to delay the wedding, would we?

Everett Shinn was helping to hunt for a permanent studio or house, but without success.

Your handwriting on the card tells of much suffering. I never saw such frazzled up handwriting from you before. Lucky that your father never saw this specimen. I will have the list [of guests] made out and take the twelve o'clock train Saturday.

The Glackens-Dimock wedding was probably the most extraordinary ever held in Hartford. The wedding guests on the special Pullman included the groom's parents, his brother and sister, and his Aunt Becky (Glackens) Settle, the Philadelphia contingent. The New York contingent included the best man, James B. Moore; George Luks, Ernest Fuhr, Mr. and Mrs. Everett Shinn, May Preston (who had been married the year before, though James could not come); and Charles FitzGerald of the New York *Evening Sun*.

One supposes that this was W. G.'s parents' first glimpse of their son's New York friends. No doubt they thought them wonderful, and would not have questioned had they all had three legs. James B. Moore was an impressive man, with great manner, which served to conceal a far from

orthodox interior. But George Luks acquired a pink rose petal, which he stuck on his nose, and went up and down the aisle urging everyone to make himself at home. There was no doubt but that he intended to be taken for the great financier, J. P. Morgan.

The train arrived to find Hartford suffering from the coldest day of the winter. A long line of carriages awaited the guests at the Union Depot to transport them to the bride's home in West Hartford. To meet them and dispose them in the carriages, as an official dispatcher, was Edith's friend Grace Dwight, daughter of the erstwhile and much loved mayor of Hartford, General Henry C. Dwight. She stood on the station platform as the train chugged in, wearing an enormous hat with an enormous plume, which began at one end a deep scarlet and faded by degrees to pure white at the other. Grace finally found herself with one carriage left over and three strange gentlemen to fill it. Boldly she stepped in with the three gentlemen, and the last shivering horses started on the long haul to West Hartford.

That the groom's parents were in any way startled or surprised by their son's friends on the New York, New Haven and Hartford Railroad is highly unlikely; they mildly accepted everything. But what must the bride's parents have thought when all these people began to converge on 744 Farmington Avenue? George Luks, though he had removed or lost the pink rose petal, was already obviously several sheets to the wind. However, in the crowd and the rush, perhaps he went unnoticed. Fortunately, James B. Moore, with his white carnation and elegant attire, was the very ideal of a best man. The groom's parents, so small, so mild and so polite, and his aunt, who was noted for her fashionable clothes, must also have served to reassure. Had the bride's parents heard the merry conversation on the train, however, they might have been startled. Somehow these New York artists were different from the Pratts and other Hartford neighbors, for whom, after all, the wedding was really being given!

Edith had announced that she would not have a bridesmaid, neither would she rustle down the stairs and through a hushed throng to her place beside the minister. When the guests were summoned and moved in concert into the Pink Drawing Room, Edith and William were discovered standing by the door to greet them. By these little unconventional arrangements Edith sought to take the horror out of the performance. But

she did at least wear orange blossoms. Her uncle Lucius Dimock (known admiringly to his friends as "the most profane man in the state of Massachusetts") had kept a lamp burning day and night over an orange tree in his conservatory, and it bloomed in time.

The Hartford *Times* reported that "the hall of the handsome residence was tastily trimmed with Southern smilax and the staircase was banked with the same." Behind the smilax, on the landing of the golden oak stairs, a small orchestra struck up a tune as soon as the knot was tied. But it was not the doleful strains from *Lohengrin*, it was the lively "Swedish Wedding March," to be highly recommended for such occasions.

The happy pair led the way to the "sit down breakfast served by a New York caterer" (and ordered, no doubt, by Miss Ella L. Fiske) in the oak-paneled dining room with its sideboard that rivaled the Albert Memorial—surely it had been constructed on the spot, and the house built around it. Above the panels, the walls were covered with a composition called Lincrusta-Walton, embossed in a perfect imitation of potato sacking, only it was gold. The swinging door to the butler's pantry was decently concealed by a leather screen richly tooled in a design of apples, pears, plums, cherries and grapes, all brown, picked out in gold. In a wide bay window large jardinieres on pedestals held lush tropical ferns, but now the room was a welter of violets, bride's roses and lilies of the valley. The dining table with its wide border carved in low relief with hundreds of animals, no two alike, and its chairs like thrones, had somehow been removed in favor of dozens of small tables. The bride's was decorated with orchids, white lilacs and American Beauty roses. Where did they get lilacs in the middle of February? No matter, it was a grandiose yet gay affair, the Pratts were handsomely repaid, and George B. Luks did not fail to pay tribute to the champagne.

It is said that the return journey, on the five o'clock train to New York, was even livelier than the trip north. In fact it is this train journey that has loomed largest in the memory of the passengers and has lived on in song and story to this day.

James B. Moore, W. G.'s best man, owned the Café Francis at 53 West Thirty-fifth Street. "New York's Most Popular Resort of New Bohemia" is how the advertisements ran. The Café Francis was a hobby with him, for he had independent means. He was a lawyer by profession and dealt in real estate besides. But his main activity in life centered around his Café because it attracted artists and writers, and artists particularly interested Jim Moore.

On the walls of the Francis hung many canvases painted by Jim Moore's friends. Some he bought outright, and others were exchanged for credit at the café. Ernest Lawson said years later that he had "eaten up" seven of his paintings at the Café Francis. The Francis was celebrated, at least for a while, for its cuisine and its cellar.

Mr. Moore's house was at 450 West Twenty-third Street, and he had given it a name. His stationery was headed "The Secret Lair Beyond the Moat." Here his most celebrated parties occurred, with Jimmy Preston, George Luks, John Sloan, Everett Shinn, and Ferdinand Sinzig the pianist all frequently present. Beer was consumed late into the night, and when the place got too littered with bottles, Jim tossed them nonchalantly over the back fence. He must have been a trying neighbor.

He had numerous young ladies about, whom he referred to as his "daughters," and it was one of these who posed with him in 1905 for W. G.'s painting "Chez Mouquin" (Art Institute of Chicago).

At the Secret Lair, in a small attic room, a poet lived in the classic tradition. Jim Moore had offered this retreat to the impecunious and obscure Edwin Arlington Robinson, who was shy as a fawn and slipped up and down the stairs only when he was sure the coast was clear. But one night the revelers at Jim's watched for him, pounced on him, and dragged him into the party, where, willy-nilly, the author of "Miniver Cheevy" was forced to join in the merrymaking.

It is said that this curious association stemmed from Robinson's having given up his seat at the table in a boardinghouse to Jim Moore who was pursuing the lady who happened to occupy the next seat. Evidently the arrangement ended in success, and Jim had a practical way of showing his gratitude.

Charles FitzGerald called one day at the Secret Lair Beyond the Moat, to be met at the door by his host with finger to lips. He explained that his sister was there, and as she was a nun he hoped that Charles would be circumspect in all that he said. Music came from the room within. Charles FitzGerald, who was so polite, so urbane, and who never

said anything uncircumspect in his life (though he was startled to learn that James B. Moore had a sister who was a nun) prepared to meet her. He discovered a young lady playing the piano, stark naked. It was another of James Benedict Moore's little jokes.

But the most surprising fact about James Benedict Moore, taking everything into consideration, was that he was the grandson of Clement Moore, author of " 'Twas the night before Christmas. . . ."

Charles FitzGerald, already referred to as W. G.'s first critic, was an editorial writer on the New York *Evening Sun*, whose subjects included art, literature, music and medicine. His father was Dr. FitzGerald of Dublin, one of the best known and best loved inhabitants of the city. He held the honorary position of court oculist there through three reigns, and lived to the "Trouble" in 1916 when fighting raged in the streets. Then, an old man, he left his fine house in Upper Merion Street and went out among the flying bullets to tend the wounded and dying, and his (second) wife took him by the arm and went, too. Nobody in Dublin would deliberately shoot old Dr. FitzGerald. He was never known to send in a bill.

Charles wrote with a goose quill in a fine crabbed hand, forming his double S's in the eighteenth-century manner, and he made his own ink by scraping hard little cakes of India ink and diluting the resulting dust with water. He spoke the charming English of Dublin, wore a cape, and had a fine Irish head that was sculptured by his friend Jo Davidson.

Though he lived thirty years in New York, no one would have known it, for he remained a native of Dublin in look and speech. His favorite authors were Rabelais and Dean Swift, on whom he was an authority. He had met W. G. through their mutual friend, the painter J. W. Morrice.

Charles FitzGerald also appears in the painting "Chez Mouquin." His face may be seen at the far right of the canvas, only partly visible, and reflected in a mirror. The lady he is with, of whom only the back of the head shows, is E. G.

The erudition of Charles FitzGerald could almost always be counted on, but in one instance he was mistaken in his facts. As he and his wife sat one summer evening at dinner in their house at Malba, Long Island, Charles observed, in his fine, positive, Dublin English, "Did you hear that squeak, Ireney? That is the Evening Bat, *Nycticeius humeralis*, a very rare species. I had no idea they ever ranged so far north as this,"

and he gazed with admiration out of the window into the gathering dusk.

Emma, the colored maid, a saintly soul who could not live a lie, was serving the vegetables.

"That squeak, Mr. FitzGerald," she said shyly, "was my corset."

W. and E., after their marriage, settled temporarily at the Sherwood, in the studio May Preston had given up to them.

The Café Francis and Mouquin's, which had for a while seemed so dull, now became gay once more. The Prestons, Robert Henri and his wife, all their friends, were often to be found at one or the other. James B. Moore was in his stride as a giver of parties. In the garden at the Francis, among other diversions, was a French "Frog Game." This consisted of a frog with a wide-open mouth, and the object was to score 100 by flinging little iron discs the size of fifty-cent pieces into his mouth. If the disc went into other holes on the board, lesser sums were scored. This simple game occupied the attention of artists, writers and news-papermen of national reputation.

Edith tried and tried, and one evening at last she landed the disc in the frog's mouth. The fact that she had the misfortune to lose her drawers, which fell in a circle about her feet just as she scored 100, was of no moment. She stepped out of them, tucked them into her purse, and went right on to score again, amid great applause.

Hartford was never like this.

That year, moreover, E. had one of her watercolors accepted by the American Water Color Society for its spring exhibition, and on May 3 a review appeared in the *Evening Sun* which, though unsigned, bore internal evidence of having come from the pen, or rather quill, of Charles FitzGerald:

These shows do not lay themselves open to criticism.... Having nothing to say themselves there is nothing to say of them, for or against, so completely neutral are they, so consistently inane....

We are tempted rather to pick out something neglected or overlooked than wantonly to tear up characters too weak to do mischief, or to add superfluously to the friendly nothings provided for the sustenance of recognized reputations. And we find it in a little drawing concealed in one of the lesser rooms: "Rain" by Miss E. Dimock. There is mischief in this artist's work, and by what strange accident it escaped the vigilant eye of a very decorous

jury we cannot guess. The hanging committee was well advised in hiding it, for it has no business in an exhibition that ranges in orthodox order from the flimsy sketch of vague sentimental possibilities to the carefully niggled ideal of the Christmas supplement. Miss Dimock is not orthodox at all. She comes to her world very unconventionally, free from pictorial prejudice, and with a purpose which is not complicated by unsettled notions. Her attitude to life is the precise antithesis of the attitude that prevails in this exhibition, where unattached sentiment rules and the "picture" instinct is so much too strong for original observation. Here is an artist with a definite aim, a keen fresh vision, readily interested in the humorous, whimsical aspect of her neighbors: the impish brats in the street, the village gossip, the plain countryman, the citizen, pathetically self-conscious in his Sunday clothes. And these little fragments are picked out with an astonishing eye to the essential features of the business in hand: the blobs of color distributed artfully and with a frugal recognition of form, no more nor less than sufficient to inclose and intensify the curiosity, oddity or quaint charm of the characters. It is a wonderful art. How futile are the many careful, conscientious studies on the walls here in comparison with this slight sketch that goes so infallibly to the point! A few leading characteristics are noted: the ruddy cheeks of the youngster facing the wind, a pair of beady eyes, a glimpse of white stocking on an unshapely leg, the black gloves of the old lady—and out of such simple material exactly noted at the cost of a hundred other facts, deliberately ignored, a picture comes that carries more conviction, a truer impression of life, than the painful laborious trifles of the professionals who are occupied with everything except life.

Thus it can be seen that E., in spite of her early studies with William M. Chase, was unalterably herself and a born disciple of the Ashcan School. No wonder Chase said that he could not make her out, but he thought she was a genius!

Charles FitzGerald was forever taking issue, in his columns, with hanging committees; it seemed to him that the better the picture, the darker and more obscure the corner in which it was hung. The Society of American Artists, which had come into being in 1877 in revolt from the National Academy, had been steadily retrogressing and now was scarcely more liberal than the parent body.

Writing of its spring exhibition in 1903, Charles had taken the hanging committee to task over its treatment of W. G. "Last year he had a picture in the central gallery; this year he has been admitted to the

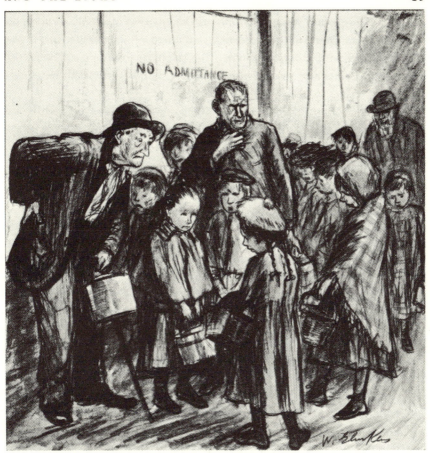

South Gallery; we may perhaps hope that next year he will get a place on the line."

It was the same with the works of George Luks, "who shares [with W. G.] the skyline at the Society and the darkness at the Colonial Club"; and he enquired caustically, "Are the makers of public exhibitions officially blind, are juries constitutionally incapable of recognizing what is vital, or is it that societies are intended primarily as hospitals for the sickly and moribund in art?"

But these diatribes did not go unanswered. In 1902 Charles had taken issue with the hanging of a canvas by Robert Henri:

Last year we had the misfortune to disagree with the Society of American

Artists ... The picture was thrust into an impossible corner and quite inno-
cently we found fault with the hanging committee, an indiscretion which was
duly rewarded with a furious letter of eight pages from a member of the
committee who, it may be said without flattery, paints better than he writes.

Hanging committees gradually learned not to cross swords with the
critic on the *Evening Sun,* and this championing in the public prints
seems to have been to some avail, for each year such works by W. G.,
Luks and Henri as were accepted were given progressively better posi-
tions. And yet they were none of them the kind of art that either the
Society or the National Academy could really approve.

Even the names of paintings caused dismay, and the Society of
American Artists was loth to hang George Luks' "Whisky Bill." "The
title of the picture," Charles commented sardonically, "seems to have
offended the tasteful and refined. We advise Mr. Luks to call it in future
'Portrait of a Gentleman': perhaps then they will forgive the acute char-
acterization, the fine drawing and sensitive modeling of the wonderful
head, the splendid painting."

Perhaps as vividly as more weighty observations and statistics, this
single fact about "Whisky Bill" illumines the art situation in America
in the early years of the century, and the point of view of the solidly
entrenched National Academy and stultifying Society of American Artists,
without whose benison no artist in those days could hope to become
known. It was Charles FitzGerald and his biting quill that helped to
bring the artist's plight into public view, for though most of them could
(and did) speak up when goaded, they could scarcely take the critic's
place and laud their own works.

After a couple of months at the Sherwood, the Glackenses succeeded in
finding an apartment at 3 Washington Square and forsook Fifty-seventh
Street for good. But the idyllic life was interrupted in the spring by the
severe illness of E.'s father. Her mother, Ella Fiske, Irene and Edwin,
were in Europe on another of their periodic progresses through the most
expensive hotels of England, France, Germany and Switzerland, and E.
hurried to Hartford to take care of her father and run the house. W. G.
was temporarily a bachelor again.

Yet his life could not have been too solitary. "We had a fine dinner

last night and roustabout afterwards [June 20]. Upwards of a dozen dirty ash-throwing men assembled and your heart would have bled to have seen the condition of the floor. Still withal Anna [the maid] did not call us 'drunken boozers' " [as she had been heard to do before].

E. suggested that W. come to Hartford; she was rattling around in the large empty house. "It would be possible to spend most of the time up in Hartford but I wished to do some painting this summer and I can't take the studio with me. I think it would be a good plan not to stay away entirely from Washington Square. Somebody might swipe it."

By early July Ira Dimock was convalescent, but E. could not leave him for long.

July 10: "There will be a gathering of the clans at Washington Square tonight. Ned[1] and Charles FitzG. and James [Preston] will be dining and the rest will come after dinner. I hope Anna will not think we are drunken boozers."

E. had to subsist on accounts of the good times she was missing.

July 13: "Dined tonight in solitary glory on the worst food that I have had in many days. I fancy the Francis Café is not making a great hit with its cuisine. I was disappointed in not finding James B. Moore as he has not returned from the seashore."

W. G. usually recounted his gastronomic adventures, as good food to him was one of the major joys of life. E., with a Yankee father and an English mother, preferred simple fare which W. pronounced tasteless.

The bad meal at the Francis had climaxed an unproductive day: instead of painting, he had been posing for Henri at the Sherwood, where the Henris were now living.

He started me off this afternoon and it promises to be a pretty good picture. He has a curious habit recently of painting one side in a brilliant light, and the other in a deep shadow. I don't think all heads are applicable to that effect, especially for portraits. I have on a gorgeous white vest that I purchased for $1.50 on the way up there.[2]

Henri also painted Edith, who at this time was running down to New York and back to Connecticut at short intervals. Years later he looked

[1] Ned FitzGerald, Charles's brother.
[2] This portrait is now in the Sheldon Memorial Art Gallery, University of Nebraska, Lincoln.

at this portrait hanging in the Glackenses' hall and observed, "It's an antique, isn't it?"

The mid-July heat was now stifling, and W. forsook his studio to spend some time in Hartford, where he painted in the garden. In September he was in Washington Square again, as he was working on several pictures he planned to send to the Pittsburgh show (Carnegie) that year. "I have decided," he reported on September 15, "to send both pictures to Pittsburgh. I have put the figures in but they are not quite satisfactory. However, I have until the third of October to fix it."

In late September W. planned to get off again to Hartford and take along Jimmy Preston. Meanwhile, "James Moore gave a party last night. There was quite a raft of men, no daughters. James announced early in the evening his intention of getting borey-eyed drunk and I guess he did. He was arriving rapidly to that state when I left. Everyone else was drinking beer, James whisky and champagne."

Back in Washington Square for the winter of 1904–1905, W. was kept busy illustrating stories, mostly for the *Saturday Evening Post*, and yet he managed to find time to paint, and to have merry meetings with his friends.

On January 25, 1905, W. G. wrote to E.:

I dined with Jim Moore Sunday evening. He is going to give a huge dinner to all his friends. There will be over a hundred. He had me writing out the list until almost midnight. James is very strong on lists. He also confided to me that he proposed running his café as a sort of club for the benefit of his friends. He didn't care about making money out of it, that he was independently rich and didn't have to.

There was some good news from the publishers of the works of Paul de Kock.

I got a letter from the Quinbys this morning. . . . I am to see them tomorrow and arrange for getting my money on the installment plan I guess . . .

I had dinner at Mouquin's with Fitz last night. . . . Fitz tells me of a medium lady or clairvoyant who gives regular seances at Lenox Hall on 59th Street every Sunday afternoon. We can go up next Sunday. Fitz would like to come along. He is very sceptical.

"Sceptical" would also describe W. G. about spiritualistic matters. On April 11:

My picture of Hen [Henri] is progressing very favorably from my point of view. Whether Henri approves of it altogether I cannot say. He appears to be afraid of not being made big enough, of having a brow not so lofty and broad as he possesses or square enough jaw or altogether as impressive and formidable as he wishes. Of course I have to gather this from the slight criticisms he gives; I may be wrong. . . .[3]

Tonight Lena is going to make spaghetti with anchovy sauce. And I have invited Lawson and Fuhr to help eat it. We will make it an Italian dinner as near as possible.

Anna appears to have recovered her spirits. I hear considerable merriment out in the kitchen. Last night we held the *shooting fest* at Jim Moore's. It consisted of two bouts and I had the distinguished honor of winning both and carrying off the capital prize of two dollars and one half. I am not at all set up about it. Lieutenant Nelson USN of submarine glory proved to be about the worst shot. He pleaded cocktails.

I dined alone last night and Lena condoled with me. She said that a lot of little Glackenses about the table would go a long way towards making things less lonely. Lena and the President [Theodore Roosevelt] have a similar turn of mind. . . . Tomorrow morning I shall run down to Philadelphia.

On April 13:

Have just gotten back from Philadelphia. And I have just time enough to dash off a short letter and then go over to the Shinns.

Lena's dinner was a great success. She was ready before we were (there had to be one more round of cocktails). We fairly gorged ourselves on spaghetti. For once our apartment gave forth an aroma that made Mrs. Tillyoutaste's kitchen seem like a miserable Third Avenue hash house. It was grand! (Onions.)

Two cheerful bits of news were recorded on July 2:

I received word from Sheffield [lawyer] yesterday that the Quinby Co. have settled up for the full amount in cash. I am to get it Monday. . . . I have succeeded in winning at the frog game. I got over three dollars.

On October 17:

We had quite a session at the Francis last night. There were eight of us and Mrs. Hen [Henri]. Paul Potter [playwright] was among us honoring us

[3] Unfortunately this portrait, if ever completed, has vanished without a trace.

at every turn. Bill Walsh and he were quite tight. You will probably remember George Luks telling about the trick he played on Paul by giving his theatre ticket to a waiter. Mr. Potter told the story last night and is still mighty incensed about it as he had to sit all through the play with the greasy stinking waiter beside him and receive congratulations from friends on his play (a first night it was). After a maudlin tirade against George with many *damns* in it, for which he would apologize to Mrs. Hen, he wound up by declaring that to the best of his belief George Luks was a son of a bitch—Great consternation. Another gallant apology to Mrs. Hen. . . . I got home at four o'clock.

My big picture got No. 1 at Pittsburgh.[4] The landscapes were fired.

It is nearly time to meet my guests. The aroma of roast duck is in the air.

James Moore was the focal point around which all these people revolved. He gathered them together, he entertained them, and he was certainly entertained himself.

April 23, 1906; W. to E. G.:

We have just returned from the roller-skating rink. The whole crew, Jim Moore, Henri, May, Jimmie and Willie. I was the first to fall and it was a good one. My whole left hip will be black and blue in the morning.

James B. made a sensation as usual. He practically upset the whole half of the rink and it was crowded to the doors. This is a mild illustration of what really happened. James B. is at the bottom of the heap. When you get back we will have to make up another party. It was a grand success. Roller skates are much better than they used to be. . . . Henri stayed all night with me Friday.

The Roller Skating Rink. "James B. [Moore] is at the bottom of the heap."

4 "Chez Mouquin" received Honorable Mention from a jury that included Thomas Eakins and J. Alden Weir.

Mrs. Henri had died not long before.

This party was the genesis of the canvas "Roller Skating Rink."

April 25:

J. Alden Weir has been around to see me about the sale for the benefit of the San Francisco artists.[5] I have promised to contribute a picture and frame. The exhibition will be held at the American Art Galleries in 23rd Street and Kirby the auctioneer is to sell them. The exhibition will commence next week. I don't mind giving a picture but I hate to part with a frame and I also hate to exhibit a picture in a poor frame.

May 1:

I haven't as yet decided on what picture to send. I was thinking of sending the other May Day, the one with the procession. I have been trying to paint one. A Washington Square with the fountain.

May 2:

I have decided to send "The Little May Day Procession" and have been gilding one of those old curly frames. I can't use them for exhibition and I won't miss it.

Every artist suffers from a chronic lack of suitable frames.

On May 4 came further news of the art world:

Sloan was invited to send his etchings [to the American Water Color Society], four were returned on account of vulgarity. That society has gone to seed. Another watercolor, pastel, etching and lithograph society has been formed. Consists of sixteen. J. Alden Weir, Winslow Homer, Sloan, Glackens, Henri, Childe Hassam, A. Sterner, A. B. Davies, Prendergast, J. Myers, Metcalf, Smedley, R. Reid, E. Lawson, E. Shinn, G. Luks, a fine mixture. They are to give a show in the autumn. No juries. Hang what you please. Place to be alotted by drawing a number from a hat.

Though art matters were therefore encouraging, the Café Francis, alas, was now perceptibly going down hill. The food there was not as good as it used to be, and patrons came in lesser numbers. It became plain that James B. Moore's business was falling off and he was finding himself in financial straits. He himself began to talk about his troubles inces-

[5] They had lost their possessions in the great earthquake.

santly, interruptirfg those who came to dine by seating himself at their
tables uninvited and going into long accounts, until the diners drifted
away.

But he would permit no such liberties himself. He was dining with
W. G. one evening when a large man came up and asked if he might
join them.

"No you may not, sir!" Jim Moore bristled. "I don't know you, sir!"
The large man turned away crestfallen.

It was then that the uncommunicative W. G. spoke.

"That was John L. Sullivan," he whispered.

When the furnishings of the Café Francis were sold in 1908, all the
artists and friends of Jim Moore attended the auction on the premises.
Jimmy Preston bid on one of the Lawson canvases which that artist had
"eaten up." "Is it signed?" a rival bidder asked. A hasty inspection
proved that it was not, and at once the bidding fell off. The painting was
knocked down to Jimmy. Ernest Lawson, who had accompanied him to
the sale, then went home with him and signed it!

In fact Jimmy Preston acquired three excellent Lawson canvases at
the Café Francis sale. One of them was a scene with a rushing river,
falls and rocks. Frederick James Gregg of the *Evening Sun* wrote a short
story about this painting, called it "The Gem of the Francis" and pub-
lished it in his column. It was a clever story in the O. Henry manner
with one trick ending after another. Jim Moore was so delighted with it
that he had it printed in a brochure, together with a reproduction of the
Gem and other paintings on the walls of the Francis (including W. G.'s
lost bullfight picture), and views of the dining room, kitchens and cellar,
and gave them about to his patrons. The present whereabouts of the
celebrated Gem—for Jimmy Preston finally parted with it—is not defi-
nitely known.

It is ironic that James Moore in "Chez Mouquin" posed for the glory
of a rival establishment. The Café Francis has left no souvenir; even the
Gem has lost its old name.

Yet its old clients long remembered the Francis, and the good times
they had had there, and in unhappy circumstances O. Henry wrote to a
friend of his memory of a red-headed girl dining there "under an original
by Glackens."

In the spring of 1906 the G.'s planned a belated wedding trip. W. wanted especially to see the Velázquezes and the Goyas in the Prado, and so plans were laid to sail to Spain and then visit France. E.'s father offered them the gift of their passage.

That is very fine and kind of your father [W. wrote her]. I don't think Spain will be too hot. It was hot enough here yesterday. I am sure Spain could be no hotter. What lines do you think probable? I could get the folders and inquire what is to be had. . . .

I will have to write over to the *Post* to send in all the rest of that serial story (if they have it) as I must clear up as much work as possible before we sail. I wonder if we could get a story out of a Spanish trip. You write and I illustrate it.

But unfortunately this idea was pursued no further.

In those happy days one could decide to visit Europe, go down to the steamship lines and buy a ticket, pack a bag and sail—no waiting lists, no passport, no visas. This the G.'s did, and landed at Gibraltar.

Gibraltar in 1906 was still a picturesque spot. A century of British rule had not succeeded in reducing it to gloom and lifelessness. When a gun was fired in the evening a great crowd of Spaniards, Arabs and gypsies trooped out the gates, and when the gun was fired again at dawn they all trooped back.

The travelers visited Granada and Seville. In Granada they saw the gypsies dancing in the Alhambra, which resulted in a painting, but in Seville W. G. had a recurrence of his Spanish War malaria. Spain at this time was still a primitive country in many ways, and Edith was frantic. The heat was stifling in Seville after all, and W. suffered from heat.

An English doctor arrived with a centigrade thermometer which he

67

left with the patient. He told E. to send for him again if the fever
reached a certain point. "But it won't go that high," he said. However,
it did. He had taught E. the Spanish word for ice—*"hielo,"* pronounced
"yellow." She rang and rang until a slovenly waiter came, to whom she
kept saying, "yellow." An hour later he returned with a brimming bowl
of water in which floated two or three pieces of ice the size of marbles.
Though W. recovered, E. had a horror of Spain for years after.

Flamenco dancers, Seville

They went to a bullfight, arrived early, watched the crowd assemble,
heard the band play, saw the doors open and the superb procession of
alguaciles on horseback in their ancient costumes, and the *toreros* in their
splendid *trajes de luces*. Then they hastily rose and left.

But W. must have returned, for he painted a picture of a bullfight
which later hung in the Café Francis;[1] and he sketched.

In Madrid, days were spent in the Prado and evenings in the cafés
and in the Buen Retiro. Though they apparently did not go to Toledo,
the G.'s seem to have spent a day among the elm-shaded avenues and
nightingales at Aranjuez.

The Buen Retiro was deserted during the heat of the day, but late in
the evening it filled: nursemaids with their charges, boys and girls playing

[1] The ultimate fate of the painting is unknown.

with hoops, and the dandies promenading. The young men carried fans. By 10:00 P.M. the crowds and the animation were at their height. But Madrid on the whole seemed to be a "little cheap Paris," and they were glad enough to set out for the real thing on June 24.

However, the painting "The Buen Retiro" remains, and sketches of the beggars, for whose benefit the English doctor taught them to say, "God will provide!" and if this pious sentiment did not abash them, "God forgive you, brother!"

In the Luxembourg

But Paris was—Paris! W. had not seen it since 1896. Paris was always my father's favorite city, and France his spiritual home. Everything suited him there, the food, the wine, the people in the streets and public gardens, whom he loved to sketch; the look of restaurants, shops,

and cafés; the color of the houses, the signs, the trees, the rivers, the fishermen, the villages, the flow of life. No other country seemed so to invite his pencil and his brush.

They settled down with James and May Preston in a studio at 9 rue Falguière. This address is a court called "Villa Gabrielle," surrounded with studio buildings. Tall iron gates were closed at night and guarded by the usual dragon of a concierge, but by day they were open and all could come and go. A hand-organ grinder played interminably in the courtyard.

Finally an irate tenant stuck his head out the window and called down:

"Go away or I'll shoot!"

"*Voilà ma poitrine!*" cried the organ grinder cheerfully, baring his breast; and a rain of *sous* came down instead as the music gaily continued. It was Paris!

Alfy Maurer and the sculptor Edward W. ("Jimmy") Sawyer also had studios at the Villa Gabrielle, and the G.'s went down to Chezy-sur-Marne where the cheerful Alfy had a cottage presided over by a thin, rather sour-tempered young woman who was presumably his girl.

They went on an excursion to nearby Château-Thierry and swam in the Marne. W. G.'s canvas of this event depicts them crossing the road toward the riverbank, E. in the bathing costume of the period, the artist in blue trunks. The figure in red trunks on the bank is Alfy Maurer. A stout widow in black sits on a stool enjoying the passing show; and the crowd swims, and plays, and naturally eats and drinks, and the tricolor floats gaily over all, as it was to do for a few short years more before Château-Thierry, that obscure river town, was on every tongue in the world.

W. G. to Robert Henri (in Spain):

> 9 rue Falguière
> Escalier F
> (No date)

My Dear Hen

When do you expect to come up to Paris? We are nicely settled here at 9 rue Falguière (studio apt.) with the Prestons.

Poor Jimmy is almost a wreck. Under the doctor's care. His stomach is responsible for his condition. I fancy it will be a long time before he is all

right again. A very strict diet and a quiet life for months to come, perhaps years.

I have been trying to do some work. I should like to be able to dash off some of my Spanish impressions but it is the very devil to get started.

I saw Morrice two or three times.[2] He has gone to Brittany—what a grumpy person he has become! He had three or four very interesting things at the Salon, very good in color. Canadian subjects.

The Salon taken all together was a tremendous horror. I hope I shall have the courage never to go there again, if I am ever in Paris again during the Spring.

The étrangers' salle at Luxembourg is closed up, but Morrice told me that your picture was on the line and looked splendidly.

I don't know whether it was the Madrid pictures or the heat, but my only visit to the Louvre was not a success. I was glad to get out.

Teed and I have been down in the country for a few days, about fifty miles up the Marne. We spent one day at a place called Chateau Thierry. I certainly like those little river towns. There is lots of go about them, bathing plages etc.

We go back on the Oceanic Sept. 26. That will mean a trip to London and then to Liverpool.

I have laid in a supply of paint and canvas and will be much disappointed if I can't take back a few things. The other day I purchased a diamond point to make dry points with. I don't know how it will go, but I decided I might as well make some sketches on copper instead of filling up sketch books with pencil smudges.

Let us hear from you and when you expect to get up here?

No. 49 Montparnasse looks much the same from the outside. My old place must be in the hands of a very careful person who stays home at nights. It has been lit up every time I have gone up the Rue Boissonnade at night.

Yours

GLACK

The Prestons and Teed send their regards and are anxious to see you. I suppose the Cook man told you how he delivered your note just as we were pulling out of Madrid. Spain does not agree with me. I was laid up in Seville with malaria.

The paintings W. G. brought back from the rue Falguière also include "Flying Kites, Montmartre" (Boston Museum of Fine Arts) and "Café de la Paix."

[2] James Wilson Morrice, Canadian painter, whom they both had known since 1895.

The G.'s chose the Dieppe–New Haven route to England as being the cheapest, but when they reached Dieppe they found the Channel very stormy and the boats not sailing. So they stayed in Dieppe two or three days, and W. sketched. The sketches resulted in "Dieppe Beach" (Barnes Foundation), in which the artist and his wife may be seen, at the right of the canvas, watching the crowd. The tradition of the artist putting himself and his family into his pictures is an old one, and W. G. seemed to enjoy following it. Though the old masters thus gave themselves front-row seats at the Crucifixion, later artists could depict themselves having a good time. These family figures in the Dieppe and other canvases, though small, are always characteristic, and can be identified at once.

W. G. returned with a number of sketchbooks filled with what he had observed in France and Spain, as well as the three Spanish and five or six French canvases. The trip bore wonderful fruit. The paintings in the Prado had inspired the artist, and his work seemed to take on an added depth and a more luminous quality. He was now thirty-six and had struck into the full flood of his creative output.

Except when he had a story to illustrate, he was able to paint all day. The evenings were given up to conviviality. On Election night the G.'s were at Jim Moore's with Henri and the Sloans.

W. G. served on the Pennsylvania Academy jury that winter, a jury that included such men as Childe Hassam, Julian Story, De Camp and Redfield, "a strange mixture," as W. would have said himself. John Sloan recorded in his diary his consternation at W.'s associates—what could one man do against all those?

Moreover, W. G., through no fault of his own, found that he was now an Associate Academician. The fluke came about through the merging of the Society of American Artists, of which he was a member, with its old parent body, the National Academy (the erring child returned repentant home), and automatically members of that Society became Associate Academicians on the terms of the merger. But it was only six years before his death that the National Academy (which, as John Sloan observed, was no more national than the National Biscuit Company) saw fit to raise W. G. to the status of a full Academician.

When E. went to Hartford in February, W.'s letters afforded as usual a few glimpses of New York life: "Nothing has happened, out of the

ordinary nights at Jim Moore's. He has been giving parties as usual nearly every evening. May and James always attend." A few days later: "There was quite a large gathering at Jim Moore's last night. Even Ferdinand attended."

James B. Moore had apparently made his house in West Twenty-third Street into the "club for the benefit of his friends" that he had contemplated making of the Café Francis. The basement was a shooting gallery, its walls decorated with murals by W. G., George Luks and Ernest Lawson. W. G.'s was "The Frog Game," a most characteristic choice of subject matter; and Luks' subject was equally characteristic of that artist —a barroom. John Sloan noted in his diary that the figures in these paintings were habitués: the artists themselves, Jimmy Preston, Charles FitzGerald, and doubtless James B. Moore. Lawson's two murals were landscapes.[3]

A few glimpses of domestic life in Washington Square were also supplied:

Lena [Marchesi] potters away as usual in the morning. Must go about my taxes again. Curse it. . . .

"Willie has the stomach ache today. . . ."

Willie has the stomach ache today. I think I must have caught cold with this sudden change of temperature. The magical 1872 brandy was called into

[3] These murals were painted on standard sheets of Compo board, about eight feet long, and according to James Preston were pried from the walls at the time of James Moore's bankruptcy and bought by the collector John Quinn. But they did not figure in the Quinn sales and may no longer exist.

action. Ferdinand's stomach must have ached too as he had to have several doses. . . .

Lena turned up today with a sick headache and little Lena Riggi [her niece] who admires my pictures very much. Now I must off to dinner. I have been working all day and among other things I painted a new coasting picture I saw in the park yesterday. It's pretty good. . . .

Jimmy Preston turned up Friday night with a wee bit of a moustache and a goatee a la Lawson. It was immediately removed by his spouse's orders.

Lithograph of Ernest Lawson

CHAPTER TEN

In February, 1907, everyone submitted his work for the Spring Exhibition at the National Academy of Design, as had been done before, with varying success. But the Fates, or whichever one of them has art matters under her guidance, were laying the groundwork for a remarkable series of events, and the beginning occurred on March 3.

Robert Henri was on the Academy jury that year, and March 3 was the third day the jury sat contemplating pictures, and deciding, like the Fates themselves, which should be hung and which cast ignominiously out. It was the jury's opportunity to vote Yes for their own works and those of their particular friends, and No for everyone else's. And this they did.

On that evening Henri came to dinner with John and Dolly Sloan, and he brought a report of what had occurred in the jury room. Sloan had submitted two pictures, one of which had been accepted. All the entries of Luks and Glackens were refused. Being an Academician, Henri could submit one painting exempt from jury judgment, but two others of his paintings were quasi-accepted under the status of "Number 2," which meant they would be hung if space could be found for them. To the loyal Sloan this was blasphemy, for he worshipped Robert Henri above all living artists.

Henri was already an arrived artist; in 1899 the French government had bought one of his landscapes, which at that moment hung in the Luxembourg. He had also received academic honors at home.

Henri withdrew his "Number 2" canvases then and there. If the dear old Academy had but known it, the fat was in the fire; and the result, still some time away, rubbed the edge off the National Academy's lofty prestige, which in fifty years it has not regained.

After dinner Henri and the Sloans went to 3 Washington Square and spent a pleasant evening with Glackens. But the Academy's actions were

75

long familiar, and the subject was only briefly mentioned; W. G., George
Luks and others of their group had become inured to having their paint-
ings turned down.

They were peaceful people and unless goaded to protest were willing
to conform. When Henri was a little boy he was discontented in school
until his mother discovered it was because the other little boys had
patches on their pants, and he hadn't. So she sewed a couple of nice
patches of contrasting colors on his perfectly good pants, and he was
happy again.

As for W. G., he never quarreled and would have been at a loss to
know how. Whenever he was witness to an altercation, he was embar-
rassed and retired into his private world. In the same February that the
pictures went to the Academy, he wrote E. regretting that he had "got
roped into a poker game." The regret was not poker but the fact that
one loser went home "very mad" and "the game wound up in a fight
between Jim Moore and Mrs. J. over changing a ten-dollar bill. However,
they all forgave each other and we demolished a capon."

But art is more important than poker. In these days when almost
anyone can find a place to show his work, no matter what, it is difficult
to realize conditions in the early years of the century. There were then
few art galleries, in contrast with the numbers today, and these few
usually were not interested in showing the work of rising painters. Everett
Shinn and Guy Pène du Bois have written vivid descriptions of the
galleries of those days. Shinn called them "plush grottoes" in which "the
cadavers were displayed in sumptuous coffins." The attendants dressed
like undertakers' assistants, in morning clothes. They looked down their
noses, and visitors instinctively tiptoed, and nobody spoke above a
whisper. How, in these surroundings, would paintings of saloons, tene-
ments, urchins, an old woman with a goose, people dining in a restaurant,
have looked anyway? The galleries were designed for the kind of art they
displayed: children sweeter than the honeycomb, ladies wrapped in shiny
satin and gleaming pearls, and lush landscapes with the ubiquitous cow.

The only way for an artist to have his work displayed at all was in the
large annual and semiannual exhibitions held by the National Academy,
the Society of American Artists and similar organizations in a few other
cities. The alternative was oblivion.

Of the four etchings by John Sloan pronounced too vulgar to be displayed by the American Water Color Society the year before, one was the now famous plate "Turning Out the Light." That same year, W. G.'s "Portrait of the Artist's Wife," originally called "Lady with a Basket of Fruit," had been rejected by the Society of American Artists for a portrait show, and the reason given was that the basket of fruit standing on a small table beside the full-length seated figure somehow took the painting out of the realm of portraiture. It was evidently a still life! Robert Henri, on that jury too, had made a row but to no avail.

Art was being smothered by the entrenched powers, whose ridiculous and arbitrary decrees had to be followed if an artist hoped to show his work at all.

The situation had long seethed, particularly in the heads of John Sloan and Robert Henri, and a few days after the evening visit to 3 Washington Square, John Sloan came to see W. G. again, and suggested the idea of holding an exhibition of their own the following winter. A meeting was called at Robert Henri's studio on the fourth of April, when these plans were more fully discussed. Besides Henri, Sloan and W. G., the meeting was attended by others of their friends who had similarly suffered: George Luks, Arthur B. Davies and Ernest Lawson. Everyone was in favor of the plan. A second meeting a month later saw things begin to jell. Everett Shinn was with them, and word from Maurice Prendergast in Boston proved that he was as enthusiastic as the rest.

Arthur B. Davies spoke to William Macbeth of the Macbeth Galleries, and Macbeth agreed to show the work of the insurrectionists the following winter in his gallery, for a guarantee of five hundred dollars, later reduced to four hundred. Each man was to put up fifty dollars.

The exhibition at the National Arts Club three years before, when the *Times* in headlines had called the six artists whose work was included "Red Hot American Painters" (though other papers, as has been shown, had other things to say), was not forgotten. These men were controversial, and had already been linked together in the newspaper mind. Mr. Macbeth was not showing paintings by unknown artists.

The New York *Evening Sun*, which, thanks to Charles FitzGerald and Frederick James Gregg, was the best informed in art matters of any paper in the country, broke the news of the insurrection on May 15:

Eight Independent Painters to Give an Exhibition of Their Own Work Next Winter: A group of eight painters who have been expressing their ideas of life as they see it in quite their own manner, and who therefore have been referred to often as "the apostles of ugliness" by a larger group of brother artists who paint with a T square and plumb line, have formed themselves into a body, it was announced last evening, without leader, president, or formal organization.

The article stated that the exhibition was to be held "perhaps in February at the galleries of William Macbeth," and one of the eight was quoted as saying with enthusiasm, "We often are called devotees of the ugly."

Various writers have been put forward as originators of the name "The Eight" by which this group has ever since been known, but as almost all writers can count, there seems no reason to claim the distinction for any particular one of them. It is sufficient that grand publicity was being offered without any unusual effort on the part of the eight revolting painters.

Hot things were thus scheduled for the following winter, but as the summer wore on the weather grew hot too, and when July arrived a domestic event changed the pleasant tenor of the G.'s' life in Washington Square. The present chronicler modestly enters the picture on the morning of July 4, 1907.

The day before the holiday had been extremely hot, and the G.'s took a boat ride to Coney Island to enjoy the sea breezes. Everyone considered E. a sensational sport to do this under the circumstances: at that time expectant mothers retired into a sort of purdah and were seldom seen in public. As a result of this innocent trip Ira Glackens was long twitted on having been born on a roller coaster.

After the return to Washington Square, at one o'clock the next morning I gave signs of preparing to arrive, and W. went out to try to find a conveyance to take E. to the hospital in West Sixty-four Street where Dr. Harry Britenstool, who had lately set up practice, awaited his first maternity case. (E. would have no old fogy.) The sole vehicle in the now deserted street was a hansom cab standing outside the old Brevoort on Fifth Avenue. The weary horse was being brushed off by the cabbie, who undertook the assignment for a liberal award. So I. G. came very close to being born in a hansom cab. (But I have always regretted the

long haul for the tired horse, and have felt that my parents should have been a little more forearmed.)

W. simply could not hurry, yet he must have quickened his step that night. E. was the kind who liked to get on a train a good half-hour ahead, while W., a calmer temperament, liked to step on with one foot and push off with the other. "What more time do you need?" he would inquire, while others sank panting into their seats. E. once showed her mother a little gold medal bestowed on him in high school for winning the hundred-yard dash. "That must be the only time he ever hurried," she observed.

Soon at 3 Washington Square family life began to assume something like the familiar American pattern. W. was already as useful as most husbands; one day E. had some important letters to mail, and W. promised faithfully to put them in the letter box and not forget them in his pocket. To make certain, she craftily hid among them a self-addressed postcard with a message ready written: "Only and Prized Wife: I mailed your letters, one and all! W. G." Next day the card came back with a picture of the artist suiting action to word.

Until it was thrust upon him, it would have been difficult to imagine W. G. in the role of parent; and indeed, in the typical American tradition, the bringing up of the children was entirely the mother's concern. Yet as the years went on he did devote a little time to the infant, and on more

than one occasion took I. G. to Central Park to ride on the carrousel. Once we went on the ferry to St. George, Staten Island, though W. would much rather have been painting. We walked out of St. George, and the highlight of the excursion was reached when we buried treasure—a penny in a match box—on a hill overlooking The Narrows. When we reached home, after 6:30, E. was having one of her anxious fits because we had been gone so long. Father detailed where we had been.

"That seems a pretty long walk for a little boy only four and a half years old!" she said.

"Oh," father replied, "I thought he was five and a half!"

On my mother's days of duty, when all else failed—apparently she had to keep me amused or the consequences were terrible—she would set up a large empty picture frame to simulate a train window, behind which I sat in a small chair, and call all the stations from New York to Hartford. "Meri-DEN! Meri-DEN!" is the station I remember best. She likewise had to be the conductor taking tickets, and the candy vendor who went through the car droning "Wrigley's Broken Mixed!" When Hartford was reached, the train returned to Grand Central Station without switching tracks. This could keep me quiet for hours, for I sat in a chair while mother worked. No wonder that after such a day, when W. came back from his studio, she could only gasp, "A cocktail!"

Father could amuse me with much less effort, which seemed unfair. Of course one reason was the novelty of the treat. He grunted, whistled, and drew pictures. When I was sick in bed he bought a copy of *Rip Van Winkle* and read it to me. That day the Catskill Mountains cast a spell that has never died away.

A little later I had two absorptions: Beautiful Princesses, and Witches, and I believed passionately in both. I came upon a color reproduction of a painting by one of the Pre-Raphaelites—possibly "The Dead Ophelia" by Sir John Millais. It was a frightful picture. A beautiful dead maiden, her hands clasped on her breast, her golden hair over her shoulders, and decked in garlands of flowers, was depicted floating down a river on the bosom of the waters. She was to me the most gorgeous and sad object ever seen. I showed this masterpiece to father. He glanced at it, snorted, and said, "Dead people float on their stomachs, with their behinds sticking up in the air." At that moment it was hard being the son of a realist of the Ashcan School. My romance with Beautiful Princesses then and

there withered and died. But when I asked father to draw me a Witch, the result was happier.

The summer of 1907 was very different from the summer of 1906. The bright lights of Paris were far away, and E. went to Hartford with the new addition. W. was left in New York. "Infants certainly change the aspect of things," he wrote. A money panic had occurred, and everyone was feeling poor.

Tom Millard, long a correspondent in China, and once one of the *Herald* men who had helped feed W. G. in Cuba, was then in the U. S. for a brief visit. He always saw a good deal of W. G., and now he was leaving. "He starts today for the East again," W. wrote. "He is going to accompany the Taft party representing the New York Times. Roosevelt is sending Taft all around the world as a sort of press agent for the U. S. I suppose it will take about a year."

Whenever Tom Millard appeared, there was great delight, yet he spoke without a change of expression or apparently one human emotion, in contrast to the G.'s' other friends, whose effervescence of one sort or another was, I thought, the natural habit of all adults. Having lived long in China, Tom Millard was an authority on that country. He was likewise

an authority on Japan, although his book *The New Far East* propounded the interesting argument that, if a foreign power had to control Korea and Manchuria, better Russia than Japan.

As was natural with an authority, he did most of the talking, and no doubt talked well. But to a small boy he seemed very dull.

On his last appearance, many years later, he expressed surprise on seeing the G.'s' two children. "How did *you* ever get such good-looking children?" he asked with a kind of sniff that was one of his mannerisms; it was merely his way of being polite.

"I suppose if *he* had children," W. G. said afterward with a sardonic touch very foreign to him, "they would be Venus and Adonis!"

E. missed Tom Millard's visit that summer of 1907. W. G. wrote her, "Everyone is asking about you and the infant. I met Flossie and Everett on the elevated last evening. He was going up to the theatre [Belasco Theatre, then called the Stuyvesant] to work on his decoration. He looked pretty well fagged out."

Everett Shinn's decorations are still in the Belasco Theatre, but have grown so dark they are practically invisible.

The tenants of 3 Washington Square were plagued by beggars and thieves:

The bums have started in again. One called this afternoon. I asked him who told him to come here? "Some gentleman over in the square suggested his calling." I asked him to inform the bums over in the square that there was nothing doing at No. 3 any more.

But W. actually was unable to refuse giving handouts, and was victimized over and over again.

October 9:

The God damn jury has got me again. It came last night and I must appear on the 16th. . . . I have got a story to do for the *Post* in a hurry—that gives me a week.

I feel like emigrating to some other country to escape the duties of citizenship. I know of no one else who is so persistently persecuted by the damn jury as I am. This is what I get for having done my duty once. I have got to do all the work for those who are never called. To hell with the rights and duties of a citizen. I'd rather be a Chinaman.

On the sixth of the month a letter indicates that the projected exhibition at Macbeth's in no way precluded further attempts to get hung in the Academy's shows, and also that the Academy's juries, undismayed by signals of approaching rebellion, continued happily in the old groove: "I needn't bother about putting up the price on my picture I sent to the Academy. It was rejected and returned the other day. I haven't heard whether Henri was rejected or not." Robert Henri, as the oldest and farthest "arrived," was the touchstone for all his friends.

But writing in December, W. was much more concerned over a telephone call from Jim Moore, who had been ill. "He gave me a long story of his misfortunes and what an awful time he has collecting owed money." The effects of the panic of the previous spring were still being felt. W. went on to say, "Poor Jim must feel pretty much abandoned. I'm sorry for him. I feel something like that myself."

At Christmas, W. went to Hartford for a week and produced the landscape "West Hartford" as seen from Vanderbilt Hill.

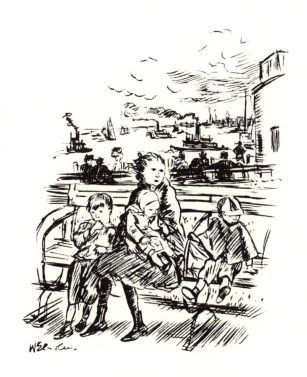

February, 1908, brought two epoch-making events in the world of art—the promised Exhibition at the Macbeth Galleries, and the final dissolution of James B. Moore's Café Francis where The Eight (and others) had long congregated.

E. G.'s exile in Hartford continued that winter, with only brief visits to New York. Consequently W.'s letters preserve much information about this period. He toiled alone at Number 3, turning out illustrations for the *Saturday Evening Post* and trying to get his pictures ready for the approaching exhibition.

E. was horribly bored in Hartford, and felt forsaken.

"That was a very pathetic picture you drew of yourself," W. wrote her early in January, "being carried to heaven by angels. I know the original." It was a Rubens "Apotheosis" which had served her for model, and W. went on to compare the Rubens lady with E., pointing out where they differed. The money panic of the previous spring had not been entirely dispelled, and cash was still scarce. Number 3 offered no facilities for a howling infant. W. G. hoped that the infant would soon grow up so that E. would have "a few hours to spend with her husband," as he put it somewhat bitterly.

He continued to recount what news there was. Jimmy Preston was soon to leave with friends for Florida. George Luks had a black eye. "I dare say he deserved it."

A few days more of toil and W. was fed up.

I am already sick of the damn exhibition [he scribbled on January 17]. There has been too much talk about it. I will probably fall very flat. In my effort to fix my pictures up so far I have only succeeded in spoiling them. The Race Track has gone by the board. Shall substitute the one I painted in Hartford Christmas week. The Shoppers I can do nothing with. It is now minus Mrs. Shinn's and Mrs. Travis's heads. I can neither paint nor draw any more.

The Shoppers

And he appended a sketch of himself crushed into despair, before his canvas "The Shoppers."

E., on hearing any such news, was crushed into despair likewise; she had nothing but admiration for her husband's work, and when it suffered, so did she. W. thought her admiration undiscriminating. One day she chanced to see a picture he was working on. "Oh, Willie, isn't that beautiful!" she exclaimed.

W. turned on her quite testily.

"Can't you see," he demanded, *"it's full of holes?"*

But nobody could see the "holes" in the composition but himself. Condemnation of his work never seemed to trouble him, but when his work was praised and he did not think it deserved it, he was annoyed. A friend and connoiseur of art visited his studio and was voluble in praise of the pictures. When he left W. complained, "He always admires my weakest work!"

A few days later he wrote again:

Everything has simmered down to a monotonous gait. I am as busy as can
be trying to turn out that story for the *Post* and at the same time get my
pictures ready for the show. I must send in my list tonight in order to get it
in the catalogue. I think I shall send six (there is only room for five so one
will not be hung).

> At Mouquin's
> May Day—Central Park
> The Shoppers (if I can finish it)
> Coasting—Central Park
> Brighton Beach Race Track
> In the Buen Retiro

We are going to get an awful roasting from some of the papers.

But as it turned out the roasting was severe only in spots.

Lawson went over to Philadelphia today to sit on the jury for medals and
attend the opening reception.[1] He borrowed Fuhr's dress suit for the occasion.
Fuhr expects to have it returned all covered with spots. I have asked Pagliugui
[an Italian friend, an engineer whom he had met in Cuba] and Lawson to
come and eat spaghetti with me Tuesday night. Lena is going to cook it for us.
I'll think of something else Italian to go with it.

But, to recapitulate, news of the Café Francis could not be ignored.

Not satisfied with driving people away from the Café on account of the
bad food James B. Moore now sits at one's table and talks of nothing else but
his café troubles to the exclusion of every other form of conversation. . . .
Somebody ought to grab him and put him out to graze in the country for a
couple of months. He is getting positively crazy on the subject.

The Café Francis was going from bad to worse, and Jim Moore was
committing the unpardonable sin—he was becoming a bore. Things
looked very dark. Art matters were depressing too. Nerves were frayed
everywhere.

January 20:

I had dinner with the Sloans Saturday. Henri and his mother were there.
(I always thought she was his step-mother but as she had nearly reached the
golden wedding anniversary when Mr. Lee up and died I deduce she is his

[1] Pennsylvania Academy

mother.) Henri as usual got into a squabble with Dolly and they both sassed each other, neither was he over-respectful to his mother, however she is a dreadful old bore. Henri and Sloan talked of nothing but this coming show. I went away feeling horribly depressed. . . .

I don't feel exactly in that buoyant condition necessary for picture making. I hammer throughout with a hatchet over and over again—I'll get clever yet.

The Evening World was hunting for someone to do the Thaw trial. Fuhr told them they could get me, but I see they preferred Stanislas. Lena has kept the house spic and span as you will see when you come down on the 3rd. That is the day the show opens.

The loss of the job to sketch the Thaw trial undoubtedly had a silver lining. W. had enough on his hands for the moment.

January 21:

I am again before the photographer. The Sunday World sent one up today to photograph some pictures and the artist. Made him promise to send some proofs. The Craftsman has come out with all of us à la Kasebier [Gertrude Kasebier]. They evidently got proofs from her. They are awfully silly.

Publicity and fanfare were things that W. G. could never face with comfort.

The little dinner party for Lawson and Pagliugui was now to be augmented by Ernest Fuhr. "Large quantities of spaghetti, a chop, salad, black coffee, and for drink some of Liquori's claret will comprise the menu."

Lawson, returned from Philadelphia, reported a good time. He had been joined at the reception at the Pennsylvania Academy by James and May Preston.

"May describes all of James' young lady student friends as looking like this. You know the type of corset. Several of them had twins. The one I picture is still unmarried. The corset is responsible for the protuberance." Then he added briefly, "Miss Mumford made a hit."

Alice Mumford, one of W. G.'s fellow students at the Academy, usually did make a hit. Small and blonde, with bright blue eyes full of sparkle, she was obsessed with a desire to *épater les bourgeois* one moment and impress the Social Register the next. This she need not have tried, as she belonged to an old Philadelphia family anyway.

On January 24 there was further news of the coming event:

Alumna of the Pennsylvania Academy of the Fine Arts

We had another meeting last night at Hen's studio. George [Luks] was there and was very amusing. I don't know what the meeting was for as George gave nobody a chance to say anything about the exhibition, for which I was very thankful. . . . Got a note from May stating we are to dine with them on the 3rd and afterwards have a party at the Sherwood. I suppose she wrote you. . . . Here it is nearly nine o'clock and I haven't had any dinner. Will go over to the Brevoort.

On Friday, January 31, there was really good news. At the last moment order was brought out of chaos. A superhuman, perhaps subconscious, effort saved the day for a suffering artist just at the deadline: "Tonight I am varnishing pictures and nailing them into frames. They go off tomorrow and will be hung tomorrow night. The Shoppers has been rescued." The Race Track was rescued too, and all six of the pictures were eventually hung.

The Exhibition duly opened on the evening of February 3, 1908. It lived up to expectations, in fact far outdid them. E. came down from Hartford to attend, and afterward there was the party at the Sherwood,

with May Preston. The breath of life, long almost extinct, blew like a gale through American art.

The public was startled, but why this should have been so, or why the exhibition became such a milestone, is a little difficult to understand today. W. G. and his associates had been exhibiting the same sort of pictures since the turn of the century, and before. They had (as reference to old newspaper files will prove) much coverage, and the more enlightened papers singled them out again and again, and devoted many columns of intelligent discussion to their work. This was particularly true of the *Evening Sun*. The writings of Charles FitzGerald and F. J. Gregg were readable then, and are so today. All these painters were well known to the exhibition-going public; they did not burst full blown upon a startled community.

Nevertheless, at the height of the furor it was estimated that three hundred people an hour were pouring through Mr. Macbeth's gallery at 450 Fifth Avenue. It seems astonishing. Realism in 1908 was even more sensational, apparently, than the wildest flights of later painters, and almost caused a riot.

It was the subjects of these paintings that shocked and astonished, and even these subjects are so entirely acceptable today that the most limited aesthetic intelligence would not turn a hair at any of them. The fact seems not to have occurred to anyone that Rembrandt, Hogarth, Brueghel (to name three respectable artists) had long before used similar subject matter, and even the courtly Velázquez had painted "Los Borrachos."

A critic on *Town Topics* whose anonymity was preserved in the name of "The Gilder" was able to unburden himself thus:

Vulgarity smites one in the face at this exhibition, and I defy you to find anyone in a healthy frame of mind who for instance wants to hang Luks' posteriors of pigs or Glackens' "At Mouquin's" or John Sloan's "Hairdresser's Window" in his living room or gallery and not get disgusted two days later. Is it fine art to exhibit our sores?

As for Prendergast, his work is unadulterated artistic slop, and Shinn's only several degrees better. . . . Arthur B. Davies is on a slightly different plane, that plane that leaves you in doubt between genius and insanity. Henri, too, has a streak of coarseness. . . . Bah! the whole thing creates a distinct feeling of nausea.

But *Town Topics* was a scandal sheet, and its editorial policy was to blast.

The prototype of another highly admired subject in those days was the model posed in rented Grecian robes—perhaps holding aloft a branch of laurel—and alleged to represent some virtue. The leap from this sort of thing to a farmer feeding pigs, or a woman having her hair curled at a cheap hairdresser's, or people drinking in a restaurant, was just too much. But one thing the exhibition did was to put the quietus on this flummery forever. The trade in Grecian robes soon took a nose dive.

It was the Academicians rather than the critics who were on the whole the more incensed. "Revolutionary Black Gang," they called the artists, and any other derogatory epithets they could devise. The one epithet they apparently did not devise was "The Ashcan School"; that term seems to have been invented afterward—there are several claimants —when the principles these artists fought for had been accepted. The phrase came into general use in the mid-thirties, probably picked up from some obscure old notice, and the expression was then used in an affectionate sense rather than a derogatory one. No one less ashcanny than W. G. could well be imagined.

The phrase did not embrace Davies, Prendergast or Lawson although Lawson was accused of *failing to disguise* the more rugged elements in his canvases. His rocks looked hard and harsh—in other words, like rocks, not cream puffs; and he often included some human sign—a tumbledown shack, a sagging jetty, an abandoned rowboat—which in those genteel days were evidently considered no better than ashcans, and no fit subjects for "art."

And when Henri painted "Fifty-seventh Street" in the snow, it was plain that the snow was grimy. All this seemed evidence of a lack of *délicatesse* in men who claimed to be artists.

But "The Ashcan School," for better or worse, has taken hold, and has even been referred to by the French, in whose tongue it acquires an almost elegant sound, "École de la Poubelle."

Two articles appeared in the *Sun* on February 9 and 10, probably written by Huneker; and of the pigs that revolted the delicate "Gilder" of *Town Topics*, the critic observed, "They are genuine porkers, pink, dirty and black." (Curiously, though cows have ever been a highly acceptable subject for artists, pigs were taboo.) W. G.'s "At Mouquin's,"

which was another "sore," this critic was able to take in his stride too. "A portrait, evidently, of the Hon. James M., with a lady in a blue dress. It is the moment of liqueurs and soft asides. A young art critic with a Mephistophelean smile looms in the background. Does he know the lady in blue? Does he envy the Hon. James? Glackens has asked these questions, not forgetting to paint with singular veracity the still life on the table, that still life which makes life at Mouquin's café far from still." The writer knew Mouquin's and "the Hon. James M." well. And nobody is shocked by a pig any more.

It was, however, unfortunate that Charles FitzGerald had ceased writing art criticisms, now that Gregg and Huneker had come to the fore. His words would have been more profound.

E. returned to Hartford after a few brief days in New York, and W. wrote her on the twenty-fourth:

Macbeth sold $4000 worth of pictures. All sold pictures with the exception of Prendergast, Sloan and myself. Mrs. [Harry] Payne Whitney was the biggest purchaser. Henri sold a panel and the little girl laughing. Luks sold the old woman with the goose. Lawson sold the winter landscape. Shinn sold the girl on the stage with the blue dress. I don't know which of Davies went. I understand Macbeth said he could have sold $25,000 worth if [it] had not been such a bad year. Jimmy Preston is back. Looks well and brown.

The fact that W. sold nothing did not seem to trouble or distress him. He was not a businessman, nor was he known to take an interest in business affairs. But he did take an interest in Jim Moore's, and the collapse of the Francis seemed to overshadow even the fate of the exhibition. He reported:

Had dinner with James Moore last night. He explained the receivership to me. It appears that about three years ago (I remember him telling it) a little girl was badly injured by the falling of a clothes pole in one of his houses and they brought suit. He was insured in a casualty company for $5,000. The casualty company lost the case for him and the jury decided $2,500 damages. It was published in the newspapers as a judgment against him for that amount two months ago. All the Café Francis creditors came down on him at once, thinking the judgment had something to do with the café. So he got two or three friendly creditors to apply for a receivership in order that he will not

be bothered with dunning and give him a chance to get together again. He has no intention of giving it up. Will turn it into a stock company if possible. Intimated to me that if it should be a dead failure he would be wiped out and have to commence over again and go back to law. I am quite sorry for him. He is very much soured on all his friends getting out during the crisis. It is impossible to make him believe that he was more responsible for the falling off of his café than anyone else.

I was going to draw you a nice Valentine but I don't think I have the energy. The last two days have been nothing but slop and slush.

Though E. felt, perhaps foolishly—and she bitterly regretted it later on—that duty obliged her to stay in Hartford, and the weather in New York and elsewhere was very bad, and though James B. Moore was in great difficulties, yet the season in town, in spite of all, was not without its frivolity:

DEAREST TEEDIE:

Speaking of masked balls, beware! It was at a masked ball, The Kit Kat Club Ball, that Fitz and Tommy started off on their continued debauch. It appears that all our friends were there. May Preston provided the costumes for Fitz, Tommy and Lawson. Fitz wore an old-fashioned high hat, whiskers and a red nose. Tommy's costume was a pair of curtains. He saw Fifi at the ball. You remember Fifi,—rushing across the room he sat beside her on a bench and started to open a conversation whereupon she promptly arose and walked off. Fitz stuck to the bar room. ——— was dressed as a friar. He was very drunk and pawed May Preston all over the shoulders front and back. (He is in disgrace.) May did not stay long I understand. Found the ball very stupid. Fitz arrived home at 7 o'clock the next morning and had to report immediately at the Sun office and write an editorial. It has not been published as yet. He says it is very good. . . .

February drew to a close. The exhibition was now history, though nobody knew that yet. March was quiet but only in comparison, while Jim Moore's affairs were caught up in the moils of the law. Things looked darker and darker for him. The receivership plan did not work out, and by April all was over:

Jim Moore's house and café are to be sold out by the receiver tomorrow. Goodness knows where Jim is. I understand through Lawson who had a conversation with the receiver that James is completely wiped out. It was not the

café that broke him as he only lost about $30,000 on that. It seems it was his real estate ventures and probably some Wall St. He has gone through about $200,000 in the past eight years. All he had. I don't know what is to become of him. May has decided that the apartment is too much to run. Jim's failure decided her.

An epoch had ended, and an epoch had begun.

CHAPTER TWELVE

Amid the great battles were minor engagements. Some weeks before the Exhibition, W. wrote, "Fitz has an editorial in the *Sun* this evening which has greatly incensed Mr. McClelland of the Grapevine. He is talking of suing the *Sun*. Shall send it up." (The Grapevine was a little barroom.)

Charles FitzGerald had amused himself by writing a lengthy piece on "Intellectual Hoboes." Dr. Ben Redman had lectured on tramps at the Bowery Mission, and had divided them into Tramps, Hoboes and Bums, explaining the differences. Josiah Flint and Jack London were "vulgar authorities on the subject" too, but all alike had snubbed and ignored another kind of Tramp—had failed to mention the Grapeviner. Charles FitzGerald supplied the omission:

His thoughts are everlastingly wandering. Were we asked to describe the character of the Grapeviner exactly we would do so by a contrasting comparison with the cabbage planter, the eternal type of the man who does things. Panurge, in danger of shipwreck, envied all who were predestined by Jove to be cabbage planters for, said he, they have one foot on the earth and the other is not far off. Now your Grapeviner has one foot in the sawdust and the other on a brass rail, his thoughts are invariably above the earth, and the whole purpose of his life is not in doing but in saying things. . . .

They took their drinking seriously in this Golden Age, that so harmless a pleasantry evoked threats of a lawsuit. Mouquin's, the Café Francis, Shanley's, the Burton Ale Vaults and the Grapevine, where once so many good times were had and so much good conversation flowed, have all long since vanished. And though some claim that the little Grapevine was the origin of the phrase now encountered wherever the English language is spoken, it is as forgotten as the others. For even Charles Fitz-Gerald's editorial could not keep it alive.

Those establishments that did manage to survive the First World War were given the *coup de grâce* by the Eighteenth Amendment. Mouquin's lingered on a short time in sad desuetude. One night W., left alone with his thirteen-year-old son, took him to dinner at his old haunt. There was scarely a diner in the rooms that once had echoed to life and mirth.

The proprietor, on discovering W. G. seated at a table, came forward to greet him, scarcely believing his eyes; and with the dessert brought with his own trembling hands a surreptitious glass of contraband cognac. And well he might, for he knew that W. G.'s painting was already his memorial. W. could have said with Tom Moore:

> I feel like one
> Who treads alone
> Some banquet-hall deserted,
> Whose lights are fled,
> Whose garlands dead,
> And all but he departed!

The place was now full only of ghosts. Especially must W. have seen those of Jim Moore and a lady in a blue dress.

If he thought of the past at all, it would much more likely be of another occasion. There was the evening he sat alone at a corner table at the end of a strenuous day spent working on a rush order for illustrations, with no time off for lunch. He had just drained a cocktail and ordered a beefsteak when George B. Luks appeared, a little the worse for a few drinks.

"Aw, Glack," he said. "Come on home with me. Babe likes you. She doesn't mind my having a few if I am with you!" So W. G. canceled the order for the beefsteak and accompanied George home.

Mrs. Luks, "Babe"—later Mrs. W. V. Frankenberg—had not come in yet, but "Boot-we" the dog was delighted to see George. Boot-we—alleged French for "Beauty"—was a dingy Skye terrier with eye trouble.

"Let's take Boot-we for a walk," said George.

It was a fatal suggestion, but the leash was secured and the three strode out. Their steps somehow led them to a café—and then to another —Boot-we's escorts each took a mere snifter or two, just to kill time until Mrs. Luks' return. A pleasant hour was had, and a pleasant stroll, with no thought for the passage of time. Suddenly W. G. was inspired to arm

himself with a bouquet to give a festive air to their return, so a florist
was visited and a large cornucopia of roses acquired.

When they reached home Babe was standing in the middle of the
floor tapping her foot and glaring.

"Aw, Babe, have a heart," said George. He put his arms around her,
including W. G. in his embrace. All three of them swayed and fell to the
floor, dog and roses going down with them.

The floor was sympathetic to George, and he decided to remain
where he fell. Babe and W. G. undressed him and hauled him to bed.
He went sweetly to sleep, and about nine-thirty W. G. started once more
for dinner at Mouquin's.

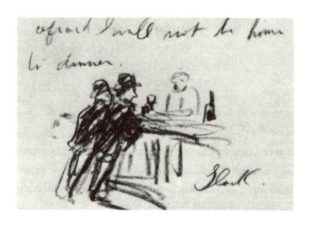

George Luks was consistent in his inconsistencies. Much has been
written of his braggadocio and his drinking, which often caused pain and
made difficulties for his friends. But he had a kindly eye with a humorous
twinkle in it, and he was warm in praise of his pupils. "See that luminous
nude!" he would say proudly, as though he had painted it himself. He
spoke of his own works with equal enthusiasm.

With all his vaunting verbiage, his tales of prize-fight days which
nobody, not even his pupils, really believed—tales that he spouted forth
with a Jacobean imagination and mastery of words, but as though he
knew perfectly well that his auditors knew *he* knew the whole thing was a
fiction, and only recounted to amuse—Luks had a most surprising and
tender streak. It appeared only in his paintings: two urchins looking
through a pastry cook's window at an elaborate wedding cake; a gutter

child wearing an elegant hat she has just picked out of the ashcan behind her—such moments were seen by George Luks, and his temperament responded. It was the measure of his stature as an artist that these sentimental moments were never painted sentimentally.

He liked to paint ancient crones, tipsy hack drivers and derelicts of all sorts, as well as small children, and it is tragic that due to his carefree disregard for the chemistry of pigments and mediums, some of his canvases are cracking, blackening and peeling beyond repair.

As a teacher, Luks did not concern himself with actually teaching, and his criticisms were negligible. What his pupils absorbed from him was a point of view; they all learned the paintable qualities inherent in derelicts and urchins, and they all absorbed a love of the medium of paint itself. A whitewing (streetcleaner) casually encountered pursuing his calling, would be inveigled into coming with full uniform and the implements of his trade to pose for the class. Then George and all his pupils got out their largest canvases, and the paint flew. Often the derelicts, plucked liked rare gems from the gutter, made the place farthest from the model stand the most desirable vantage point for one's easel. Guy Pène du Bois called Luks "a dealer in the riches he finds around him," and sometimes these riches were very rich indeed. But it was all for Art.

Luks had another side too. Sensitive to the dignity as well as pictorial quality of all kinds of people, and their specific personalities, he had a strange lack of ethical sense.

A collector visited his studio to buy one of his paintings, and after selecting one he mentioned that he intended next to visit Glackens' studio and acquire one of that artist's canvases.

"I have a Glackens!" said Luks, produced it, sold it, and pocketed the money. This was a canvas that W. G. had given him. And the next time he saw the artist, he told the story with boastful pride. (The painting was "The Artist Luks at Work," now at Los Angeles County Museum, Preston Harrison Collection.)

George invented several fine names, and he brought them into the conversation from time to time, so that these imaginary personages became almost aspects of George himself.

He came to the G.'s' to dinner one night and said, "I was walking through the Square the other day and chanced to see a child and nurse. 'Is this little Ira Glackens?' I asked."

" 'Oh no!' " said the nurse. " 'This is little Percy Saddlenose, *a very rich child!*' "

He liked to give an imitation of a wedding. First he made the sound of a deep, rumbling organ, full of emotional quivers, wonderful to hear; and then, in the same rumbling, quivering, emotional tone, the minister's voice began, "Augustus Smearcase, do you take this woman . . ." etc. The effect was very powerful. To this day I cannot hear a quivering organ without expecting George Luks' voice to begin, "Augustus Smearcase . . ." Another of his favorite names was John W. Beeswax, which he employed as a sort of John Doe.

One evening back in the Sherwood Studios he stayed for supper and gave his hostesses a sermon, the text of which was, "And *who* went up into the mountain?" This text was repeated with a hundred variations; the sermon consisted of nothing else. "And who went up into the *mountain?*" "And who went *up* into the mountain?" In George's deep, resonant voice it sounded very well indeed; and to be sure, the Sherwood Sisters said charitably afterward, the cognac bottle and the French vermouth did resemble each other.

But George Luks never made any mistake about the bottles before him; all were worthy of his attention. Many years later he wrote to I. G.:

<div style="text-align: right;">136 East 36 N. Y. Jan. 28, 1930</div>

DEAR IRA:

I had been in such a want of a vacation that I went out to "Hugo's," got drunk and finished up my gaiety by receiving a double fracture of the ankle—here I have been for two weeks in plaster and believe me I am happy if it is really possible. Reading, writing, and today am up and hopping around—tough old rascal—about Friday I shall grace the old studio with my presence and take up the fun with the rest of the nuts.

Yes, Ira, one must become a philosopher in order to sit back and laugh at our glorious countrymen and their silly actions. Everybody wearing ammo-proof garments and still the Greeks, Armenians and wops keep shooting 'em up stealing evidence from the courts, judges, giving dinners to gun-men and now to add to the mischief our police commissioner contemplates a twenty-nine story police building at a cost of $8,000,000 claiming that the different departments are too scattered and should be intigrated. Wouldn't it be funny if the crooks awaited the moment all of the officials, detectives &c. were at their desks—were to lock the building—Hold up the City Treasury and leave us just as Chicago is at present! Boy, what times we are having, washing the

whole damn thing down with denatured alcohol. I think I will introduce ankle-breaking as an indoor sport and really I think it is the most restful thing that could happen in as much [as] you have your meals served in bed and your friends send all kinds of delicious fruit. What a life? "Willie Reilly" never could have had this in his days of luxury and ease—and furthermore perfect quiet—and God knows you know how I enjoy it?

Wall Street has again put all the rich illustrators back to the tracing paper and eight hours a day—(what a terrible thing for the poor old fools) they are all broke and here's your uncle George just the same as if nothing out of the ordinary had happened. Oh, it's a great life!! weaken or not. Then again all the damn fool painters taking themselves seriously when both you and I know 99% o' them are liars. We now have with us the *sophisticated* connoisseurs and that adds to the amusement. This is "Sandy," Mercedes latest acquisition

and I can assure you he is wonderful. Now Ira dear we do miss you and both M and I are anxious to see not only you but the whole family enjoying the best of health. As for "Butts" the man who made Dr. Barnes—he must be getting good drinks and I am not envious—perhaps one of these fine days I may go to live in Capri and also hit 'em up with a gusto. We have in the class a very distinguished young lady 6 foot tall—handsome and intelligent & if Lenna don't mind I have christened her our big Lenna.

<div align="center">Write soon.

GEORGE AND MERCEDES</div>

Love to all
that includes Irene and Charlie [FitzGerald]

The "rest of the nuts" referred to in the first paragraph were his pupils, who called him George and looked upon him as one of themselves. Though Luks was sixty, and long one of the most famous painters in America, there was none of the "Master" attitude in his class, as there would have been in the days of Whistler and Chase.

Mercedes was his wife, a tall, handsome, intelligent girl half his age. She was a native of Cuba, and she was spellbound by George. She loved him with devotion and found him the most attractive and brilliant of men, except of course at times. But she loved him in spite of all, with the tenderness a mother might be expected to feel for a child.

Not infrequently George appeared at his class much the worse for drink. It was then the duty of one of his students to take him home. Once this duty fell to I. G.

A taxi was procured, and George, in his wide-brimmed black hat and with his glasses secured with a long black ribbon, looked like a highly respectable revivalist preacher, or a traveling seller of patent medicines whom one would instinctively address as "doctor." The impression was false.

One never knew what problems would be raised by George before one got him to his apartment near Murray Hill. On this occasion, as the taxi was speeding up Fifth Avenue, George ordered the driver to stop. He said he wished to step out and relieve himself in the middle of Madison Square. Nowhere else would do. What he really wanted was to make life difficult for the cab driver and his distracted but faithful pupil. He was teasing us both, with no intention of carrying out his threat. Quite a little tussle ensued, and I. G. ordered the cab driver to "drive on!"

George was delivered home to his long-suffering but devoted Mercedes, and she and I. G. put him to bed. Here was history repeating itself. A quarter of a century earlier, I could not help reflecting, much the same scene had been enacted by my father and George's former wife Babe. And it had been going on, with variations, ever since.

Though accounts of George Luks' actions may make him sound somewhat trying, and he was often difficult, and probably scrappy in bars and public places, he was at his best irresistably likable. His pupils adored him, for he amused and inspired them, and they understood him, and he thought they were all splendid—how could a pupil of "Little Old George Luks" be anything else?

George's brother Bill Luks was for many years the director of the old Northern Dispensary, that ancient wedge-of-pie-shaped building at the junction of Waverly Place and Grove Street. George often called there when in need of patching up, and sent his friends and acquaintances there too. "Go and see Bill—he'll fix you up." It was handy to have a brother in this line of work. The number of black eyes, abrasions etc., that Bill Luks "fixed up" for George and his companions through the years would be staggering if ascertainable.

Bill had a share of George's humor, which must often have been needed, but they differed in many other ways. Perhaps one George Luks

in a family was enough. His friend the late Edward W. Root described him well: "Rubicund, bald, active, durable, fearless, observant, easy of approach." He could have added enthusiastic, amusing, unmanageable, imaginative, exhausting. . . .

To such a friend of the bottle, the coming of Prohibition might have spelled death much sooner than it did. The amount of poisonous bootleg liquor George Luks consumed would have killed a battalion in much less time. And when he was found dead in a doorway, the papers said, with more concern for romance than fact, that death had overtaken the artist when he had gone forth to paint the dawn as it filtered through the elevated railway tracks. Actually, he had begun his braggadocio tactics once too often in a speakeasy, and the harmless old man had been beaten to death by one of the customers.

But he had a fine funeral. The chapel was crowded by his pupils, past and present, as well as faithful friends, and among the mourners was a faithful younger friend, Gene Tunney. Had George told *him*, one wondered, about his days as Chicago Whitey, the terror of the Windy City? (A city which quite possibly he had never visited.)

George was buried in an embroidered eighteenth-century waistcoat which had been his pride and joy, and with him went from American art a certain quality which has not yet returned.

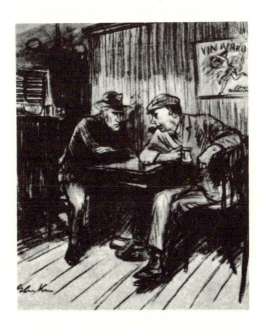

→»→»→»→»→»

"We have received tickets for the opening night of the St. Gaudens Memorial Exhibition at the Metropolitan Museum. I guess I shall go up and mingle with the Academicians," was W.'s news on the first of March, 1908. The spring promised to be a busy one in the world of art, after all—and likewise in the world of industry.

On March 5, he wrote:

Should have written this letter last night but I worked until five minutes of six and had an engagement with Fitz at 6:15 to go to the Opera and hear Pelleas and Melisande. That left me twenty minutes to get dressed. I did it.

I think I like the opera, it is unlike anything I have ever heard, and the characters all looked the part. Mary Garden fills my ideal of an opera singer. She is a splendid actress and she is not fat. I fancy all the other lady singers hate her.

But his hate among operas was said to be *Aïda*. A waggish friend, however, claimed that if one didn't *tell* him it was *Aïda* he did not suffer so much. This was a cruel *canard*. W. G. could recognize operatic Egyptian as well as the next man.

"I met the Brooks [Richard Brooks, the American sculptor, and his wife] "at the St Gaudens memorial exhibition," he wrote in due time. "There was an awful crush. The Honorable Mr Choate and Sir Purdon were receiving." (Sir Charles Purdon Clarke was then director of the Metropolitan.) "It was without doubt the funniest looking assembly of freaks I have ever seen. Musicians, actors, artists, financial kings and what not were assembled. Miles of automobiles and carriages. I could scarcely see a thing of the sculpture." But perhaps he did not mind too much. He once said to a friend of I. G. (*not* a sculptor), "Sculpture is bad drawing you can bark your shins on."

About this time E. had gone to Cape Cod to look at a house for rent at Dennis, and she reported that it would do and she had taken it. She drew a picture of it.

". . . oilskins for all three of us."

W. commented:

The house looks like the real story book house, white, green shutters and chimney. We will look like real natives living there. I suggest sweaters and oilskins for all three of us. How many rooms has it got? And how far from the beach? [This was to be their first summer together since Europe, and it could not come soon enough for W. G.] Don't worry about my health. I feel too healthy but I am addle-pated and can succeed in doing nothing. I wish all the damn pictures and paints would fly out the window or burn up. I loathe the sight of them.

How about settling down on Cape Cod for the rest of our lives? I might be able to catch codfish now there is nothing doing in the way of whaling. You could stand on the beach with a spy glass and wait for my boat to come in just like the illustrated ballads.

Cape Cod

The Shinns had given a large party which E. had missed. "The house crowded to suffocation and obligations paid off in one fell swoop."

Everett Shinn's wife, Florence, belonged to an unaffluent branch of the Biddle family of Philadelphia, an august connection that brought her only a few pieces of old Biddle silver and a lock of George Washington's hair, which had been handed down and down in the family until it finally reached her. The hair gradually dissipated, for Flossie explained that every time she took it out to show anyone, the gasps of awe and astonishment it evoked created a draft in which a few hairs blew away, until there was none left. But her background proved useful, for when an old lady named Cole preened herself on being descended from the veritable Old King Cole of the nursery rhyme, Flossie was not floored.

"*We* are mentioned in Literature too," she said proudly.

"High Biddle Biddle
The cat and the fiddle!"

When Flossie and her young art student friend Everett Shinn decided to get married, this necessitated, among other things, a call upon Flossie's great aunts and cousins. Everett was a swagger and rather brash young man, given to high collars, checked suits and much assurance. But even he quailed somewhat under the Biddle greeting: "An artist! But what do you *do*, Mr. Shinns?" This historic event was depicted by the late Wallace Morgan.

Everett Shinn meets his future wife's Philadelphia relatives.
"An artist! But what do you *do*, Mr. Shinns?"

Drawing by Wallace Morgan

In a house with ample room it seemed as though the G.'s could have some of their friends to visit. They hoped the Shinns could come to Dennis for a month that summer. And on March 17, W. wrote:

Saw Henri Sunday night. He tells me Sloan has been quite ill. Neuritis in the right arm. Rheumatic Neuritis the doctor called it. His mother suffered from it a great deal. . . .

If I can find an opportunity I will ask Sloan if he can come up to the Cape alone. He had rheumatism in both arms but is apparently all right now with the exception of an intolerable itching all over his body. . . . I dine with the Sloans tomorrow night.

The Brooks show is on but I received no card. There are about five sculptors exhibiting busts and portrait medallions. Haven't seen it yet.

But one of history's little ironies occurred in March too: "The Academy has turned over a new leaf and has accepted everybody this year. Jimmy has a picture there, and of course May."

Had the National Academy of Design turned over its new leaf only one year earlier, there would not have been an exhibition of The Eight, or any Eight at all. Yet perhaps it was the exhibition itself, and the great furor it caused, that loosened up the Academicians. This fascinating puzzle will never now be solved.

April 8:

Dearest Teed, I had a letter partly written last night but my mind refused to work and nothing but scribbles and incoherencies would come out. I have been working all day long for three days trying to make a line drawing. The studio is littered with torn efforts. When you once get out of the habit of drawing that way it is hell to get back. It is like every other game, you have to practice all the time. Shall rig up a lamp tonight and continue the struggle. . . . I have not said anything to Sloan about coming up to the Cape.

Seems kind of funny for Ella [Fiske] to have a birthday. One would think she was so self sufficient she wouldn't need one—give birth to herself, sort of self made—

Everett Shinn, during this time, was a very busy man. He had invented what he called a "political puzzle," and now was the moment to launch it. The year 1908 was among other things a political year. Teddy Roosevelt was finishing his second term, and there was great interest in whether he would break precedent and run again. He very much desired to do so—

a trait that ran in the family—and here was where Everett came in. His puzzle consisted of the well-known face of T. R. in the form of a round flat box with a celluloid cover. The pupils of the presidential eyeballs, in the form of two BB shots, rolled about within. The trick was to get them simultaneously into their sockets to answer the question, "CAN HE SEE A THIRD TERM?" The invention had just the mixture of the absurd and the amusing to stamp it a product of Everett Shinn's bizarre imagination.

W. G. had considerable to say about this puzzle, which rapidly became a *cause célèbre* in the art world.

May 9:

Shinn is up in the air about his puzzle. I saw one last night. It looks quite an object d'art. Will send you one as soon as he gets more. We are all going to be interviewed about our views on Teddy as a third termer. I think that is what he intends. He has a press agent camping out in his studio turning out ideas to advertise the puzzle. One would think it was a circus coming to town. I suppose however that is the proper way to handle things of this sort.

Tonight the new World Bld. will be opened with a grand reception. Shinn and I are going down as invited guests to see the new shower baths that have been put in for the benefit of inebriated editors and reporters.

A manuscript from Putnam's was sent to me yesterday. Please redirect it here to me at the Brevoort. They want it by the first of June and I can at least read it over and get it started.

On May 10:

Jimmy has received the annual invitation from Stinson to come up to his place and fish so we called him up on the telephone and accepted. We go up Tuesday morning for a couple of days. Gregg is going to lend me his rod but I thought it better to use my own reel.

There was a grand celebration at the World Bld. last night. Speech making by Senators and Governors and other public celebrities while a gorgeous display of fireworks was spouting from the dome to entertain the fifty or sixty thousand people packed in the streets below. It was the twenty-fifth anniversary of the Pulitzer regime. A cold collation with champagne was served in the business offices on the ground floor. Pulitzer blew himself although he was not there. . . .

Tonight we go over to the Shinns to be interviewed on the political outlook for advertising purposes.

The plan for launching the puzzle had seemed ready-made to Everett Shinn. He and his seven colleagues were at the moment riding on the crest of a wave of publicity, and it struck him that this was a wonderful opportunity for the puzzle business. He formed (entirely in his mind) the "Theodore III Club," ostensibly created by The Eight, all of whom appeared to be Republicans that year. Actually it was a publicity stunt to benefit Everett Shinn's little business enterprise. The enterprise was so ridiculous that nobody at first took it seriously.

W., from his fishing trip, noted developments:

May 14. Thursday. Greenwood Lake. [N. Y.]

Shinn's puzzle is out and the stories published in the papers about it make first class idiots of the whole lot of us. Everett has certainly taken advantage of his friends for advertising purposes.

"Theodore III" Club. The Club's secretary, Mr. Calvert, writing at left. From left to right: Shinn, Sloan, Davies, Luks, Lawson, Prendergast, Henri. Inset, Glackens.

J. Norman Lynd in the New York *Herald*, May 17, 1908.

"All the formal meetings have been held in the studio of Mr. Shinn," the *Herald* reported on May 17. "Mr. Glackens is one of the most forcible speakers, but he was away last week fishing with a Philadelphia journalist and the oratorical part of the propaganda was neglected. Nobody understands why Mr. Glackens acted that way when there was so much need for the silvery beauties of his rhetoric."

"However," Everett told the reporter, "Glackens has been working very hard about the Theodore III Club, and I guess he needs a little rest. He'll be back, though, before long, and well before you write anything you must hear Glackens talk. Don't you miss it."

"Messers Shinn and Calvert,"[1] the *Herald* continued, "consented in the absence of the official orator to discourse at some length on the aims and aspirations of the Theodore III Club."

It is doubtful if the public at large appreciated the notion of Glackens in the role of a silvery orator, which was perhaps Everett Shinn's most brilliant flight of fancy.

On May 17 W. wrote from New York:

I saw Flossie and Everett last night. Eve is absolutely crazy over this puzzle business. He has gotten [it] into his head that he is a *captain of industry* and purposes to do things with strictly business methods, with modern means of advertising. It sounds all right but you should see the results.

Shinn's studio at 112 Waverly Place was jammed with boxes of the puzzle which came by the gross from the manufacturer; posters were up in the elevated platforms and similar places: there was an advertising campaign. W. was glad enough at last to flee New York, and join E. G. and "the infant" in Boston, where they settled in a small hotel, the Curtis, at 45 Mount Vernon Street, on Beacon Hill, to wait for suitable weather to go to the Cape.

E.'s lively friend from Hartford, Grace Dwight, had lately married Daniel H. Morgan of Springfield, Massachusetts, and the Morgans were in Boston too. It promised to be an agreeable interlude.

Charles FitzGerald to E. G.:

DEAR TEED:
Prendergast is only a few doors down your street. His address is 56 Mt. Vernon Street. Send me a line some time and let me know where you are

[1] Everett's press agent

going next, that I may write occasionally while you are absent and inform you if anything amazing occurs in this city.

The G.'s and the Morgans spent much time with Maurice Prendergast, and came to know his younger brother Charles, who shared his studio and carved picture frames. And Charles FitzGerald kept his word, for soon he sent more news:

Jim Moore dined with me last night. Looking uncommon well and in good form. He has decided not to go mad but still dreams of a new café—God forgive him. He is not drinking which is more than I can say of the most of my friends or even of myself—God forgive me.

This news was good, but shortly after the G.'s had settled at Dennis some disturbing intelligence arrived—Flossie Shinn to E. G.:

You ask in your last, "How is the Puzzle?" It is quite well thank you but it has brought on a social war which makes the Battle of Bull Run look like a game of bridge. It seems that Lawson didn't like being brought into the political part though he gave his consent when Ev asked him. Instead of coming to Ev and kicking, which he had a perfect right to do, his old friend Aunt Sallie Gregg[2] publishes in the paper [the *Evening Sun*] as an appendix to Henri's marriage notice (such good taste) that E. Shinn was running a political club to sell a "mechanical device" which he said the Eight belonged to, but that every member of the Eight indignantly denied having any knowledge of such an organization or its meetings. As this was a malicious lie and made out that Ev had stolen all their names Ev called him up and told him what he was, and incidentally said, "I'm going to sue your little old paper for libel!" and in the following issues of the paper the appendix about Ev was cut out, which is of course an admission of guilt. So we're getting ready to sue them if they don't make a retraction. . . . I can't understand why Lawson can't come and talk it over like a man. He just hides behind Gregg and lets all his grievances come through the Sun. I've forgotten to state that Gregg won't admit he wrote the article. . . . We are cheered by Sloan and Dolly's loyalty. Am feeling a little exhausted but hope to last till Fall.

And she sent to Edith a postal card with a picture of the little eighteenth-century door at 112 Waverly Place, under which she wrote: "Historic Doorway Series, #36. Many battles have been fought here."

2 Frederick James Gregg

Everett Shinn telephoning the New York *Evening Sun*. Caricature by Flossie Shinn.

The big news was of course Robert Henri's marriage, which nobody knew anything about. Henri's first wife had died in 1905. On June 7 the *Times* printed an unexpected item:

Robert Henri, head of the New York School of Art, it was announced yesterday, was married on May 5 to Miss Marjorie Organ, who was a pupil at the art school. The ceremony was performed in Connecticut. . . .

Mr. and Mrs. Henri are now on their way to Spain on board the *Moltke*. Mr. Henri is accustomed to take every year a number of his pupils to Spain, and did not drop this practice because of his marriage. The wedding was announced the day the ship sailed, last Tuesday.

Flossie Shinn finished her letter about the Puzzle trouble:

But to more cheerful matters! No one knew Henri was married until they were all on board (not even the Sloans). Think of the consternation among the twenty pupils! Wouldn't it jar you to think you were sailing with an eligible parti, (first having invested in a becoming steamer-rug, a sea-shore bang and scented soda-mints) and then be confronted with a golden-haired bride, just as the gang-plank creaked its good-byes to the gaping crowd?

"Patriots in the Making," July 4, 1907. Cover for *Collier's*.

There are things even more cruel than political puzzling. My pall-bearers will give you all future news.

Marjorie Henri's hair was a rich auburn, as it turned out; she had a beautiful complexion and cherry lips. She also had an Irish wit, though she spoke her mind in a calm, quiet way. Her amusing drawings had been appearing in the *World*, and her cartoons, "Strange what a Difference a Mere Man Makes," in the *Journal*. She was a great addition to the G.'s' circle of friends, and a devoted wife to Robert Henri. His portrait of her, called "The Beach Hat," now in the Detroit Institute of Arts, is an excellent likeness.

E. G. sent glowing reports of Dennis, but John Sloan was unable to come, and Flossie wrote on June 16:

Nothing would suit us better than being a month at Dennis but can't desert the ship. If "Our Theodore" accepts the nomination the puzzle will go on the whoopee. We are waiting anxiously for news of the Convention and speak feelingly . . . of the needs of our Country! . . . Have heard nothing of the enemy. Sloan and Dolly dined here a few nights ago. No news of course yet from Henri. . . . I have a job for Harper's Bazaar so will close and struggle with a few hands, after having rubbed out several feet. All the ears have come to stay, thank God.

It looked as though the Shinns might still join the G.'s, but by August 5 this plan was seen to be impossible. Shinn had decorated the Belasco Theatre, but money was still scarce. Flossie wrote once more:

It's all D. Belasco's fault. We expected to be lolling about in the lap of luxury this summer, only the bad year affected the theater crops, so no more payments came in after April 1st and won't until after October. This was a sad blow for we had not "looked ahead" and building studio, etc., had swallowed up our fortune. So back to the hod! Let joy be unrefined! (as Wallace Irwin says). How I would enjoy dipping in the deep with you. I like a conservative bather. I always swim towards shore. It seems so foolish not to.

Teddy Roosevelt did not have the opportunity to "accept the nomination," but William Howard Taft did. Not for a moment was there any consternation in the Theodore III Club. Everett withdrew the old puzzle and quickly put forth two new ones—"William Howard Taft" and "William Jennings Bryan"—take your pick. But after the election the business was dead. Everett was free to set his fertile mind to something else.

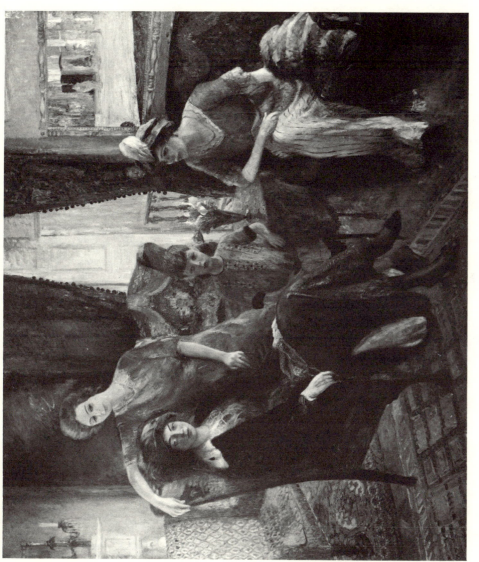

Family Group, 1911 (*left to right:* Irene Dimock, Edith Glackens, I. G., Grace Dwight Morgan)

NATIONAL GALLERY, WASHINGTON

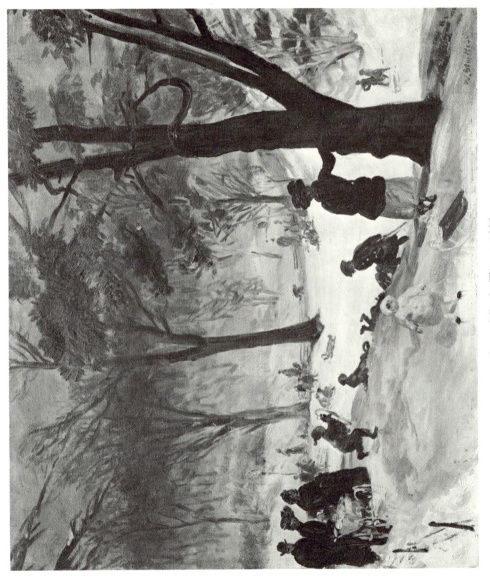

Central Park, Winter, 1905

METROPOLITAN MUSEUM OF ART, NEW YORK

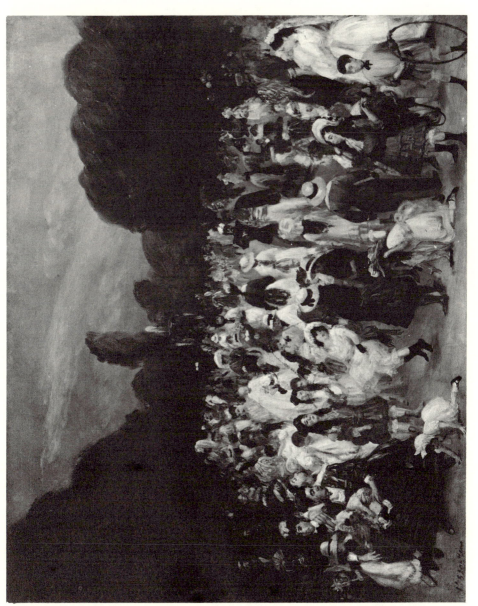

In the Buen Retiro, 1906

Luxembourg Gardens, 1906

ROLAND C. MURDOCK COLLECTION, WICHITA ART MUSEUM

Roller Skating Rink, 1906

COLLECTION OF MR. AND MRS. MEYER P. POTAMKIN

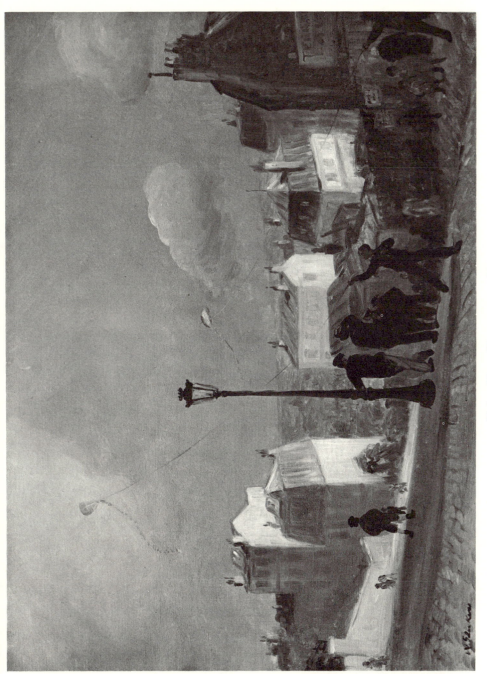

Flying Kites, Montmartre, 1906

MUSEUM OF FINE ARTS, BOSTON

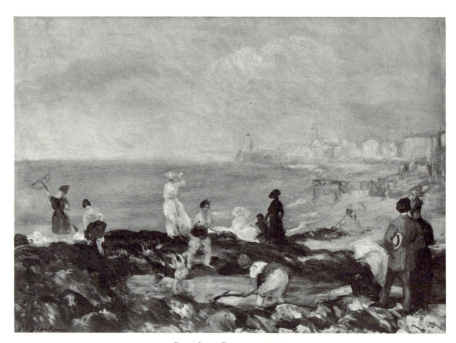

Beach at Dieppe, 1906

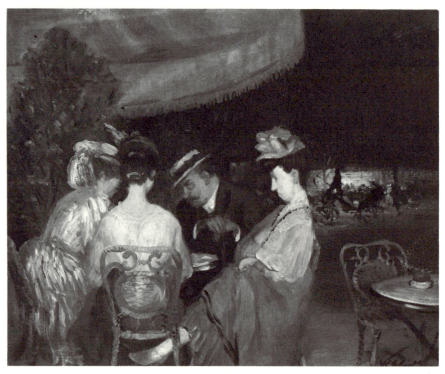

Café de la Paix, 1906

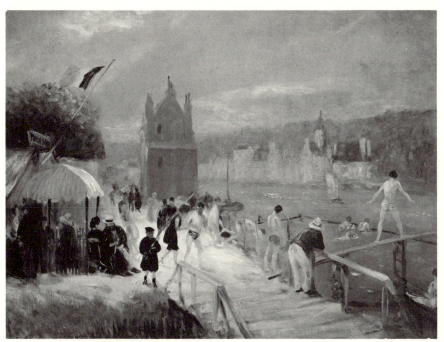

Château-Thierry, 1906
THE VIRGINIA STEELE SCOTT FOUNDATION, PASADENA

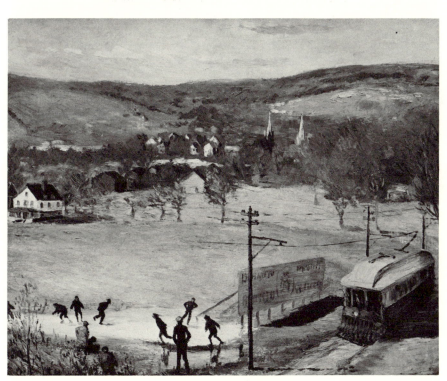

West Hartford, 1907
WADSWORTH ATHENEUM, HARTFORD

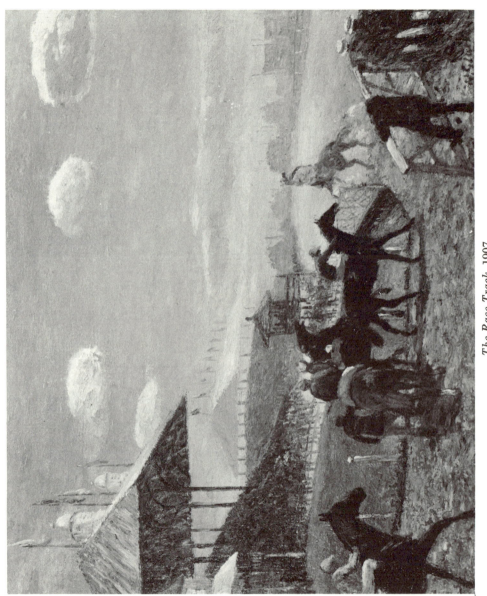

The Race Track, 1907

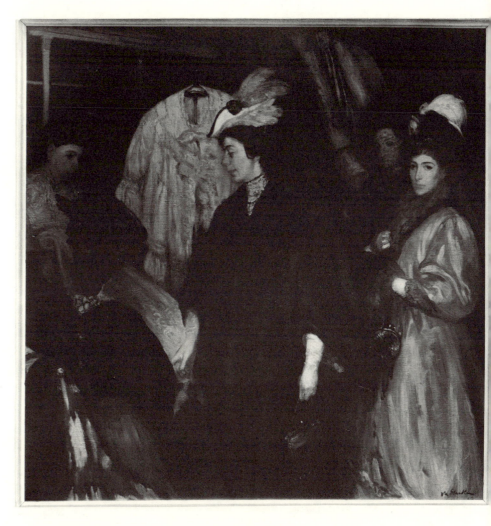

The Shoppers (Mrs. L. E. Travis, *seated,* Edith Glackens, Florence Scovel Shinn), 1908

CHRYSLER MUSEUM, NORFOLK

Gypsies Dancing, Gardens of the Alhambra, 1906-12

COLLECTION OF MR. J. C. GUTMAN

"Yuletide Revels," c. 1910. Cover for *Collier's*.

Charles FitzGerald remained true to his word, and reported on the fourth of July:

The World of Art . . . well, nothing is doing since Henri ran away with the cherry-lipt Organ and the Shinn puzzle was withdrawn from the market. Besides I have dropped out of the Art World more or less since Gregg turned connoisseur. There are little rumblings of the great storm that raged a month or two ago, the most amusing being a rumor of a grand libel action against the Evening Sun. But that is much too good to be true. Oh, for Shinn v. the Sun Printing and Publishing Corporation or whatever it would be! But of course I don't believe it. But you have no notion what bitterness arose out of that unfortunate "Theodore III Club," and with what desperate seriousness it was discussed. For my own part—

I hear that someone had a card from the new and picturesque Mrs. Henri, with words to the effect: This is better than drawing comics. Let us pray that she will continue in that conviction. I have no great faith in the joys of drawing comics. Matrimony I know nothing about, only it is a grand argument in its favor that people will persevere so. As you say, it's like drink.

And so, after the turmoil of the winter and the early summer storms, the G.'s settled down to a peaceful and pleasant time on Cape Cod:

DEAR MRS. GLACKENS. 56 Mt. Vernon St., Boston

Please excuse me for not being more prompt in my reply to your nice letter.

Your invitation was earlier than I expected and I had to change my plans somewhat.

So I will start on Thursday week September 3rd taking an early train 7:38 A.M. and reach Yarmouth at 10 A.M. I hope all the people in the little white house have profited by the summer and are enjoying excellent health. I shall be interested to see what Glackens has done.

I hope he found the new easel satisfactory.

I am sceptical about doing any work. If I don't I shall help you exterminate the mosquitoes. I am sending you and Glackens [and] the baby a hearty handshake and shall look forward to seeing everybody again with pleasure.

Thanking you most cordially for the invitation I am yours faithfully

MAURICE B. PRENDERGAST

August 26, 1908

I hope there is a lot of sunflowers around!! and if you have any commissions, or Glackens, don't fail to write.

M.B.P.

"Far From the Fresh Air Farm," (Thompson Street, New York) c. 1910. Cover for *Collier's*.

The Prendergast brothers, Maurice and Charles, are a classic example of lives lived entirely for art. For Maurice and Charles, producing works of art was as natural and daily an activity as eating and drinking. They got up in the morning in their studio, made breakfast, and then began to work. For those who knew them it is impossible to think of one without the other.

When I was a small boy we lived at 29 Washington Square in an ugly old red-brick apartment house long since vanished, and W. had a studio at Number 50, on the south side of the square. This was a typical old New York house, with high ceilings, and had seen much better days. W. had the parlor floor through. He painted in the front room, where the north light was good, and the old back parlor was used to store canvases. Large ones leaned against the wall, and there was some old furniture, tables, chairs, the sofa that appears in "Nude with Apple," some piles of draperies, a woman's large, old-fashioned hat covered with artificial flowers (often painted), and a green-backed hand mirror for the model. There were likewise beautiful black marble mantelpieces, the last reminders of the house's stately past. I was afraid of this back room, all dark and dingy with the blinds drawn (to keep the north light in the front room pure) because of the "flapdoodles" which lurked among the canvases, or so father said.

To the top floor in this house the Prendergast brothers came from Boston, in 1914, to live and work. Maurice stood before his easel in the front room, and Charles had his workbench in the back room, where he made his beautiful panels and chests. Charles was at this time in what is now called his "Celestial Period," which is inhabited by angels and bounding deer, trees full of fruits and birds in gold and silver.

The place was furnished with the minimum necessities of life, but all about hung Maurice's paintings and Charles's panels. One of Charles's

116

beautiful carved chests stood between the two front windows. These treasures, in all their glowing colors, made the place as rich as a palace.

The Prendergasts owned two beautiful old Persian pottery jars in which they kept a few scraps of old brocade, two or three inches long, which they had picked up in Italy and prized for their fine faded colors. A group of little Italian marionettes hung by their wires in a corner of the room; these had been similarly acquired. Under a bench was a small wooden box containing ancient pieces of mosaic, laboriously brought home—a treasure found likewise in Italy. Charles made several designs with them.

The Prendergasts' studio at 50 Washington Square, as remembered by a small boy, was a magic place. There was so little in it unconnected with art that the paintings, panels and chests (gold, silver, vermilion, viridian, cobalt), the Persian jars, the marionettes, the smell of paints and whiting and the faint aroma of rabbit glue, mingle in one wonderful *pastiche*.

Everywhere that Maurice and Charles looked, their eyes discovered something to enjoy. The faded scraps of brocade, the fine variations of their muted colors, gave them more pleasure and interest than most of us could derive from contemplating some grand work of art. They saw color where other people saw nothing. Compared to them, most of mankind is not only color-blind but unseeing.

Maurice once went to an express office to check a dog. The agent required a description of the animal to go on the slip.

"What color is it?" he asked.

Maurice looked critically at his dog, standing there in the brilliant summer sun.

"Yellow, with purple spots," the Impressionist decided.

Maurice, as is well known, was very deaf. He did not seem to mind his affliction.

"GREAT RELIEF!" he said in the hollow shout that many deaf people employ. He said that now he did not have to hear all the foolish or disagreeable things people said; and if anything very good were said, someone was sure to let him know about it. Thus he got only the cream. His deafness left him undisturbed by the clatter of the world and able to live in peace with his paints.

One day W. G. had a message for the Prendergasts and went up from

his studio below and banged on their door. Charles was out, but Maurice could be heard moving around within. It was useless to try to make him hear. W. noticed an old broom standing in a corner of the stairs. Picking a single broomcorn from it, he thrust it through the keyhole and twisted it. Maurice's quick eye saw that at once.

Maurice painted all day long, except for a walk in Washington Square, during which he often sketched; and when the light began to fade he worked on a large piece of canvas that was tacked to the wall in the hall, using up the beautiful pigments that remained on his palette.

Charles undertook to show me how to make a gesso ground on wood, preparing it for decoration in color and the laying of gold and silver leaf. I was nine or ten when I went over to the Prendergasts' to become a "pupil" of Charles's. Each seated on a high stool, we melted rabbit glue over a gas ring, dissolved whiting in water until it was like thin cream and tacky when tried between the fingers; we laid gold leaf, burnished it with a little instrument that had a piece of rounded agate at the end; and painted our boxes and panels. Sometimes Charles had to go out to buy groceries for supper, and then, working away in great absorption at the bench, I was only half-conscious of Maurice painting with even greater absorption in the next room. There was no sound but that of Maurice's brush scratching on the canvas. Occasionally he leaned around the corner of the door and beamed at me, and I smiled back. Words were unnecessary. These were golden hours.

The workbench was covered with sticks of pastel and little glass jars of water colors. These colors were very precious and came, I believe, from Germany. In particular there was a jar of red—a beautiful dry vermilion that no other brand of water colors could equal. The pastels were mainly French and also prized, being far superior to domestic ones, Charles explained. There were blues and purples no longer obtainable. These paints and pastels were the Prendergasts' most prized possessions: and I was allowed to use them! They had been brought back by Maurice from Europe.

Occasionally Maurice sold a picture and Charles sold a panel or received a commission to make a frame. Their riches consisted in the fewness of their wants and the completeness of their lives. But with a little extra money with which they found themselves one time, they decided to buy some Telephone stock. Their friends advised it.

Every day they looked anxiously in the paper to see if their stock had gone up or down. It was seriously interfering with their work. Finally Maurice decided that the stock should be sold, and whatever Maurice said was right by Charles.

The two brothers went to their bank, and Charles, who of necessity was the spokesman, diffidently approached the window while Maurice waited in the background. Soon Charles came back and told Maurice that the man at the window said he thought it would be very foolish to sell that stock just then. It was going up.

"TELL HIM TO MIND HIS BUSINESS!" Maurice shouted, his voice echoing through the building. And so the stock was sold, and the brothers could paint again in peace.

Maurice Prendergast

Maurice came tò visit the G.'s when we were spending the summer
at Bellport, Long Island, in 1912. He brought his sketch box of course,
and when everyone was sitting on the lawn under the trees one hot day
he noticed a small bowl of fruit on the grass, got out his paints, and
painted it. He left the picture behind him, and we have always treasured
it. In later years W. more than once spoke of the difficulty of painting
those green apples against that green grass, and much admired the little
painting. After Maurice's death Charles made one of his beautiful frames
for it.

Maurice likewise started a small canvas of I. G.—I was then five—
but unfortunately he never completely finished it. However, Charles made
a frame for it too.

In those days Maurice had a hearing aid in the shape of a little black
box containing batteries, which he could set on the table beside him and
which did help him to hear conversation. When he went bathing, how-
ever, some action of the water brought back his hearing, and for a few
minutes when he emerged from the waves, he could hear the crowds
laughing, the children playing, and all the bells ringing.

Though Maurice Prendergast had been a well-known name since early
in the century, his paintings were not popular with those who buy pic-
tures. They were far too modern. At the exhibition of The Eight, as has
been noted, he was one of the three artists who did not sell a canvas. He
was admired by those who count in other ways, and he had a few patrons,
notably Dr. Albert C. Barnes and John Quinn.

But on his deathbed, Maurice was told that he had received a prize
for one of his paintings.

"I'm glad they don't think I'm crazy," he said.

Maurice Prendergast, one of the purest artists America has produced,
died on February 1, 1924, when he was sixty-five. My mother wrote me,
"Our rare Maurice Prendergast has gone!" and the bleakness of the day
seemed bleaker still.

Charles was bereft of his lifelong companion. He brought one of his
own panels to our house one day when everyone happened to be out, and
when the family came home it was hanging in the living room. E. G. had
much admired this panel, and Maurice, it appears, had said, "If Mrs.
Glackens [he was always formal] likes it, she should have it." Everything
Maurice had said was still law to Charles.

Charles soon moved out of the studio which was now so empty to him, and settled in one in Irving Place. One winter morning while the G.'s were at breakfast the doorbell rang and Charles came in. His hand was bandaged and he looked white and shaken. A fire had broken out in his building, and his hand had been badly cut by breaking glass. Maurice's paintings and watercolors were stored there.

Charles and W. G. labored at the burned-out studio among the ruins, rescuing Maurice's work. E. G. herself lent a hand, and Charles stayed with the G.'s that time for several weeks. Miraculously, the only damage sustained by Maurice's work was charred edges on some of the canvases and watercolors (which were stored, fortunately, in stout portfolios). Even the firemen's hoses had been unable to ruin them. Had they gone, most of the life work of one of our great artists would have been lost.

When Charles came to visit the G.'s, which he did very often in later years, he went about the rooms enjoying and investigating every object in them. A small figure of an animal, perhaps discovered in a ten cent store, gave him—if it were good—as much pleasure as the rarest treasure. His appreciation was based on intrinsic interest.

A few years after Maurice's death, Charles married Eugenie Van Kemmel in Paris, and the rest of his life was comfortable and happy. Soon the Prendergasts moved to the country and bought a house near Westport, Connecticut, and turned it into a beautiful museum, glorified by Maurice's work and Charles's, which furnished it upstairs and down.

There were fine trees around the house, and Charles put up several birdhouses. From their porch he and his wife Eugenie watched a bird building a nest in one of them. But a beam of the porch screen cut across their vision, so Charles timed the bird: she was apt to be gone nine minutes. As soon as she flew away he ran up a ladder, already placed, and moved the house six inches higher on the tree. When the mother bird came back she did not notice the difference.

In the winter he decided to take the birdhouse down and clean it out for the next season. He brought it into his studio and carefully removed the roof. A small squirrel, who had been spending the winter curled up in it, looked up at him indignantly, roused from his sleep. Charles hastily clapped the roof back on, and all a-tremble hurried out and replaced the house in the tree. He decided to leave birdhouses undisturbed henceforth. He could not face such a look from a squirrel again.

From time to time Charles and Eugenie took a trip abroad. Eugenie gave the G.'s the reason: "Prendy wants a little bottle of wine." We knew what she meant: Prendy longed again for the pleasant, art-filled life he enjoyed in Europe; the "little bottle of wine" was a symbol.

Charles Prendergast followed his brother on August 20, 1948. He had never made a final disposal of his brother's ashes, and the problem was left to Eugenie. So she, accompanied only by Edith, took Maurice's and Charles's ashes to Riverside Cemetery, Norwalk, Connecticut, and the brothers were reunited. "I was very glad to have her," Eugenie wrote I. G., "and I know Charles and Maurice felt the same."

->>>->>>->>>->>>->>>

When Ernest Lawson reached man's estate he claimed American citizenship, to the consternation of his British relatives. "Oh Ernie, how could you?" they said.

He could because his parents, Dr. and Mrs. Archibald Lawson, started back to Nova Scotia from Mexico, where Dr. Lawson had charge of the health of workers in a mine, in a clipper ship belonging to Ernest's grandfather. They intended to travel overland from California, and hoped to reach home in time for their child to be born on British soil. But when the clipper landed them at San Francisco, Ernest Lawson was born there, in March, 1873.*

Ernest paraphrased the song sung about Ralph Rackstraw in *Pinafore*:

> For he might have been a Rooshian,
> Or French, or Turk, or Prooshian,
> Or perhaps I-tal-i-an.
> But in spite of all temptations
> To belong to other nations
> He remains Amer-i-can!

In fact he went out of his way to display Americanisms, even playing professional baseball for a while.

But the real blow fell when he announced his intention of becoming an artist. Tennyson's immortal line, "He is but a landscape painter," placed the profession as it was then regarded in some circles, and Ernest's relatives were less kind than the poet. "Hardly the profession for a gentleman," pronounced his cousin, the Colonel.

Ernest went to Paris, however, and there steeped his soul and his canvases in paint: robust pigment laid on almost in a frenzy, sometimes with his palette knife. He spoke also of joining a poetry club, but admitted it was probably for the pleasure of hearing a Scotsman recite Shelley:

* See Appendix 1.

Hail to thee, blithe SPIRRRRIT,
BURRD thou NEVERR WURRRRT!

Before returning to America, Ernest decided to attempt to reinstate himself with some of his British relatives. With this thought in mind he purchased the correct attire for a young gentleman: striped trousers, morning coat, silk hat, smart gloves and everything else the haberdasher could suggest. Armed with all the attributes of elegance, Ernest left France and crossed the Channel to the home of his ancestors, in a final effort to alter the family opinion of the vagabondage of art.

The Colonel received him as cordially as his military position would allow. It had been the Colonel's tragedy that no war had been vouchsafed him in which to accomplish deeds of prowess for his country. Instead, a tame period of peace had reigned, calm, uneventful, robbing him of the opportunity to cover himself with fame and glory. He was a bit touchy on this point.

All went well through the elaborate first formal dinner, but while discussing the port afterwards, the Colonel spoke feelingly and frankly about Ernest's "wasted life."

Goaded past endurance, Ernest said, "What have *you* ever done but cry 'Halt'?"

An icy blast blew through the already chilly dining room, and a sudden realization of what he had said overcame Ernest. Rising with what dignity he could muster, he murmured good night and retired to his room to consider the outlook, which appeared dark indeed.

Soon a rising moon came to his aid, calming his agitation, and disclosing a substantial water pipe just outside his window. It was strengthened by ivy, good English ivy, commended for its dependability from the time of Shakespeare. He decided that the only solution to his dilemma was to take what is called "French leave" in England and "English leave" in France, and his belongings were soon packed and lowered to the ground. Placing his silk hat on his head, he himself quickly if not gracefully followed them and fled by the light of the moon.

He never saw the Colonel again, and the Lawson family's conception of art and artists remained unchanged.

However, blood is thicker than paint, and some years later Ernest received a note from cousins from Nova Scotia, informing him that they

The Escape of Ernest Lawson. Drawing by Wallace Morgan.

were stopping at a certain hotel in New York and inviting him to call. He did so, and learned that they were out, but that their daughter, a young lady whom he had never seen, would be down directly.

Among several callers sitting in the lounge Ernest noted a famous visiting swami, who had parked his turban under his chair while he, too, awaited the descent of a friend.

The lift door opened and a young lady emerged. Glancing about the room, her eye lit upon the Indian, and without hesitation she hurried to his side.

A bellboy pointed out her mistake, and when she sat beside Ernest she confided, "Oh Cousin Ernest, *I am so glad you don't wear earrings!*"

Lawson must paint, there was no question, and if he had no studio he could manage with a closet or any place available. He unfortunately had to sell his paintings too, often at ruinously low prices. He seems to have sold many pictures, for they are found everywhere, but as his reputation grew, and there might have been a chance for better sales, some of the old canvases came back on the market, no longer in his possession and in competition with his own sales.

Yet, being an artist, he kept painting, and sometimes was obliged to paint the subject that would be most likely to sell.

E. Lawson to R. Henri: 23 MacDougal Alley
 (May, 1913)
DEAR HENRI:

I send a check for six dollars. We must get up a good show. I am going through my annual struggle to make Spring blossom pictures look human. I have never succeeded yet and this year's crop is a little worse than usual. If anybody mentions apple blossoms to me I am going to spit in their eye. The very thought of them is nauseating.

As ever, LAWSON

Ernest Lawson's landscapes hang in a surprisingly large number of museums and turn up in unexpected places. One once hung (it may still) in the upstairs lounge of the Paramount Theatre, Times Square. What a delightful surprise to find it there among the atrocities produced in the name of art and architecture, a rose among thorns!

Once I said to Lawson, "Ernie, how do you paint your beautiful landscapes *and never get them too green?*"

He held up his forefinger impressively, and said with a twinkle in his eye, "Naples yellow!"

When Ernest was courting his future wife, Ella Holman, a crisis occurred to which he most nobly rose, far out-Raleighing Sir Walter himself. The couple went for a country ride behind a fine horse, which drew them in some small but curious vehicle that lacked a footboard. The future Mrs. Lawson was wearing a beautiful starched white muslin dress, her Sunday best, and Ernest had put on his fine new Panama hat. Each hoped to impress the other favorably.

It was a splendid spring day, everything was going smoothly, the birds were joyously caroling (for all the world loves a lover), when . . . It is difficult to explain the predicament that arose without offending the tasteful and refined. But the horse suddenly decided to answer a call of nature. Due to the curious design of the vehicle, Ella's muslin dress faced imminent disaster! There was not an instant to lose! Heroically, and with great presence of mind, Ernest snatched his fine Panama hat from his head, and with the speed and agility of a pelota player, caught in it the articles that menaced the snowy muslin and tossed them in rapid succession into the road. It will occasion no surprise to learn that soon thereafter he won the hand of the lady. Who could resist such gallantry?

A year or two later the Lawsons journeyed to Paris, and they were soon both busily painting (for Mrs. Lawson was likewise an artist), exploring the countryside for the beautiful and picturesque. An addition to the family was expected, but there still seemed time to finish some of the fine canvases under way, time to acquire the little garments that would soon be needed. But little Margaret made her appearance before any attire for her had been provided. She had to be wrapped in one of her father's undervests.

Ernest hastened to the Bon Marché, but just as he had once been a prey to the haberdasher, he now fell victim to a wily saleslady, and returned triumphantly home laden with lace veils and mountains of other expensive nonsense.

Mrs. Lawson was a handsome woman with a curious faraway quality. As the years went by she had to face a good deal, including many bills and the bringing up of two daughters. Ernest, as usually happens to true artists, found little sale for his work.

Once at a large dinner party a sudden silence descended, in which

Ernest was heard to say loudly to his dinner partner, "My wife, you know, lives on the astral."

Everyone turned to look at Mrs. Lawson, who with great dignity was eating her dinner and seemed not to have noticed. It appeared that Ernest was correct.

Ernest Lawson was convivial, but most of his good times were had without his wife. One evening he came home, having wined and dined well. He found his wife reading a book; she did not look up. Ernest went to the kitchen and returned with a dozen eggs. Standing on the threshold, he tossed the eggs, which landed neatly one by one at Ella Lawson's feet. Ella Lawson went on reading.

Ten years after Ernest's death she remarked that now she realized she could never have lived with any other man, and regretted she had not gone out with him more often. "I could have got drunk with him every night," she said. At last, too late, she had come off the astral. She outlived her husband by fifteen years.

In the depression Ella had written E. G.:

I have been thinking for a long time how dreadful it was that E. had worked so faithfully for forty-five years and painted so many good pictures— that every museum of note has a good Lawson and now in this period of long depression no thought or provision is made for artists of worth to live. Many other men have pensions after long years of service and artists should have it if needed—so their ability is not lost.

As is often the case with true artists, Lawson had recognition from those who understand art, but never financial success. Yet his courage had not failed, and his last years were made comfortable, spent with devoted friends, Mr. and Mrs. Royce Powell, at Coral Gables, Florida, and there he painted some fine canvases. His daughter Margaret possessed great talent as a sculptor of animals, and her daughter, Jean Nison, with her ceramic tiles, recalls James Huneker's phrase so often quoted about her grandfather's paintings—"a palette of crushed jewels."

Ernest Lawson was a most amusing raconteur, a delightful companion, and one of W. G.'s closest friends. On the day the news arrived that William Glackens was dead, he wrote E. G. from Florida:

DEAR DEAR EDITH,

The horrible news has just come and I am grief stricken. I can't believe it.

Ernest Lawson and William Glackens at Coral Gables, Florida, 1932.

Well do I know how ghastly it is for you and how you loved him. I think I liked him better than any man I knew and it is a blow to me. . . . What can I say to you. . . . He was the best of his kind both as a man and as an artist. I always think of you and be [sic] as one and mourn for you. . . . Please be brave and believe me always your sincere and sympathetic friend,

ERNEST

Love to Lenna and Ira.[1] *Oh! how sad I feel.*

Ernest Lawson's body was found in the ocean at Coral Gables on December 18, 1939. Whether he had wandered into the surf, or had suffered a heart attack while walking on the beach and the rising tide had swept his body off shore, will never be known.*

On December 20, two days after his death, the New York *Herald Tribune* published a tribute to him from his friend Guy Pène du Bois. It said in part:

The artists who do not in one way or another keep their names constantly before the public risk oblivion. Ernest Lawson was one of those painters who believe in painting. There are very few left. He never did anything out of the way of painting to enlarge his name. He never did anything to his pictures to make them sensational or, which is the same thing, to make them catch the eye of the notoriously tired business man or to jab into some sort of reaction the brass-bound humor of the fashionable in art. This would have required a kind of wit he did not have, a kind of dishonesty which was out of the reach of his character. He was innocent and simple.

His love of nature was real. He never attempted to popularize the tunes he wrote about it nor to give them those pseudo-nationalistic twists by which fools convince other fools that they are real sons of the fatherland. I don't think he thought particularly about the fatherland. I know that he never wore even the tiniest American flag in his buttonhole. But when he sat in unconscious humility before an American or any other landscape he could and did, in those happy moments that came so often to him, go beyond its outer to its inner significance.

He was a lover of nature who knew the language of his art so well that he could render all the richness he saw in her and all the joy she made him feel. When the ballyhoo of the advertising painters has come to its natural death we shall turn to Ernest Lawson, among a few other great Americans, who saved what they had to say for their pictures.

[1] The artist's daughter and son.
* See Appendix 2.

->>>->>>->>>->>>->>>

The Exhibition of Independent Artists took place in April, 1910, that famous exhibition to which the riot squad had to be summoned. On the night the show opened there were said to be two thousand people packed in the street, trying to gain admission. John Sloan and Robert Henri were the spearheads of the exhibition, the first "no jury–no pri. ᵌs" exhibition held in America. It completely overshadowed the Spring Exhibition of the National Academy, where the police have never been required, and was held in a large empty warehouse in West Thirty-fifth Street, a few doors from the departed Café Francis of hallowed memory. It was the second salvo for freedom in art.

Our old friend "The Gilder" of *Town Topics* was on hand once more to pronounce all the pictures "vulgar"—vulgar in subject and vulgar in execution:

"When it is not an ugly, poorly drawn nude sitting on her bed washing her feet (May Wilson Preston) or a strumpet in night gown, cigarette in mouth, cooking something on a stove (John Sloan's "Three A.M."— note title) it is a coarse, woodeny [sic] nude, like Glackens' "Girl with Apple."

But another paper observed of the eager crowd, "It was enough to make the most hardened Academician burst into tears."

Art in New York was indeed seething, and Maurice and Charles Prendergast came down from Boston at intervals to catch up on what was taking place and lend their time and their names to the various activities. Whenever they appeared the news spread through the community, "The Prendies are in town!" for they were much loved, and all their friends made haste to wine and dine them.

Then, after a few days of festivities and visiting the galleries to see what was going on in the way of art, the Prendergasts could return to the

131

peace of Mount Vernon Street, saying New York was fine, but how did anyone ever stand the pace? They were soon to find out.

One fine thing however was gone—life at James B. Moore's. James B. Moore to W. G.:

Phila., Feb. 26, 1910

MY DEAR BILLIE:

I have been so rushed lately that I have had but little chance of replying to your fine, long letter of recent date which was like a sniff of brine to an old salt long denied a sight of the ocean.

I am delighted to know that you and the fat-paunched genius Fuhr contemplate a run down to this Paradise of the moribund and the drying up. In about ten days I shall have leisure. At present I am rather crowded with work as the Federal Appraisal Co. (Drexel Bldg., Room 724) have taken me into partnership and reorganization work is being done.

I am progressing in good shape from a business standpoint and a rival appraisal firm taking me into partnership rather suggests to me the idea that I am going to be ultimately successful. But in other lines Bill I am afraid I am stagnating. There is so much temptation here for the commonplace, the unexciting, the bromide. I am constantly upsetting ideals of propriety. I refuse to take life with the seriousness that Old Convention here has decreed and sometimes it seems to me I detect a feeling of joy—uncontrolled joy—that the bizarre has been done. But the gentle air of repose and disgusting decency soon sinks down like lead and flattens out the ephemeral ripple. . . .

Dolly [Sloan] has been here but has flown to the arms of her spouse. . . . Black Bill Gruger I hear pounds and keeps in place the bricks on lower Spruce Street . . . Guernsey Moore I occasionally encounter . . . But the old gang, Billie, has become a memory. No more shuffleboard; no more bloodless duels thereon[1] (you always beat me at that, you slob); no more of Tom Millard's concentrated dissertations; no more chatty dinners, domestic infelicities, and bouillabaisses of the unexpected and unforeseen. Ah, me! (That's meant to be a large sigh.) . . . Too little imagination; too much search for the golden solidity and neglect of the chasing and the floriture.

Well Bill old Scout, I try hard to be unhappy and dumpy and to convince myself that Destiny has lit upon me with both ironshod No. 11's but I'll be damned if I can keep up the role and find myself winking at the prompter in the wings. But I do miss you fellows desperately.

[1] Diligent research reveals that the shuffleboard was at the Burton Ale Vaults, in Twenty-fourth Street.

Give my highest regards to Mrs. Glackens, Mrs. Morgan and Mrs. Preston, not forgetting dear old Jimmie himself. Falstaff Fitz, the handsome voluptuary Byron Stevenson; Bob Henri; John Sloan; fashion-plate, snug-lapeled Gregg; and the other notables that made up that mosaic of genius that I formerly contemplated with awe; and last but not least to Master Ira Glackens whom I have never seen.

<div align="right">Faithfully yours,
JAMES B. MOORE</div>

P.S. Your illustrations of Glass's story in the current Sat. Eve. Post were fine.

Jim Moore's sad letter was the swan song of one who had united so many creative people. He never got back to settle in New York: café and shooting gallery were gone from him forever, and he was able to come to New York only on short visits. Yet his interest in life and his genuine interest in art did not desert him.

Now a new and very different character began to make a stir in certain

art circles: John Butler Yeats, the father of William Butler Yeats the poet and Jack Yeats the painter.

Old Man Yeats, as he was invariably known, had come to New York with his two daughters on a visit from his native Dublin, and here he found a small and admiring coterie of artists and writers who were fascinated by his brilliant conversation. Yeats settled at Petitpas, a rooming house and restaurant run by three French sisters in West Twenty-ninth Street, and about him gathered his followers. The most devoted of these were John and Dolly Sloan.

The conversation at Petitpas was good, and Old Man Yeats preempted most of it. He had never been so surrounded in Dublin, where, though his conversation was doubtless equally good, the impact of his Irish was lost. In New York his words were hung upon, and he decided to remain in New York. "I would rather be with the living than the dead," he explained.

Yet when his two daughters went back to Ireland at the end of their visit, he met a friend in the street and said, "I am like King Lear! Me daughters have forsaken me!"

John and Dolly Sloan arranged for Mr. Yeats to give a lecture on the manners of speech in various parts of Ireland, and everyone bought a ticket. "There's your Ulster man, and your Dublin man"—he produced examples of the various accents and idioms, and from time to time he clutched at his mouth and said in an aside, "I'm tormented with me teeth." Everyone was present, with the exception of Charles FitzGerald. He kept away because he well knew Old Man Yeats would single him out of the audience and use him to illustrate some point. ("I see Charlie Fitz-Gerald over there. Now he is an example of . . ." etc.) When Charlie was a little boy in Dublin, Yeats had painted his portrait, with long curls and holding a violin. Even then he was "tormented with" his teeth, and while he was painting, took a swig from a tumbler of hot water, kept it in his mouth as long as possible, and then spewed it out across the floor.

Old Man Yeats was a philosopher, a painter and a critic. He was a fascinating but at times difficult old man. Someone invited him to dinner, and he arrived with his bag and demanded, "Where's me room?"

W. G. did not fall under the spell and was infrequently among the admiring throng at Petitpas. But every time he was introduced to Yeats, the old man said, "I am very pleased to meet you, Mr. Glackens." Finally

Marjorie Henri grew tired of this and said, "You met him before, you gazoon." She was of Irish descent herself.

The Sloans took Old Man Yeats under their wing. They got him new teeth, which presumably would not torment him so much, had him often living at their studio, and nursed him when he was sick. In return he was a mentor to John Sloan, whose art grew and strengthened with Yeats' conversation and his keen observation about other artists' work and life in general.

John Sloan also gained much inspiration from the art of Isadora Duncan. He drew her many times, and he spoke with admiration of her "heavy solid figure, large columnar legs"—attributes with which the average lady would scarcely like to be credited. In one of his drawings these features were unusually prominent.

"What do you think of my drawing of Isadora?" he said, showing it to the Glackenses. "Her friends like it, and her enemies are crazy about it."

A reception was given to the Divine Isadora (or "Isadorable" as her more fervent admirers sometimes called her). The Sloans, the Henris, the Shinns, many in the art world were assembled to honor the great dancer, who lay like Madame Récamier on a divan, festooned in blue draperies that cascaded to the floor. Isadora Duncan was very strong on draperies (or the absence of them), as W. G. would have said. The guests were led up to be presented one by one. To each man she held out her hand to be kissed.

Old Mrs. Haggin, the mother of the artist Ben Ali Haggin and a *grande dame* of the old school accustomed to good manners, said graciously as she approached the Presence, "Please don't get up."

"I have no intention of doing so," breathed Isadora.

It came W. G.'s turn, and Isadora held out her hand as usual. W. took it, shook it briskly, and with a politely mumbled word, withdrew. He could no more kiss a lady's hand than fly; he had no intention of doing so.

John Sloan was the only one of the five Ashcanners (as they are now called) who had a strain of the Puritan in him. It was this perhaps that made him fall under the influence of socialism. Abetted by his wife Dolly, John Sloan began to devote his time and his talents to Socialist propaganda. After he joined the staff of *The Masses,* the years were stormy.

He saw less and less of his old friends, and he became at times cantankerous and difficult.

Sloan was also a friend, though not a follower, of Emma Goldman, the anarchist. Art makes strange bedfellows, for there occurred a dinner at which Miss Goldman, Sloan, Mrs. Harry Payne Whitney and Juliana Force were all present. As soon as she was served, Emma Goldman started to eat. Then she noticed that everyone else was waiting until all were served. She said, "Excuse me. I learned my manners in jail."

But W. G. was neither an agitator nor politically minded, and Sloan was unable to convert him. Sloan's own political fixation finally faded, and he returned to art and his old friends. Dolly seems to have given up the battle, and the Sloans reappeared at the Glackenses'.

Dolly talked a good deal about her husband, to whom she always referred as "John Sloan." She was a tiny Irish-American who suffered from nervous disorders and who, in spite of devotion to Sloan, had at times caused him a good deal of worry and distress. His art was not improved by his excursions into social reform, nor was his disposition, and it was a great pleasure to find him returning at last to his birthright. In his old age, when he became "the grand old man of American art" after a lifetime of official neglect, serenity was finally achieved. But by then both W. G. and Dolly were dead. Sloan married a former pupil, Helen Farr, and the rest of his life was happy and contented. He painted at last in the peace that his colleagues Maurice Prendergast and W. G. had never been without.

CHAPTER SEVENTEEN

In the autumn of 1908 the Glackenses had moved into an apartment at 23 Fifth Avenue, on the northeast corner of Ninth Street. Twenty-three was a fine old house, the ground floor of which was occupied by the owner, General Daniel Sickles, who had lost a leg at Gettysburg and had shot his wife's lover. These two facts are undisputed but whether the General had won the battle or nearly lost it by his unauthorized charge at the Peach Orchard has ever been a matter of controversy. About his head for most of his nearly ninety years had blown a tornado of scandals, lawsuits, bankruptcies, international intrigue and an accusation of murder.

Another matter of controversy was the status of his companion, Miss Wilmerding, who came every afternoon "to read to the General." General Sickles sat ensconced on a kind of throne at the far end of his living room, an apartment hung with battle flags, furnished with glass cases containing swords, medals and other souvenirs of military glory, and carpeted with the skins of animals, which gave forth an unpleasant smell of preservatives and moth balls. When I. G. was led forward to be presented to the old soldier, he tripped over the head of a polar bear and fell just short of the General's lap. Miss Wilmerding assisted in picking up the terrified child, who was soon hustled away. But not before I had managed to ask the General where his other leg was. (He could have told me, too. It was, and still may be, preserved in the Medical Museum of the Armed Forces, with the General's card attached.)

Absence of that leg made the General an awesome and godlike figure in my eyes, to be emulated at all costs. Shrieks from the nursery in the early morning then conveyed to my harassed parents that "Ira is General Sickles again," and would not permit his second shoe to be put on. Only father at such crises could succeed in inducing me to allow a shoe to be crammed onto my nonexistent foot, and even then I preserved the illusion by hopping on one foot all the way to Washington Square.

137

The General had a Spanish wife who lived around the corner and would not inhabit the house as long as Miss Wilmerding was in it. Her son Stanton Sickles in a violent mood threatened to "kill" the tenants on the third floor, who happened to be the Glackenses' old friends, Grace and Dan Morgan, in order to rid the place of them and acquire the flat for his mother and himself.

Grace Morgan became alarmed at these threats and finally went to the police. The police were not impressed. "If he does anything, let us know," the officer in charge said easily.

Grace left with a parting shot. "If he kills me, I will come right over and tell you!" she promised.

Through all the hurly-burly the General sat unperturbed. The inscrutable Miss Wilmerding continued to appear every day, and on those occasions when the General sallied forth, his colored orderly Mosely rolled a crimson carpet from the door to the curb, so that he could reach his carriage in the royal manner befitting "the hero of Gettysburg"—as he never doubted himself to be. The Glackenses and the Morgans were privileged to step out over the crimson carpet too, if they happened to be leaving the house at one of these imposing moments.

Mark Twain lived on the southeast corner, just across Ninth Street, and his house should have been the venerated mansion of the neighborhood. But the Sickles' house was apparently, like an embassy, extraterritorial, and regarded with awe by the policemen on the beat. When a parade was expected, Mosely decorated the front of the house with flags and bunting. No passing person could fail to note that this was the abode of the great General Sickles.

Once the flags proved helpful. Across the front of the Glackens apartment was an iron balcony on which the Glackenses, the Morgans, Ernest Lawson and others were assembled to see a parade. The sound of music drew nearer; the crowds below pressed to the curb, and the cordons of police proclaimed that no one else could cross the street. At this moment lithe little Jimmy Preston was seen on the opposite side to break through the crowd and start over. A policeman grabbed him and shook him like a rat.

"Leave him alone! He's coming here!" voices shouted indignantly from the Glackens balcony. The policeman dropped Jimmy like a shot—he was going to the Sickles house.

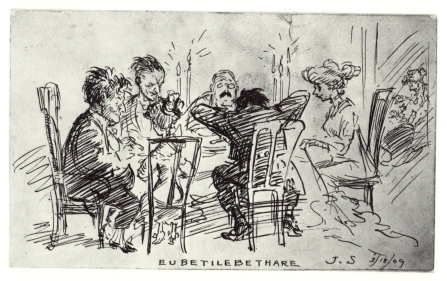

Acceptance by John Sloan of an invitation to dinner at the Glackenses', March 18, 1909. Left to right: W.G., Everett Shinn, James B. Moore, E.G.; (back view) Flossie Shinn, John Sloan. In cradle at right, I.G.

When Mosely was not rolling out the carpet for the General, he performed the duties of a janitor for the General's tenants. At the age of two, little troublesome Ira succeeded in turning the key in the nursery door and locking himself in. Frantic urgings from behind the door to "turn the key the other way" proving useless, Mosely was summoned to put a ladder up against the house on the Ninth Street side and climb in the second-story window.

But Mosely had too much to do to keep the place up, and this with the alarms and excursions at 23, the explosive appearances of Stanton, the enigmatic Wilmerding, the newspaper gossip—for the General's marital troubles were fully aired—finally forced the tenants regretfully to move elsewhere, in spite of the crimson carpet. Stanton never achieved the Morgans' apartment, for Mabel Dodge moved in and there held her celebrated salon with John Reed and others as her guests.

While in residence at 23 W. G. painted two large canvases in the living room: "Family Group," which depicts, besides Edith and Ira, Irene Dimock and Grace Morgan; and "The Artist's Wife and Son." These are all that remain of 23 Fifth Avenue.

There is no such memento of the little theatre built about this time by
Everett Shinn, in a small court behind his studio at 112 Waverly Place.
Shinn, as his paintings prove, was stage-struck. His theatre was complete
with proscenium, stage, and crimson curtains that parted in the middle
like those at the Opera. The capacity of the house was fifty-five.

Everett wrote a play, designed and built the sets, and organized the
Waverly Place Players. Among the members of this distinguished com-
pany, besides the Shinns, were William and Edith Glackens, James
Preston, and Wilfred Buckland, who was an assistant to David Belasco.
The first play was so successful that two more followed it. The titles of
Everett's dramas were *Ethel Clayton, or Wronged from the Start* (this was
a Civil War epic); *Hazel Weston, or More Sinned Against than Usual* and
Lucy Moore, or The Prune Hater's Daughter, and a few of the most privi-
leged people in New York saw them in the years 1911–1912.

In *Hazel Weston* ("A 4–Act Drama of Upstate Folk") Everett and
E. G. played Mr. and Mrs. Prentice, a farm couple, and Jimmy Preston
was Boob Jordan, the village simpleton. The Prentices have Hazel Wes-
ton, the village schoolteacher, boarding with them. Some scandalous, and
of course totally unfounded, rumors are circulated about her, and Farmer
Prentice orders her out of his house.

"I wun't have no son of mine under the same roof with a gal whose
past wun't bear huskin'!" he cries. "It's snowing outside, so out you go!"

Here flakes of snow (torn-up newspaper) are seen drifting by the
little window in Mrs. Prentice's kitchen, where this sad scene is laid.

Hazel ("a young girl with no place to lay her head"), played by
Flossie with great pathos, is thus driven into the storm.

The real villain of the piece, Flugeon Smith ("owner of the Belleville
quarries"), was played by none other than the mild and peaceful W. G.
Nothing could be done to make his rather small and amiable mouth look
villainous, so he blotted it out with a large black moustache, and *painted*
a huge mouth full of carnivorous teeth below it, on his chin. For bags of
dissipation under his eyes he employed caramels molded into the correct
shape.

Failing to acquire Hazel Weston by foul means, Flugeon offers matri-
mony. Everett's inspiration as an author failed here, and at rehearsal he
told Flossie to supply her own lines for this situation. So she cried, "You
vampire in viper's form! Rather a thousand times would I be dead—with

a snowdrift in my hair! That, Sir! would be *my* bridal wreath!"

On the opening night the performance was stopped at this point by the cheers of the frenzied audience.

In *The Prune Hater's Daughter* Everett played a slick villain, Glu' Melch, and Wilfred Buckland was the heavy, Doc Allen ("in the Devil's pay"). In a deserted mill festooned with cobwebs the two gamble for Lucy, the Prune Hater's daughter. A spider is seen crossing a beam, and they decide that the side the spider goes to will determine who gets the prize.

The spider starts in one direction.

"The gal's mine!"

It reverses its direction several times. The suspense is frightful.

Finally, when the creature hesitates, Jimmy Preston as Sammy the village simpleton rises out of a prune barrel where he has hidden to overhear the plot and aims his peashooter at the spider, which falls down dead in the exact center of the stage.

Lucy Moore is saved!—at least for the time being.

Lucy (played by Flossie) works in the Eureka Artificial Flower Shop in Boston, that wicked city, eking out a pitiful existence making "Happy Home" wreaths. (Her coiffure was mountains high, however, and her fingers glittered with diamonds, for was she not the Star?) Lucy is harshly treated by Miss Wasp, the forelady, played by E. G.

It seems that Lucy's father, Edgar Moore, so detested prunes that he had invented a machine for pitting them, under the theory that if he could destroy all the prune pits in the world the hated fruit would become extinct. Edgar's hatred of prunes amounted to a phobia.

Lucy believes herself to be an orphan, but such is not the case. Edgar is imprisoned in the old mill, chained under the floor by the villains, to work on his machine. Its one defect, not yet ironed out, is that if the lever be but reversed, all the pits are put back in their skins. The two villains, Glucose Melch and Doc Allen, plan to steal the invention (as soon as it is perfected) and make a fortune selling pitted prunes. Edgar Moore so detests the fruit that he is incapable of seeing any money in it. He is purely a philanthropist.

The villains want not only the machine, but Lucy as well. Doc Allen visits the Eureka Artificial Flower Shop and orders a wreath of daisies, provided that Lucy is the one to deliver it—to the Old Mill, of course.

He bribes the wicked Miss Wasp to see that this occurs. And so the plot goes—the drama ending in a spectacular fire at the Old Mill in which the villains perish and father and daughter are reunited.

The *Tribune,* which devoted four columns to this off-Broadway epic, said, "If the enthusiastic reviewer of this extraordinary first night should refer to the artist-dramatist of the occasion, Everett Shinn, as the white hope of a new and real national drama, the reader must be lenient."

The *Times* stated, "Act Two was chiefly successful for the histrionism of Mrs. Glackens as a forelady." Ira Dimock's opinion of his daughter's comic talents here found official confirmation.

The programs of those dramas were unusual reading, for Everett did not always limit his cast of characters to those who appeared on the stage. One of his plays had these among the dramatis personae:

> Puma .. a colored nurse
> Prickly Pete .. a friendly alligator

Neither appeared to the expectant audience nor, I believe, was even mentioned in the play. In *Hazel Weston* the titular role was set down as being played, not by Flossie who did play it, but by Ben Ali Haggin, that large and swarthy portrait-painter who was half Irish and half Turk. Flossie was small, with feet and ankles like a gazelle's, and was known in her circle as "the pocket Venus." The audience must have been amazed at the success of Ben Ali's disguise.

But all these actors were artists first, and as may be expected, their make-ups were works of art. E. G., to give her face a long, doleful look as Mrs. Prentice, the farmer's wife, put a candleshade on top of her head and drew her hair over it.

Jimmy Preston *always* played the village simpleton; he was a typed actor. He said that he could either act or speak lines, but not both, so Everett wrote parts for him with the minimum of lines, and his pantomime was superb.

Everett's theatre was staffed, both the back and the front of the house. Mrs. George Bellows constituted the orchestra, and played "Hearts and Flowers" and other appropriate compositions on an old, tinny piano. Dr. Harry Britenstool was house physician and left his seat number at the box office in case his services should be required.

The subsequent history of Everett's dramas was astonishing. They

THE WAVERLY PLACE PLAYERS

Hazel Weston or More Sinned Against than Usual

The Old Deserted Tool Shed: W.G. and Flossie Shinn

Mrs. Prentice's Kitchen: Everett Shinn, E. Glackens

were bought and put into vaudeville. When the first was performed by professional actors—I think at Keith's—photographs of the original production were blown up to giant size and displayed in the lobby, and the Waverly Place Players went to see themselves. One or two of the plays were then translated into numerous languages, including the Scandinavian, and were performed for many years through the rural sections of Europe, where the simple peasants are said to have taken them seriously. But as Everett had sold them outright, he got little or nothing for them.

Everett Shinn's mercurial talents had too many facets. He went on dabbling in the theatre for most of the rest of his life but never repeated his earlier successes. He made beautiful model sets and had his house filled with them—with changes of lighting and everything else complete. I well remember the set for a play called *The Dump*. It was a one-set play, laid on a city dump, and no one ever saw a more beautiful dump. The plot involves derelicts and hoboes, and as the night descends and the distant lights of the city begin to twinkle, a lone lamppost beyond the dump is suddenly observed to have taken on the shape of the Cross. This religious allegory seemed very unlike Everett and his former plays. The play never saw Broadway, and I believe the producers felt, and not without reason, that a religious play laid entirely on a dump, however beautiful, tended to be depressing.

Everett was a born theatre man, and the American theatre lost much by neglecting him. In describing some new play taking shape in his mind his dramatic frenzy was wonderful to behold. He acted out all the roles, his resonant voice changing by the moment; if there was, for instance, a rowboat on the scene, he acted the rowboat too. His audiences were spellbound. His rich imagination, which never seemed to be at a loss for a moment, invention piling on invention, was perhaps at its apogee when he wrote his melodramas; but there was nothing that he could not do.

And this was surely his weakness. No one line of endeavor was enough for Everett Shinn. His temperament was volatile and inconstant.

He finally told Flossie that he wanted a divorce. Little Flossie, "the pocket Venus," took some time to recover from the blow, and when she did she embarked on an entirely new career and seems never to have drawn again. She got religion, but in a way all her own. I believe Flossie's religion was what is known as New Thought or Unity. It was a religion of success.

THE WAVERLY PLACE PLAYERS
The Prune Hater's Daughter

The Eureka Artificial Flower Shop: E. Glackens, Wilfred Buckland, Flossie Shinn

The Old Mill: James Preston, Everett Shinn, Wilfred Buckland

Flossie worked out her own philosophy and then wrote a book with a
sure-fire title: *The Game of Life, and How to Play It.* No publisher would
touch it. So Flossie sold her old Biddle silver (George Washington's hair
having long since blown away) and published it herself, in 1925. The last
I heard, it had gone into forty editions.

Flossie could not be dull if she tried, and her book, along with its
inspiration, brings laughs. She became a widely known speaker, and her
talks were always bright and lively. In 1928 she published a sequel to
her first book with another catchy title: *Your Word Is Your Wand,* and in
1940 another, *The Secret Door to Success.* She rented a large apartment
on Fifth Avenue, overlooking Central Park, as her religion required her
to "affirm" wealth—her basic thesis—so that it would "manifest." Some-
how, it always did.

Everett used to visit her there, especially when he decided to marry
again (which he did three times after leaving Flossie), and Flossie would
bless the marriage and say, "Now this is the real one!" But Everett died
divorced.

Finally one day Flossie went into her living room, sat down and died.
Not long afterward her effects were sold in a dingy auction room. E. G.
did not learn of the auction until too late. Hurrying there, she found
Flossie's goods and chattels had been sold and carted away. Only a few
of her old drawings were scattered on the floor, not yet having been
swept up, and the attendant said she might have them. So E., faithful
to her old friend, picked her drawings off the floor and carried them home.
No one else had cared. One or two of these rescued drawings are now in
the Library of Congress.

Everett perhaps could not help his inconstant nature, though in the
end he gave signs of regretting it. "With every one of my wives I have
had a complete set of new friends," he said, "and the first ones were the
best."

But with the First World War the whole world was changing. Fer-
dinand Sinzig died, and from the hospital where he was recovering from
an appendectomy, W. G. wrote E., "I am awfully sorry about Mrs. Sinzig,
what with the war and her other afflictions she must feel pretty de-
pressed." One day Ernest Lawson and Jimmy Preston were walking
through Madison Square when they encountered Louise Sinzig in rusty
black. She spoke of "dot beautiful life" as it all came back to her, *couleur*

de rose, and then she wept until a policeman decided she was being maltreated by the two men and hurried over to investigate.

Louise finally returned to her native land and took with her her two most prized possessions, a mattress of white horsehair and an urn containing Ferdinand's ashes. After a year or two she found she could stand Germany no longer, and back she came with urn and mattress, an American flag pinned to her bosom. Then she went again, and when her mind changed once more she found it impossible to re-enter the United States. And so, with the ashes, she had to stay in Germany.

Not long after Sinzig's death, Jim Moore died, and he who had led such an unconventional life had a highly respectable funeral, as befitted the grandson of a founder of the General Theological Seminary. Among the pallbearers was Ernest Lawson, who explained afterward that though it might have seemed that they all had tears in their eyes, it was not that, but alcohol. "Jim would have wished it."

CHAPTER EIGHTEEN

May Wilson, who became the internationally known illustrator May Wilson Preston, was born with enough talent, determination and energy to supply a dozen people. When she was a girl her father locked her in her room, since he thought she was ill and he was afraid that she would play in an approaching tennis tournament. May got out on the roof, slid down a drainpipe—probably clutching her racket in her teeth —and won the finals.

But this was not enough. May also was determined to become an Artist.

All the tools and materials known to be used in the production of works of art were procured, including a large piece of Bristol board, which was mounted on an easel in readiness. As was not unusual with beginners in that romantic epoch, May chose for her first masterpiece the subject "Cupid's Rehearsal."

The composition offered no difficulties to May. She merely closed her eyes, said "Hickory dickory dock!" and brought her pencil down on the Bristol board in a number of places. On each of these spots a cupid was portrayed. Some of them were aiming to the right with bow and arrow, some aiming to the left, and others just lying at ease on toadstools.

May's parents, as portly as they were cooperative, posed (in union suits) for the cupids. When a dozen or so of the little love gods had been executed the work was considered finished.

It was crated and expressed to the old comic magazine *Life* in New York at the cost of seven dollars—but not before Papa Wilson, with the thought of a possible railroad wreck in mind, had caused a large photograph of the work to be made for the benefit of Posterity.

The drawing came back in a mailing tube—two cents postage due. Furthermore, a printed slip accompanied it with the surprising statement that it was "not available." May took pen in hand to point out this

148

paradox to Life Publishing Company. "Why not?" she inquired. And added, "I've seen lots worse in your magazine."

A kind reply from Mr. Mitchell, the editor, asked Miss Wilson to put the drawing aside for a few years, when she would be able to answer the question for herself. Many years later May found herself at a dinner given by Mr. Mitchell in her honor. "Cupid's Rehearsal" then at last scored its long-awaited success, in narrative if not in graphic form. Among her many talents, May had that rarest gift, the ability to laugh at herself.

Though he had encouraged her artistic ambitions, Mr. Wilson hoped that his daughter would be, above all, womanly and domestic, her interest the home, puddings, dust and so on. To encourage her in these virtues he offered her twenty-five cents a day to wash the breakfast dishes. May gave a small boy ten cents for doing them and pocketed fifteen cents daily.

After attending Oberlin, and several years at the Art Students League, May went abroad to put the finishing touches to her work at the world's art center. She had some trouble with her French, and the natives, too, suffered a good deal. This was not the way the polite tongue was spoken at Oberlin. Entirely different subjects were discussed there too. When a boy snatched her purse she intended to summon the police but instead called loudly for the postman. As the postman was not due for two hours, nobody paid any attention—just another crazy American.

This impression was not modified when she went to the hairdresser to have her hair singed, and asked instead for a monkey, *un singe*. But her greatest triumph in French came when an irate maid called her a rude name—probably "camel." Only May could have achieved the cold dignity of the retort, *"Je suis, suis-je?"*

May had lost no time in joining Whistler's painting class, which consisted of fifty or sixty women of widely divergent ages, and a few men. About once a month a criticism was given, but May hid at these times and never came under the Master's eye.

Black paint on a palette aroused Whistler's wrath, and he scraped it off, saying, "There is no such color." Whenever he required a paint rag, fifty or sixty handkerchiefs were offered, lace-trimmed or otherwise, to be kept forever as coming from Whistler's brush. The students were required to set up the same palette, colors being mixed in advance into a sort of pudding. It was very discouraging, and finally May remembered

a story that William M. Chase, with whom she had studied in New York, told about Whistler.

A woman asked Whistler to say something about Art to her little boy, something he would never forget. Whistler called the awe-struck child to his side and the following conversation took place:

"When you grow up you are going to be an artist?"

"Yes, sir."

"Well, when you grow up and your painting master tells you to do something—*don't you do it!*"

May at length realized the wisdom of this lesson, for she worked independently the rest of her stay in France.

May's greatest break in Paris was meeting James Preston. James was living in the rue Notre Dame des Champs with his easel, a stove, and a mountain of prune pits in the corner of his studio. Whether the intention was to plant the pits if some garden spot could be found, or whether they were just souvenirs, history does not state.

James was an interesting dresser. In those good old days an artist *looked* like an artist, and could be told at a glance. James wore his hair longish in back, and it stood out as though in a perpetual high wind. Once when he and Everett Shinn were walking in the less elegant quarters of Philadelphia a large wet dishclout spattered onto the pavement beside them from some point above.

"Don't look," whispered James. "That was meant for me."

James was not only an interesting dresser, he was particular about the cut of his clothes. He scorned the French styles, and so, though his clothes were showing wear, he decided to wait until he reached England on the homeward trip before having new suits made. Unfortunately that vulnerable spot, the seat of the trousers, began to show a gleam of white, and by the time England's shores were reached the garment gave unmistakable signs of being on its last legs.

James, with May and a group of students, arrived at the Metropole Hotel in London at the dinner hour. All was life, animation and evening clothes in the lounge, as the English public, faultlessly attired and debonair, milled about the travelers. After a rough crossing they looked the worse for wear, and so did their baggage. James' sole leather trunk rattled alarmingly, containing, as it did, dozens of stiff collars and a pan for cooking prunes. James placed his hands behind him in the classic

attitude of John Bull and kept them there until the new suits were delivered.

Jimmy Preston was famous for being dapper. He had the bright and quizzical look of a bird, and he was always a great favorite on sight of everyone from infants to octogenarians. For the former he had a wonderful language full of strange sounds and chatter, and so expressive that they were invariably held spellbound.

Jimmy went to the Illustrators' Ball in a harlequin costume that fit him like a glove. There he encountered his friend the late humorist Irvin S. Cobb, who had clothed his generous proportions in a voluminous clown suit.

"Jimmy," said Irvin Cobb, "how much do you weigh?"

Jimmy Preston told him, "Ninety-eight pounds."

"Jimmy," said Cobb, "I have an old aunt in Paducah, and she has a *goitre* that weighs more than that!"

When May reached New York after her Paris studies, she set out in earnest to become an illustrator. She took some of her drawings to the editor of a magazine.

The awesome editor, when she finally gained admittance to his holy sanctum, glanced at her drawings with a sour eye. Vital, expressive, amusing, they were not the sort of thing that he was used to. How could he know, benighted man, that he was looking at the work of one of the rising stars of the all-too-brief Golden Age of American illustration?

"Why did you bring this stuff here?" he asked.

May was as honest as she was determined.

"I will tell you," she said. "I looked at all the magazines, and yours is the worst. I thought if I had a chance anywhere, it would be here."

The editor laughed so heartily that he had to take off his spectacles. He bought her first sketch.

May began to find work, and she left no stone unturned to get the correct background and details into her drawings. On one occasion she was given a story to illustrate that involved an employment agency, and so she went to one and said she wished to engage a cook. But she was obliged to sit with the prospective employers and so got little view of the domestics themselves. She left disappointed.

May's determination, however, did not fail her. The next day she returned as a cook seeking a situation.

A Park Avenue friend obligingly wrote a splendid reference for her, praising her meats and pastries as well as her character, and regretting that a trip to Europe would rob her of the services of Elizabeth Pope. (May had assumed the name of a cousin, knowing she would be sure to forget any made-up one.)

She dressed the part in a black-and-white checked skirt with a tailored coat to match, which did not fit at all well, as it was borrowed. On her head perched a small, ugly black hat at the most unbecoming angle. It was thus that cooks dressed at this period.

Clasping her reference firmly in her cotton-gloved hands, she timidly entered the employment agency. The office head gleamed joyfully at this highly recommended prize and told her to wait in the servants' room.

This was, of course, just what May had hoped for, and the visit was a complete success. An old Irish cook with her feet on the stove was instructing several young Swedes in what *not* to do.

"Don't take your trunk with you, but just your bag till you look the land over," she advised. "My last lady got just enough cream for herself and her husband, but I put a little water to it and made enough for three," and so on.

When May had absorbed enough atmosphere and details she decided it was time to flee. She was running the risk of being hired out as a cook, and it was unsafe to linger longer.

"Where are you going, Elizabeth?" said the Patron sternly as she attempted to slip out without causing comment. "You can't get lunch now," the woman went on. "Childs is full."

"I thought I'd just get a cup of tea at a drugstore," answered the alleged Elizabeth Pope with presence of mind. She fingered her reference nervously.

"Very well, but see that you come right back," the woman consented, after a pause. May scuttled out.

On her way home, still clutching her reference in her cotton-gloved fingers, May passed her old master, William M. Chase, in the street. There must have been something familiar in the style of Elizabeth Pope's garments, for Mr. Chase, for the first time since she had studied with him, recognized his former pupil and bowed politely.

After she had married Jimmy and was running her own household, May tackled the employment problem from another angle with equal

William M. Chase recognizing May Wilson Preston disguised as a cook. Drawing
by Wallace Morgan.

originality. When the G.'s lived at 23 Fifth Avenue, May and James were
only a few doors away, at 22 West Ninth Street. The Prestons' work was
more and more in demand, and as they needed extra space they rented
the top floor of the house, with two studios, one in front and one in the
rear. One studio was ample for both Prestons, so they decided to find an
artist to take the other off their hands. The artist was found and rented
the studio, on condition that the Prestons would provide someone to
sweep up the place daily, for which service eight dollars a month was
offered.

Willie, the janitor's son, a gangling youth of fifteen, was looking for a
half-time job. His gainful employment up to the present had consisted
solely in pulling up the dumbwaiter from the Prestons' basement kitchen
whenever they gave a dinner party, at twenty-five cents per dinner. Even
at this he had not scored a signal success, having once yanked the rope

without noticing that the ladle was protruding from the tureen of tomato bisque.

"You were the only one, Willie, who got any soup tonight!" said May, comfortingly, after the doctor had treated his burns.

A "green" maid in those times was paid eighteen dollars a month, and Willie was certainly green. Half-time wages would amount to nine dollars—eight dollars of which must be used to clean the top studio. This left a dollar extra for May to play with. She had an inspiration. Why not train Willie to be a butler?

A butler for a dollar a month!

Undaunted by the soup incident, which might have given pause to a less courageous soul, May began her instructions forthwith. Willie served May and James their evening meal that very night.

A dinner party, at least then, began with soup. So, though James did not like soup and May's diet forbade it, Willie was instructed to place an empty soup plate before each of them, just for the training. This he did, but walked in carrying the plates at his sides.

To prevent this, the next night hot water was served in the plates. After a proper interval, a dignified nod from the hostess indicated that the soup plates were to be removed. And so on down to nuts!

Willie, however, tramped around in a hearty, military style. "Oh Willie, go lightly!" his instructress suggested, and after that the obedient boy followed to the letter. When his apprenticeship seemed complete the G.'s were invited to step down the street to dinner, as a sort of trial run or dress rehearsal. By now Willie's airy tread, as he tiptoed around the table, suggested the stealthy progress of a second-story man, and the guests felt nervous. But this was only a detail. May had accomplished another of her miracles.

————————————————

———————————

CHAPTER NINETEEN

In 1910 or 1911 W. G. one day received a letter from an old Philadelphia schoolmate, Albert C. Barnes. W. G. and Albert Barnes were classmates in the Central High School, but had not seen each other for many years. Dr. Barnes was now the tremendously successful inventor and manufacturer of Argyrol. He had apparently always been interested in art, and with new leisure and ample funds, he wanted to know more. So he thought of his old schoolmate, whom he had always liked, and who he knew was an artist.

W. G., whose one interest was in the actual employment of paint, and who tended to become absent-minded when other things intervened, put the letter in the pocket of his smock with the best intentions, but soon forgot about it as he continued to paint. Another letter followed, perhaps two, culminating in a telegram which went something like this: "For God's sake, Butts, why don't you answer?" Then W. G. did, and the old friendship was renewed.

And so began many arrivals of the Barneses at the G.'s apartment, and frequent week ends when the G.'s were absent visiting the Barneses at their place at Overbrook, near Philadelphia.

Dr. Barnes was musical too, and it was his pleasure on these occasions to have a musician come to play. Then he could settle comfortably on the sofa in his slippers, and listen to Leopold Stokowski, Guiomar Novaës or Mischa Elman. The house was full of clocks of all sizes, and as Dr. Barnes was a perfectionist they all had to start to strike at the same moment. But before the recital began it was Mrs. Barnes' duty to run all over the house and stop all the clocks. Frequently the audiences for these high-priced recitals consisted of Dr. and Mrs. Barnes and the two Glackenses, one of whom was not in the least musical.

Sometimes high-strung and high-priced musicians presented diffi-

155

culties. Miss Novaës arrived at the door and announced in sepulchral tones, "I am angry." After a startled moment it was realized she meant *hungry*, and wanted to be fed. It was just her Brazilian accent.

Stokowski was often at the Barneses', and time was spent looking at pictures, with which the walls were hung and the closets crowded. A canvas by William, a portrait of the model Zenka Stein, known as "Old Stein," who posed for all the artists of her day—for she was peculiarly paintable—fascinated him. Again and again he returned to it, shaking his head and saying, "The Gräfin!" And so the painting is known today as "The Gräfin S.," though Stein was from Bohemia, and certainly no gräfin.

It was through W. G. that Dr. Barnes met other artists, notably Ernest Lawson and the Prendergast brothers, whose work he bought.

Dr. Barnes' original collection of paintings was what one might expect. They were good, but they were not as good as they might have been, consisting of the then accepted painters: Corot, and others of the Barbizon School, etc. W. G. told Barnes that greater painters were more worthy of his attention.

The upshot of this was that W. undertook to go to Paris and buy some pictures for his friend. Dr. Barnes was determined to find out what was considered good, and he gave W. twenty thousand dollars to spend.

W.'s old friend Alfry Maurer happened to be a traveling companion.

> A Bord du Rocheambeau
> Feb. 12th, 1912

DEAREST TEED,

We expect to land at Havre some time this afternoon. The trip over was fairly good in regard to weather, although it snowed the first Sunday out all day and blew very hard later in the evening and kicked up a big enough sea to make it rough all the way over. However we had but little fog.

Mrs. Sokoloff has kept to her cabin practically the whole voyage. In fact I did not see her from Saturday to Saturday, although I saw quite a lot of Nicoli [*sic*].[1] Nicoli is all right and I like him very much.

We have the usual assortment of queer looking passengers, probably a little more queer than usual. There is an old Swiss, seventy-five years old, a filthy old hog, who is escaping from a breach of promise judgment of $12,000.

[1] Nikolai Sokoloff, the conductor.

It appears that he brought a young Swiss woman over to America in the promise of marriage. He failed to marry her. She sued, got judgment, and is now being deported on the grounds of having been brought into the U. S. for immoral purposes. We get all our information from a detective, one of the passengers, who is on his way over to France to bring back a bank defaulter who is being held there. This detective from St. Louis is the most simple-minded of creatures and tells everybody his business, speaks of the ship as *staunch* etc. However he proved that he is a real sleuth for it is he who discovered that a Mrs. Ferguson, another passenger, was not confined to her cabin through seasickness but was suffering from piles. He didn't say where he got his clue.

There is another character on board named Algie who reminds me very much of James B. Moore. He is an old Scotchman, a manufacturer from Toronto with a remarkable gift for talking.

This boat has many good points and one great failing, it rolls like a porpoise. I wouldn't recommend it to anyone who suffers from seasickness. Otherwise it is splendid. It hasn't the slightest odor, and the food is excellent.

[continued] Tuesday Feb. 13th

Arrived in Paris last night 11 o'clock. It does seem like Tilly's Nightmare to be here. The weather is delightful. The sun shining and as warm as a spring morning. What a pity you couldn't have arranged to come. I have just finished my cafe au lait. I am stopping at the Hotel Helder although my address will be Morgan, Harjes, 31 Boulevard Haussmann. We came up from Havre with the Sokoloffs. We had an appartement to ourselves. They are stopping over in the Latin Quarter.

I am to meet Alfy at one o'clock and he is going to introduce me to a Mr. Stein,[2] a man who collects Renoirs, Matisse, etc. In the meantime I will see Mrs. Brooks and give her your letter.

The Hotel I am stopping at is a typical French place. I fancy I am the only foreigner in it. It is right off the Boulevard not far from the Opera and will be very handy to the art dealers and banker. Now I must go over to the bank and introduce myself. I think I shall try the Maison Blanc for handkerchiefs.

W. G. to Richard E. Dwight:

Feb. 13th

My dear Dick

Many thanks for the Coronas. I can assure you they went very far toward easing up the strain of a tiresome voyage. There was no such thing as a Mon-

2 Leo Stein.

terey on that boat, and Maurer and myself lorded over the rest of the emi-
grants in the smoking room.

Paris looks very fine to me. Sunshine, spring weather, and the Boulevards
crowded.

Of course you wish you were here. And I don't blame you. I just arrived
late last night and haven't had time to get around and see anything as yet. Yes
I did see two things as I was whisked by in a cab on the way to my hotel.
They had blue legs up to the knees and gold lace turbans with tassels. I saw
no more.

Hotel Lutetia, Paris, Feb. 16th, 1912

DEAREST TEED

You will see by the heading of this note paper that I have changed my
domicile. This is a new hotel and has everything up to date. I got tired of that
stuffy old French place off the boulevards and moved over here to be near
my friends. The subway is right in front of the hotel and I can get across to
the Madeleine in about 8 minutes. Had dinner with the Brooks [Richard
Brooks] last night, Alfy and myself, and a very good dinner it was. They have
a very nice place in a three hundred year old house. I couldn't see very much
at night but I noticed that the windows were covered with ivy vines and that
they looked out on a garden. . . .

I have been all through the dealers places and have discovered that Mr.
Barnes [sic] will not get as much for his money as he expects. You can't touch
a Cezanne under $3000 and that for a little landscape. His portraits and im-
portant pictures range from $7000 to $30,000.

I got a fine little Renoir at Durand Ruel, a little girl reading a book, just
the head and arms, in his best period. I paid seven thousand francs for it
($1,400). They asked eight but came down. I consider it a bargain. This is all
I bought so far. Am still looking around.

I haven't started shopping yet as I have been too tired. Hunting up pictures
is not child's play. Poor Alfy [Maurer] is about worn out. I am taking a
vacation today.

The weather over here continues fine, just like early Spring.

My room is quite distinguished looking, is green and yellow, brass bed,
steam heat and all the comforts of home. I see in one corner of the room one
of those things that May put in her picture for a foot bath.

I hope Ira is behaving himself. I have been looking around for some toy
or present for him. I haven't been near any of the gardens as yet and so
haven't seen many little French boys.

You forgot to tell me your and Irene's sizes in gloves.

I don't see how I came to forget to tell you to send letters c/o Morgan Harjes. However I got your welcome letter from Alfy. I see him every day. It seems as if I have been here for weeks and it has only been four days. I think that I shall be very glad to start back when I have finished over here. Will write soon again.

Your WM

After the paintings were all selected and the twenty thousand dollars spent, W. discovered a fine Degas. He cabled Barnes this fact, and Dr. Barnes cabled back the money to buy it.

Though the work of hunting up pictures was exhausting, W. had some good times with friends.

Hotel Lutetia, Feb. 21st, 1912

DEAREST TEED,

Yesterday was Mardi Gras and I had the Brooks family and Alfy over to Marguery and gave them a good dinner. The boulevards were knee deep with confetti and jammed with crowds of people. The good citizens of Paris were enjoying themselves, young men and girls rushing around dressed in all sorts of costumes. After dinner we went to the Bal Bulier to the masked ball. Bare legs to the hips seemed to be a favorite costume among the girls, one of them also was bare footed. Perfectly filthy, but from the dirt of the floor. Chemises with apparently nothing else except shoes and stockings was another excellent disguise that two of them wore. . . . In fact there was an infinite variety of costumes and everybody was appearing to have a good time. . . . Alfy and May Brooks took the floor several times while Dick and I looked on from the balcony.

Finally his work was over and he wrote on March 1:

I sail tomorrow. You will get this letter probably a day before I land as I am sending it by way of England. Everything is settled up here and the pictures being boxed. I am mighty glad it is finished and I am sick of looking at pictures and asking prices. I have been very well but I don't think I care for Paris in the winter. It is too damp.

I will be glad to see you on the dock in your new black coat or without. . . . I must get Ira a toy today. I suppose I will have a devil of a time with the customs people over the pictures. I am loaded down with invoices and consular certificates.

When at last the paintings reached Dr. Barnes and were uncrated, he sat and looked at them for many hours at a stretch. The scientific mind

that had invented Argyrol was now bent on the scientific analysis of great paintings. Why were these paintings good? Cézanne, Renoir, Manet, Degas, Gauguin, Van Gogh (his "Postman"), Matisse—these confronted a collector used to "fuzzy Corots" and other such respectable artists.

The paintings had come framed in beautiful antique French frames, in themselves of great value, but Dr. Barnes ordered these frames removed and bright new ones substituted. He continued to gaze and study, and finally he gave orders to have the new frames taken off and the old ones put back.

Dr. Barnes, whose training was scientific, had a passionate interest in aesthetics. It became his idea that there must be some scientific analysis— a sort of laboratory test—to which a painting could be subjected, and which would prove irrefutably whether it were true gold or base metal. You put a work (let us say) by John W. Beeswax or Augustus Smearcase through the tests. No soap! You put a work by a great artist through the same tests. A triumphant affirmative! Nobody had ever conceived of doing this before.

So with the admirable determination to keep on studying, and analyzing, and trying again, which in the field of chemistry had resulted in the discovery of Argyrol, Dr. Barnes continued to look at and to study the paintings his old schoolmate had selected for him. From these beginnings Dr. Barnes, as the whole world knows, went far. His knowledge grew and mushroomed until he had amassed perhaps the world's greatest collection of modern art. He sought no one's advice again; in fact he rapidly became the czar of modern art. His name became the terror of all who sought to see his great collection. He not only laid down the law about aesthetics, but as the years went by he breathed fire and brimstone, it appeared, on all who disagreed with him. Few were permitted to see the great possessions of which some felt Dr. Barnes should have considered himself solely in the light of guardian, preserving his treasures for the benefit of the whole human race: a point of view that he did not share.

What manner of man was he, and what was the cause of his extreme attitude?

CHAPTER TWENTY

During his career as a collector of art, Albert C. Barnes became celebrated for many things, and since his death in a motor accident in 1951 his figure has continued to grow into a colossal legend. The highly colored stories and anecdotes about him have overshadowed his achievements both in chemistry and aesthetics. This is perhaps not surprising, for his character lent itself to legend, but it is unfortunate. Albert Barnes was a genius, and the true story of his life will probably never be told.

He had begun life as a poor boy in South Philadelphia with many handicaps, one of them surely being a morbid sensitiveness. Had he been a little more affluent then, he might have been a less explosive person later on.

When he was rich and famous he received a letter from an old schoolmate beginning, "My dear Barnes." It so happened that Albert Barnes had suspected, probably correctly, that the writer of this letter had not wished to be seen with him during their school days, because his pants were frayed.

With a large blue crayon Dr. Barnes wrote what he thought of the writer across the letter, in a few well chosen words, and returned it. The memory of his frayed pants never left him, and he spoke of the incident thirty years after it happened.

Riches, success and fame, a great position, all achieved by his own efforts, had been powerless to reduce the old slight to its true nothingness. This is the tragedy of Albert C. Barnes, and the key to his lifelong prejudice against those with inherited wealth.

But he had made considerable effort to renew his friendship with W. G., who, among his many virtues, was a poor boy who had earned his own living.

Albert Barnes has left the only first-hand account of W. G.'s days at the Central High School, Philadelphia:

He graduated by reason of luck rather than scholarship. He had no interest in the prescribed studies and in the class he paid little or no attention to what was taught. While the teacher talked Mr. Glackens made a drawing of him and it was of what the teacher was in reality, never what the teacher would have us believe that he was. Very often the drawing would be passed from one pupil to another with results disastrous to book-learning but very illuminating of life as it exists. The general complaint of his teachers was that Mr. Glackens would not study and that his drawings made it impossible for the rest of the class to study. Nothing could have saved him from expulsion except his obviously great intellectual endowment, a personality universally loved and respected and a sense of humor so contagious that it disarmed the justifiable wrath of his teachers when the question arose as to whether he should be banished from the school.

When W. G. was obliged to undergo an appendectomy, in 1914, Dr. Barnes donned a surgeon's white coat and attended the operation to *count the sponges*, which used sometimes to be nonchalantly sewed up in the victim's interior. Letters from W. G. written from the Jefferson Hospital, Philadelphia, report Barnes' continued interest:

Oct. 23, 1914

DEAR TEED:

Have felt much [more] chipper today although the regular evening head ache has set in. I am keeping it in abeyance with a tiara of cracked ice in the form of an ice cap, and a migraine pill. Mrs. Barnes was in this afternoon and Barnes in the morning. Father turned up about four with a clean night shirt. Ada he tells me is out doing some sort of suffrage work. . . .

They are going to give me a sleeping potion tonight. I didn't get any sleep last night. I have sort of forgotten the knack of going to sleep.

Ella [Fiske] writes a very meaty letter doesn't she? I enjoyed the fireless cooker story. I shall be glad to see you Monday.

WM.

Oct. 25, 1914

DEAREST TEED:

I continue to improve. I slept very well night before last and last night. The headaches have gone. . . .

James B. Moore came in last night after supper and stayed quite a while talking and smoking. In fact we were both smoking. Barnes brought in some homemade soup this morning and I had some for dinner and [the] rest will

keep until supper. It was quite a different thing from the hospital variety. I suppose you will arrive on the noon train. Mrs. Barnes said your room will be ready for you any time you get out there and that probably you would telephone her from here. . . .

I am expecting any minute to hear the patter of the whole Glackens family coming down the hall. I must get this note off earlier today on account of the Sunday mails. . . .

<div style="text-align:right">Jefferson Hospital, Oct. 30th, 1914</div>

DEAREST TEED,

Doctor Stuart has just been in and tells me he will put me on my feet to-morrow. Today I am in a large invalid's chair. . . .

Jim Moore turned up today and presented me with a basket containing three enormous apples, each one of the size of a melon.

Tell Ira I am very sorry I am not home to make him a *pumpkin moonshine* for tomorrow night. I suppose next year he will be almost big enough to make one for himself. . . .

And on Monday W. wrote:

Dr. Stuart tells me I can go Thursday. I shall go out to Barnes and shall probably stay five days or so. I think Barnes counts on my staying that long at least . . .

Whenever E. heard Dr. Barnes criticized in later years, she always remembered the sponge count, and defended him; her gratitude was undying. But if W. G. never had an unpleasantness with Dr. Barnes, the same cannot be said of E. G. The tiff between them was eventually made up, perhaps a unique record, but E. G. was undoubtedly the only human being who ever told Dr. Barnes to "shut up."

It happened when the Barneses and the G.'s were out for a drive in the environs of Overbrook. Mrs. Barnes had only lately learned to drive, and was at the wheel. E. G. was beside her, and the two men in the back seat. As they were rolling along, a dog leaped into the road, and Mrs. Barnes swerved to avoid it. The occupants in the car were slightly jolted, but in no way hurt, and the drive proceeded. But Dr. Barnes was upset, and that made him angry. He began by observing that they might all have been killed, and continued in the same vein.

E. G.'s sense of female solidarity, never dormant, was finally roused to action. She observed her friend Laura growing more and more nervous

at the wheel, and at last she turned full around and pronounced in a commanding tone the rude but forceful phrase mentioned above.

An icy silence descended, and everyone was more nervous and uncomfortable than ever. The evening meal was unenjoyable, and on retiring for the night, W. G. observed, "I guess we won't be invited here again in a hurry"—a prognostication that proved well founded.

But Dr. Barnes had no quarrel with W. G. then or ever, and used to drop in to see him at his studio when he came to New York. He merely wished to avoid E. G. In fact, Uncle Albert, as my sister and I called him, had put up with a lot from her before this.

E. G. was an emancipated woman; she did not hold the male sex in any awe whatever, and like her mother before her would brook no belittling of her own.

Uncle Albert, lolling comfortably on the sofa, said, "Laura, my pipe!" and Laura's feet could be heard in the silence pattering up the stairs. The silence on this occasion was particularly deep with E. G. in the room. She believed in object lessons. From her chair she tossed her handkerchief ostentatiously into the middle of the drawing room rug and said in the same peremptory tone:

"William, my handkerchief!"

The reconciliation between E. and her affronted host occurred after Dr. Barnes called on W. in his studio in Washington Square one morning. W. asked him home to lunch. "Edith is in Hartford," he explained. Dr. Barnes went, and the ice was halfway broken. He came again to the house, and the two met unexpectedly when the great discoverer of Argyrol was coming down the stairs holding a slab of apple pie in his open palm. The past was tacitly forgotten in this informal moment, and never alluded to.

Mrs. Barnes had been a Miss Leggett of Brooklyn, and her father was in the wholesale grocery business. In their courting days, Albert Barnes had worked out his formulas and made his experiments on the Leggett kitchen stove late at night, because he had no laboratory of his own, and Laura stayed up and made coffee for him. He tutored students for good fees, and when he had saved up enough, he worked his way across the ocean on a cattle boat to study medicine in Germany. When his money was gone he returned home to raise more by the same method. He was also said to have been for a short time a singing waiter in a beer garden, but this seems hardly conceivable.*

* See Appendix 3.

Mrs. Barnes was and is a woman of strong humanitarian and charitable impulses, as well as a learned horticulturist. The gardens of rare plants and the fine arboretum at the Barnes Foundation are under her direction, and she lectures on advanced horticulture there.

Her tender heart was shown once when E. found her scribbling Christmas cards in the middle of July. They were addressed to a leper colony off the coast of Africa and had to be got into the mails early.

"The lepers think they are forgotten," she explained.

"*And they are dead right,*" the factual E. G. replied.

Mrs. Barnes had a model poultry house with fine runs and everything else including automatic waterers in which fresh water was constantly supplied. E. exclaimed over these expensive arrangements.

"How would *you* like to have filthy drinking water all the time?" Mrs. Barnes asked.

"Laura," Edith replied firmly, "I refuse to be compared to a hen. *I* would not commit a nuisance in my drinking water, and then take a drink."

But in spite of all the avian luxury, when a protracted rainy spell arrived three of the hens caught cold.

Dr. Barnes, as the years went by, acquired various enthusiasms, and one was the work of the artist Soutine, whose fame began when Barnes bought a whole raft of his paintings—report says a hundred. E. could see nothing in the works of Soutine. And she did not hesitate to say so, though the Barnes house and the Foundation were heavy with them. She there told Professor John Dewey that in her opinion it was poor Soutine's

". . . three of the hens caught cold." Sketch by E. G.

constant state of semistarvation that had caused him to paint people's hands like bunches of bananas or a half-dozen rolls. This amused Professor Dewey. W. sat quietly smoking his pipe. Nobody heard him express any opinion on Soutine, and he felt no compulsion to do so.

Dr. Barnes, before he set up his Foundation, was busy acquiring paintings. He wanted to buy a certain canvas by Maurice Prendergast, but Maurice did not want to part with it. Barnes then offered a larger sum, without avail: it was not the price that was unsatisfactory, but the fact that Maurice wanted either to work further on his picture or to keep it to study and contemplate.

"Do you like Dr. Barnes?" Maurice innocently asked E. She replied in the affirmative. He assumed a quizzical expression, and then after a moment's cogitation said in his hollow, deaf shout, "He doesn't understand an artist!"

There came a day when E., with her customary candor, repeated this to Dr. Barnes, and some time later, having occasion to write her on some other topic, Barnes' letter began good humoredly, "Dear Edith, I may not understand an artist, but . . ."

The idea of a museum had long been in Dr. Barnes' mind, and he finally acquired a fine tract of land at Merion. The property was owned by an old sea captain who had for many years brought rare and exotic trees home from his voyages. The old man consented to sell, for his beloved trees would thus be assured of care and preservation, one of the functions of the Foundation being the teaching of advanced horticulture, Mrs. Barnes' métier.

Dr. Barnes, long before this, had had other notions about a museum, and had told the G.'s that he intended to establish one that was to be open to all the world, the only rule being a rigid one that no guided tours, lectures, or critical explanations whatever were to be allowed: the public could come and look for itself. It seemed an Elysian project.

But how different was the fulfillment of the dream! The exact opposite finally occurred. Dr. Barnes had long been working on his theories of art, and in 1925 he published a remarkable book, *The Art in Painting*; and by the time the plans for his Foundation had jelled, it turned out that they were educational after all, based on the theories in this book.

Had Dr. Barnes opened his Foundation as a public museum, which is what was officially announced in *The Arts* for January, 1923, time might

have hung heavy on his hands. He had unbounded energy and was obliged to keep going like a steam engine.

12 March 1928

DEAR BUTTS:

It looks as if I won't see you on Thursday. We hold a class that afternoon at the Johnson collection and I am due to talk on primitives. In the evening I speak in a negro church and on Friday morning, there's a class in our gallery.

But I can see you Thursday the 22nd—I have to be in New York to speak over the radio in the evening. . . . A duo stag at Spaghetti House on Mulberry St. Tomorrow is your birthday.

Je vous bien serre la main.

Perhaps no one ever drew greater pleasure from a fortune, and that earned entirely by his own efforts, than Albert Barnes. He was able to indulge all his interests and enthusiasms, teach his own theories, and become an international figure, indeed somewhat of a dictator, in his chosen field. In France he was even more famous than in America, and if he bought an artist's work, that artist was made. With his personality, all this was necessary to his content. W. G. was at the opposite end of the pole in every respect, which may account for the unblemished friendship of the two.

Dr. Barnes to W. G. after a trip to Europe:

Philadelphia, 22 Jan. 1923

DEAR BUTTS:–

About the frames:— I told both the frame-maker and Guillaume[1] that I would guarantee the payment of your bill, so I presume that the bill will be sent to you direct, after the frames are sent to your address. Measure them as soon as they arrive, and if the dimensions are not correct don't pay the bill. When you receive the importation papers, consisting of way bill and consular invoice, give them to any custom house broker and he will attend to the formalities. Even with the duty—which is, I think, about 40%, I believe your frames will be much, much cheaper and certainly much better than any made in America.

After I wrote you I nearly dropped dead in seeing a choice Greco and an extraordinary Claude Lorraine belonging to a private collection where they had been for many years and were so dirty that nobody at a casual glance would recognize their values. I bought both of them on the spot and they will

[1] The late Paul Guillaume, Paris art dealer.

be here in a month. The Greco is a composition with four full-sized figures in the foreground & a dozen or more heads of a crowd surrounding Christ. All of Greco's bright colors and characteristic painting are there. Never has such a Greco been on the market in my time and I consider finding it a just act of God's kindness for the saintly life I've led. The Claude Lorraine is equal to any of his in the Louvre, is colorful, dramatic & as painting is equal to anything done in this world.

Another piece of luck was finding an old Greek, so old he is tottering, who has the best collection of antique Greek & Egyptian sculptures—figures, bas-reliefs, marbles, stones, bronzes. I shook a good-sized check at him and now own about 40 of as fine specimens as exist anywhere in the world in their particular fields. I got also two Holland & 1 Italian primitives of XV Century.

On the whole, the trip was the most successful I ever had. I'm terribly excited about ancient Greek and Egyptian art which I started to study last year & now feel able to tell what's what in that line.

I'll eat your spaghetti and drink your wine sometime in the next few weeks. When the new things arrive I'll tell you to come over. Remember me to Edith.

<div style="text-align: right">Yrs., B.</div>

Naturally so great a collection of paintings attracted many people, who employed all sorts of ruses to gain admission to the gallery. But the difficulties were insurmountable, the excuse given being that visitors would disturb the classes.

"I shall be in Philadelphia on such a date and would like to run out and see your pictures" is a good example of the sort of letter it was suicide to write. A willingness (and ability) to come on any day and hour set by Dr. Barnes, even if it were five o'clock in the morning, was more apt to attain success.

Yet when the headmistress of a girls' school wrote Dr. Barnes that she was bringing her pupils to the gallery on a certain date and hour, and please to have it open and ready, he meekly did so. He maintained his reputation for complete unpredictableness. Privileged friends were treated well, but however one was treated it would not be formally. When Lenna Glackens wrote to ask Uncle Albert if she might come on a certain day and bring a friend, the answer was scribbled on the back of an envelope in pencil, to her delight: "O. K. Toots for Thursday."

The late Adolph Borie, the Philadelphia portrait painter, was able to get himself invited to a lecture at the Foundation. As he sat on a folding

chair listening to the lecturer hold forth on plastic values, he finally could bear no longer the thought of all the great treasures that hung unseen in the rooms all about. Clutching his hat in his teeth, he slipped onto all fours and crawled out unobserved between the rows of chairs, and was rewarded with an hour alone among the masterpieces in the deserted galleries.

All this time Dr. Barnes continued to operate his laboratory for the manufacture of Argyrol, but in 1929 he sold the business. The reputed sum paid was enormous, but Dr. Barnes spent the summer in Europe during the negotiations. The Glackenses were then in Paris.

"I can buy pictures and I don't have to work," he told E., after the deal was concluded and the money was in the bank, adding in a light vein which few ever gave him credit for possessing, "Expect to get drunk every night!"—a thing he never did in his life.

A unique fact about the Barnes Foundation is that the works of art are not displayed there according to artists, "schools," or even periods, but according to their eternal plastic values, so that a Giorgione may hang next to a Cézanne, with perhaps a Grecian vase near it, or a canvas by Maurice Prendergast, all demonstrating their aesthetic kinship, a main thesis of Dr. Barnes' teaching. The Foundation thus is a living thing instead of a tomb, and its great possessions speak with overwhelming power.

CHAPTER TWENTY-ONE

In 1911 the G.'s went for the summer to Bellport, Long Island, on Great South Bay, and rented a cottage.

Bellport was still an unspoiled town, and life was largely confined to the village street. There were no large estates in the neighborhood. Near the beach stood a huge barnlike "Vacation Home" for New York shopgirls, which supplied subjects for many canvases. A ferry every fine day took bathers across the bay to the ocean beach, Old Inlet, whose rolling, white dunes and scraggly bayberries and beach plums saw many picnics.

Almost everyone in art, literature or music appeared at Bellport sooner or later. The Prestons were there; they had remodeled an old stable into a fine studio. Also among the neighbors were Mr. and Mrs. Raymond Brown. Votes for women was a live topic, and Gertrude Brown was a famous leader in the suffrage movement.

The G.'s had frequent guests, among them Mrs. Lillian E. Travis of New York, an old schoolmate of E.'s from the Art Students League. She had obliged W. by posing for his canvas "The Shoppers," in which the back of her head—she had beautiful dark golden hair—may be seen at the left.

One of W.'s interests was mushrooms, and he possessed a number of books on mycology. It happened in Bellport, while Lillian Travis was there, that an indescribably horrible, potent and nauseating smell began to invade the house, which made living there almost impossible. A hundred dead rats in the wainscoting could not have competed with this frightful stench. W., the mycologist, proclaimed that this stench was produced by a stinkhorn, a variety of mushroom, and its location had to be discovered. Few would believe that a single mushroom could produce this effect, and those not mycologists had been known to tear their houses apart in a futile effort to find the dead rats or faulty drains.

After diligent search the stinkhorn was discovered by Lillian, growing under the porch, and could fortunately be uprooted by a long shovel. Lillian was so fascinated by this incredible mushroom that, at her urgings, Edith overcame her nausea and carried it all the way down the street to show triumphantly to the Browns, who had doubted the existence of such a fungus, thus impugning W.'s knowledge of the subject. But the Browns were at lunch and their scientific interest was practically nil.

It was to Bellport that Maurice Prendergast came on a visit, and Dr. and Mrs. Barnes. Mrs. Barnes' mother had a summer cottage at Blue Point; the Barneses and the Glackenses drove over, and W. found new subjects there to sketch and paint.

Life was freer, because a nurse had been acquired for I. G. Laurentine Spect ("Peppy") came first to sew, and stayed on for sterner duties. She remained a member of the Glackens household for thirty-eight years. In due course she graduated from taking care of a small, unruly boy to taking care of Lenna, who was born December 6, 1913.

E. informed her mother of the coming event in a manner not usually employed for such news; she drew a caricature of herself to illustrate a letter. "Note the stylish dip to skirt and middy blouse," she pointed out. "This is how I keep the secret dark."

Caricature of E.G. by herself

Lenna was a small baby and grew slowly. She did not walk until she was two, but she began to talk at an unusually early age, and by the time she could walk was carrying on lengthy conversations with a large vocabu-

This is what happened to a bad little boy named Oscar.
for Lenna from Daddy.

lary. Her interests and sympathies early turned to animals. At six she was dictating stories in long, measured sentences to her mother and Peppy, who had a scramble keeping up with her without shorthand. "Her style," it was said of her then, "would make Dr. Johnson's skip."

She drew all the time. Through no fault of theirs, the Dimocks had another artist in the family. When he looked down at his strange little granddaughter, not yet three, sitting up in her crib busily drawing horses with her left hand, Ira Dimock, who was nearly ninety, chuckled and said, "A regular little Rosa Bonheur!"

Lenna's drawings of people were ludicrous, but her animals were drawn with keen observation, and she visualized herself as an animal. Lenna-the-Horse was pictured as a horse with Lenna's gold curls. Lenna-the-Rabbit was similarly identified. This love of animals came from both sides of the family, but the Glackenses were primarily cat people. In Philadelphia, Grandmother left the cellar window open for the convenience of the neighborhood cats. Many eventually became Glackens cats, and of an afternoon the conversation might be sprinkled with references to the "Germantown Avenue cat" or the "Tioga Avenue cat" that had, or had not, put in an appearance lately.

There never appeared to be any cats around the house. They lived independent lives in the cellar, where they were fed, and could come and go as they liked. This independence now seems to me charactristic of the Glackens live-and-let-live philosophy, as was the calmness required to meet the emergencies incident to this peaceful coexistence. Once when Edith went to Philadelphia to visit her parents-in-law there was a great commotion, the cellar door burst open, and a large black cat flew through the house and dashed through a closed window, shattering the glass.

"Why, Blackie!" said my grandmother mildly. "Sam, you had better run right round and get the glazier."

W. had an inherited way with cats. They always came to him, and without apparently paying any attention to them he would reach down and scratch them with one finger in just the right place. He explained that this place was at the base of the neck.

There was another pet in that serene and equable Philadelphia household—a box tortoise father had found in the woods when he was a boy. It had initials on its shell even then. In summer it lived in the back garden, and in winter it hibernated behind a door on the unheated third floor of the house. Every January it emerged for a meal of bread and milk, and then retired again behind the door till spring. If, in summer, it managed to dig under the fence and start down the street, the neighbors cried, "There goes the Glackenses' turtle!" and brought it back.

"We've given up telling how long we've had it," grandmother explained, "on account of Ada."

When the household was broken up, Lou gave the tortoise to the

March Day—Washington Square, 1912

COLLECTION ENCYCLOPEDIA BRITANNICA

Beatrice Standing 1918

Woman on Sofa 1910

Pony Ballet, 1912

The Artist's Wife and Son, 1911

AUTHOR'S COLLECTION

The Green Car, 1912

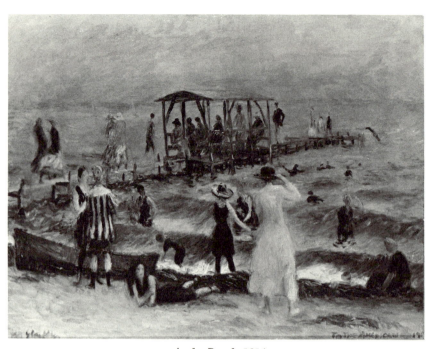

At the Beach, 1914

PENNSYLVANIA ACADEMY OF THE FINE ARTS, PHILADELPHIA

Bathing at Bellport (Edith and Ira in center), 1911

BROOKLYN MUSEUM

Café Lafayette, 1914

COLLECTION OF BARNEY A. EBSWORTH

Maurice B. Prendergast: *The Picnic*

NATIONAL GALLERY OF CANADA, OTTAWA

Charles Prendergast: *The Hill Town* (Incised panel with silver and gold leaf)

ADDISON GALLERY OF AMERICAN ART, PHILLIPS ACADEMY, ANDOVER

Ernest Lawson: *After Rain*

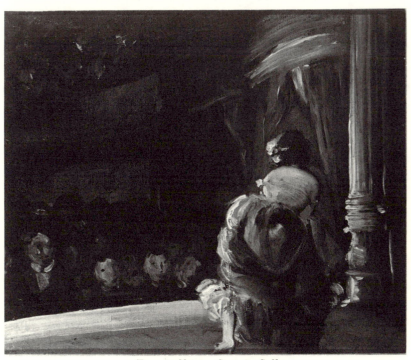

Everett Shinn: *Curtain Call*

Edith Dimock: *The Sunday Walk* (Watercolor)

Lenna Glackens: *William and Imp*

William and Lenna

Philadelphia zoo, as it was too tame to liberate in the woods. It had lived with the congenial Glackenses over fifty years, though Dr. Ditmars gives "ten or fifteen" as the box tortoise's usual record in captivity.

Now every evening after Lenna's supper W. G. stepped into the nursery and a continued story was spun out, usually about Lenna-the-

Horse, although Whiskie-the-Witch also had many extraordinary adventures. Both artists drew rapidly while the story unfolded.

"I suppose," a sweet old lady gushed, "her father gives her drawing lessons every day!"

But it was the other way around.

"Is *that* Lenna-the-Horse? Where's the eye? Give me the pencil."

Laurentine Spect, by Lenna called Peppy, had been born in Prince Street, New York, of Alsatian parents who fled to America after the Franco-Prussian war because they were unwilling to live under the German flag. When a little girl, she had been employed as a seamstress by a fashionable New York *couturière*, where the girls were kept working all night to finish a dress Mrs. Astor or some popular actress wished to wear to a ball. As a result of this, and of nursing her mother through a long, terminal illness, her health had broken down, and when she recovered she had gone out to sew by the day. It was thus that she had finally landed at the Glackenses'.

Peppy devoted herself entirely to Lenna from birth, sat up with her night after night when she was frequently ill, nursed her, guarded her, and by her ministrations and saintly devotion saved her life through her delicate childhood. When Lenna grew older and stronger, Peppy turned to helping run the house, marketing, cooking when cooks were unobtainable, and altering E.'s and Lenna's clothes. Peppy was blessed with a cheerful nature, and E. and she often did a little dance together in the kitchen before breakfast.

At the cocktail hour W. G. never failed to carry a Martini into the kitchen for Peppy, if she was busy getting dinner and unable to be with the rest of the family. She went to great lengths to make dishes that would please W. and yet would conform to the doctor's orders, whatever they might be.

Her long and faithful services made life smooth for the whole family, but Lenna was her special pride. When in 1943 news arrived of Lenna's death in Buenos Aires, where she had gone with her husband, the whole meaning of Peppy's life was lost. But she was obliged next day to visit her sister, who had been ill, and fearing the news would cause a relapse, she spent the day with her and never let fall a single clue that anything was wrong. She had the courageous and selfless nature found only among saints.

When E. and Peppy were left alone in later years, they made and *signed* a pact that whichever of them went first, the other would not shed a tear. On October 28, 1955, it fell to Peppy, at the age of 83, to live up to her bargain; and again she rose nobly to her duty. The writer can find no words in which to express what Laurentine Spect's forty years' devotion to his family meant, nor any way in which to pay her adequate tribute.

The summer of 1916 was the last spent in Bellport. It was the year of the great "infantile paralysis" epidemic. Much less was known about the terrible scourge then than now. People gave up the newspapers, because they came from the city and might carry "germs." The postmaster's daughter was down with the disease—sure proof. Letters were burned, and even checks held over a flame until they were scorched.

As the G.'s' cottage was in the middle of the village, it was decided to abandon it, and a large vacant house in secluded grounds, in the township of Brookhaven, was taken for the rest of the summer. Here the G.'s lived banished from the outside world.

Lenna was now two and a half. Small, determined on her own rights, imaginative and brilliant far beyond her years, she was growing stronger. No sign of the epidemic visited the family.

The house was a large wooden one with claims to pretention. A winding drive lined with maples led from the gate and the gatekeeper's lodge to the door. On the other side of the house, wide green lawns stretched and fell away to the marshes and a view of the bay beyond. Mary Roberts Rinehart had once lived there and used it as a setting for her thriller, *The Red Lamp*. She declared in her autobiography that strange psychic phenomena had been observed there and in fact the house had a local reputation of being haunted. But to the G.'s, less sensitive and psychic, no ghosts ever appeared.

It was here, however, that the difficulties and irritations of painting did manifest themselves to a marked degree one day, and overcame for one brief moment W. G.'s usually unruffled calm.

He was painting a family group in the garden below the house. A peach tree laden with fruit bent over beds of marigolds, beside which Lenna stood holding a few flowers in her hand. E. G. was seated on a garden chair knitting, and I. G. leaned over the back of her chair.

W. was having great trouble finishing the painting. It was a windy day, and the easel would not hold the canvas steady. Each time he put his brush to it, it wobbled. Finally in exasperation he seized the canvas to rip it from the easel's hold. But the easel would not give up its work of art. It was tenacious now. There developed a tug of war between the easel and the artist. It lasted but a moment, and the easel won. W. G. sat down hard on the ground.

I watched my parent in horror; I thought the end of the world had come.

He rose, of course more wrathful than before. With one great effort he wrenched the canvas free and flung it into the sky. The wind joyfully seized its rare prize—up, up it went like a kite. We all watched fascinated. And then the painting, which now looked very well, swooped on a new gust of wind toward the house behind us and came to rest, securely

lodged in the branches of a giant wisteria vine, just outside a third-story window.

E. hurried into the house and up the stairs, reached out the window and hauled the painting in, and hid it in a closet.

The next morning Lenna, who breakfasted in the nursery, came downstairs to find her parents still at their own breakfast in the dining room. Her eyes lighted on one of the dishes on the table.

"I want my breakfast over again!" she demanded in angry tones. "*I didn't have a lot of Parker House rolls!*" She was not yet three.

As a whimsical parlor trick, E. had taught her daughter to answer the question, "Why do I love you?" with the words, "Because I am like my little father in every respect." She had the sentence down pat. E. put the question then, and the angry child gave her answer mechanically, but in even more furious tones. W. looked up from the morning paper guiltily.

-⟫-⟫-⟫-⟫-⟫

CHAPTER TWENTY-TWO

The year of Lenna's birth, 1913, was also the year of the International Exhibition of Modern Art, little known under that formal name, but celebrated as the "Armory Show." It was held in the Sixty-ninth Regiment Armory, at Lexington Avenue and Twenty-fifth Street, the only available place large enough. This historic edifice is still standing.

The exhibition was given under the auspices of the Association of American Painters and Sculptors, an organization formed for the express purpose of holding a large exhibition of its members' own works and those of others who were frowned on by the Academy. They later decided to include some European artists, to give a fuller picture of the new trends. In the end, the Europeans quite ran away with the affair.

There were about twenty-five members of the Association, for though some withdrew in a rage or for other reasons, more joined.

The concept of holding this great exhibition originated with Elmer MacRae, Jerome Myers, Walt Kuhn and Henry Fitch Taylor, an artist who conducted Mrs. Davidge's Madison Art Gallery. Arthur B. Davies, when approached, emerged from his shell, accepted the presidency of the Association, and steered the wayward course of the whole venture to overwhelming victory.

Walt Kuhn went to Europe and scoured Germany and France for paintings, aided later by Davies and Walter Pach, and they decided to include works by artists as far back as Ingres and Delacroix, for the purpose of tracing the legitimate descent of the new work.

The association also included Robert Henri, Guy Pène du Bois, Ernest Lawson, George Luks, William Glackens, Maurice Prendergast, John Sloan and Mahonri Young.

The story of the Armory Show, without doubt the most sensational

180

art exhibit ever held in America, has been told by several of the men responsible, to whose accounts the reader is referred.[1]

W. Glackens was appointed chairman of a committee to pass on the the American art. So much arrived for admission that it was a Herculean labor, and as W. G. sought good in all artists' work, and was very conscientious, the labor was even greater than it might have been.

The art magazines as well as the newspapers ballyhooed the coming event. An entire edition of *Arts and Decoration* was devoted to the affair. In this there was an article by W. Glackens, "The National Art." It was ghosted by Guy Pène du Bois on the basis of an interview. The magazine also included articles by Arthur B. Davies, tracing the descent of modern art; Frederick James Gregg, who also wrote the introduction to the catalogue; Guy Pène du Bois in his own person; John Quinn; Jo Davidson and others.

In his interview W. G. spoke of the status of art in America, which he termed above all skillful, but "limited by a lack of bravery." Americans seemed to fear appearing ridiculous—they had a fear of freedom and honesty. And he said, "The man with something to say is an important man in art—in fact, the only man who may claim the title of artist. The manner of his expression matters very little. That will take care of itself. The man with something to say generally says it pretty well."

He also made a prophetic remark: "I am afraid that the American section will seem very tame beside the foreign section."

And well he might be afraid. Cézanne, Van Gogh, Matisse, Brancusi, Picasso, Picabia and many, many more burst like a shower of meteors on a public that had never seen anything like them before. Cubism, Fauvism—Modernism!—had reached America in a Trojan Horse. The cryptic phrase "significant form," which nobody understood, was soon on everyone's tongue.

Twenty-five years after the Armory Show, Walt Kuhn, executive secretary of the Association, wrote:

The exhibition affected every phase of American life—the apparel of men and women, the stage, automobiles, airplanes, furniture, interior decoration, beauty parlors, advertising and printing in its various departments, plumbing,

[1] Walt Kuhn, *History of the Armory Show*; Jerome Myers, *Artist in Manhattan*; Walter Pach, *Queer Thing, Painting*.

hardware—everything from the modernistic designs of gas pumps and added color of beach umbrellas and bathing suits, down to the merchandise of the dime store.

America was never the same again!

No accounts of the Armory Show can exaggerate the sensation. Men of God thundered in their pulpits, warning their flocks away—which may in part explain the huge attendance. Everyone came, from Enrico Caruso to Teddy Roosevelt (who probably said "Bully!"). The rich and mighty gave their servants time off to take it all in. The man in the street, who had never looked at art before, appeared in great numbers. "People came in limousines," Walt Kuhn wrote, "some in wheel chairs, to be refreshed by the excitement. Even a blind man was discovered, who, limited to the sculpture, nevertheless 'saw' by the touch of his fingers. Actors, musicians, butlers and shopgirls, all joined in the pandemonium."

Some of the critics were delighted because it gave them so much to write about and explain to those of lesser perspicacity. Others were equally infuriated, which was also good. Several nearly burst.

The Show was taken to Chicago, and the hullabaloo did not diminish there. In fact it accelerated. Students of the Art Institute, which housed the exhibition, went so far as to burn Matisse in effigy, and the counterfeit presentment of kind, gentle Walter Pach, who was lecturing on the exhibition in the city, was also fed to the flames.

It makes one sad to think that today no art, good or bad, could possibly rouse us to comparable emotional heights. We are too blasé now to care that much how people paint or sculpture. Or perhaps we are just older. A sixth toe on a nude by Matisse was then worth columns in the papers: now two noses on a head by Picasso aren't even worth mentioning.

For some reason or other I. G. was taken to the Armory Show. But the memory is vague. I do not recall seeing, though it was surely pointed out to me, my father's large canvas "Family Group," with myself looking like a monkey in it. I do not recall my mother's watercolors, which hung there, nor "Nude Descending a Staircase," nor nudes doing anything else, but only garlands of green leaves festooned all about, and a dim vision of father stopping to speak to two gentlemen, one of whom had a beard. The two men were Arthur B. Davies and Albert P. Ryder.

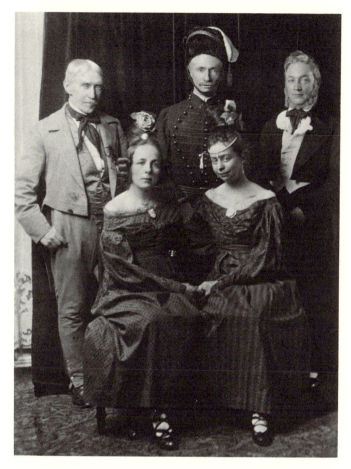

The Illustrators' Ball, Hotel Brevoort, 1917. Maurice Prendergast, Charles Prendergast, W.G., Mrs. Lillian E. Travis, E.G.

And thus Albert P. Ryder is one visitor's main memory of the Armory Show; it might have been worse. And Ryder is the only American painter whose work I remember my father ever specifically mentioning—it was that great artist's "Death on a Pale Horse" that I was early introduced to.

Maurice Prendergast's comment, when he came down from Boston to see the great exhibition (in which of course some of his own work hung, as he was one of the members), has been preserved by du Bois: "Too much—O my God!—art here." And it was certainly too much for a child of five.

Everyone who wished above all to be on the bandwagon turned into

a Cubist or a Fauvist over night, and the galleries soon blossomed with works that would have been inconceivable a short time before. Ernest Lawson wrote to Henri not long after: "We are now old fogies, my dear man, with all this howling dervish mob of cubists, &c. *My* show looks like a Philadelphia Sunday compared to the one at Montross."

The aftermath of the Armory Show, one regrets to learn, was loud with discord and strife among some of the members of the Association of American Painters and Sculptors. Arthur B. Davies was accused of being arbitrary and dictatorial, the books were questioned, sides were taken, names were signed to manifestoes and letters sent to the papers. Forbes Watson wrote that the battle of words "made the rafters of the old Manhattan Hotel quiver." The Cubists and Fauvists had so stolen the show that some felt their own works were outmoded. This not unnaturally soured them.

But in all this turmoil, where was W. Glackens? His work for the Armory Show was done; he would take no part in these proceedings, which embarrassed and distressed him, and which he told a friend were "foolish and unnecesary"; he was serenely back in his studio, trying to capture on canvas his vision of a bright, living world.

Art had fired a great blast in favor of freedom and a new life, and later that same year there came another manifestation for freedom. A great suffrage parade marched down Fifth Avenue, witnessed by enormous crowds. All the Glackenses were ardent suffragists. Edith and William marched in the parade, as did E.'s sister Irene.

Irene had come to New York to study medicine. After dissecting corpses for a while, and once bringing home a human brain that had to be boiled on the kitchen stove, she relinquished that study and enrolled at an acting school. She then came to live with the G.'s at 29 Washington Square.

She had a make-up box complete with rabbit's foot and many sticks of different-colored grease paint. She got up in the morning and said, "I feel like Louis the Eleventh today," and made up like that wicked monarch, green with blue shadows. Sometimes she did "ruddy old age," but her favorite disguise was just an old hag in a shawl. She had a stage tooth to stick out of her mouth to complete the illusion, and it was then her pleasure to go out and sit on a bench in Washington Square. All huddled

and bent when she hobbled through the square, if she passed a policeman, she wheezed. She was in her early twenties.

Soon she had a job in the movies, which at that time were full of primitive action in one or two reels. Her job on one occasion required her to leap off the Staten Island ferry and be dragged through the water by her long hair. She gave that up to work for suffrage, and for a while she was a secretary for Mrs. Carrie Chapman Catt.

Now, for the big parade, Mrs. Dimock and Miss Ella L. Fiske came down from Hartford and took rooms at the old Waldorf at Fifth Avenue and Thirty-fourth Street, on the line of march. It was a fine day, sunny and warm. The whole city was on holiday.

The women marched in white tailored suits with skirts to the ground, and they carried banners in the suffrage colors, purple and gold. The floats were impressive, and so were the tableaux afoot. One tableau consisted of a beautiful lady in flowing white Grecian robes, who walked with her hands manacled. Six long ropes were tied around her, each one held by a man, and they were dressed in yellow oilskins and sou'westers. The maritime state of Maine had lately rejected a suffrage referendum. There were great divisions of schoolteachers, factory girls, shopgirls, actresses, female professors (who marched in their caps and gowns), artists, musicians, female doctors, and so forth. Each division carried a banner proclaiming its profession. It was very impressive.

When the men marched briskly by, to the tune of a fine band, there were mingled boos and cheers (for their bravery) which could be heard for blocks as they approached. W. G. was among those who got the boos and cheers. But on the whole everyone was good-natured, and this exhibition of the vast public sentiment for universal suffrage would probably have succeeded in achieving it, had not the First World War intervened. So, first, the country got Prohibition.

W. G. naturally could not bear Prohibition. He was a rock-ribbed Democrat, and E. G. an equally rock-ribbed Republican. They were one, however, on the subject of repeal. They read different papers at breakfast, and when the suffrage amendment became law, went together every year to the polls and voted opposite tickets. I think the only Republican W. G. ever voted for was Henry Curran, when he ran for mayor of New York.

An honest mayor was preferable even to a Democrat. The G.'s took a 360–mile trip to vote for him.

Prohibition and suffrage were the livest issues that ever struck the Glackens home. As the years went by and good liquor became unprocurable except by millionaires, and good harmless wine was not procurable at all, desperate means were resorted to by the entire nation—home brewing. And among the home brewers, as has been said, none was more active than W. G., nor more successful.

During these dreary years a great testimonial dinner was given Robert Henri, at which all the leaders of art, by turn, arose and did homage to the man who had done so much for artists. The more emotional speakers were reduced to the verge of tears, so moved were they by their subject.

It became W. G.'s turn to join his voice to the paeans. No one had known Henri longer than W. G., nor knew better what he had accomplished in freeing the artist from official tyranny and freeing his art from the stultification of the academies.

He rose and said, "Henri's all right. But what are we going to do about Prohibition?" This brought down the house and ended the eulogies forthwith, to the great relief of the guest of honor.

But before Prohibition had come to change completely the pattern of social life, time had not been wasted. These were the days of many costume balls. There was the Kit Kat Ball, and every year the Illustrators' Ball, a highlight of the art season. Sometimes these balls had a theme—one year it was the Cannibal Islands. This was a wonderful opportunity for the artists, and they outdid each other in wild and savage masquerades. They painted themselves tawny colors, wore raffia skirts and necklaces of tigers' teeth, and carried spears. But W. G. went as a missionary, all in black, with a shovel hat, black gloves and a black cotton umbrella.

Flossie Shinn had it easier, for when everyone had to appear disguised as the title of a book, she merely drew a picture of a mill and pinned it to the front of her dress: *The Mill on the Floss.*

It might seem as if artists, as Ella Fiske suspected, spent their time in revels if not in nudity. But they were very busy nevertheless, and found time to do more than paint and dance.

In 1916 the Society of Independent Artists was organized, a direct

outgrowth of the Independents of 1910. The grand democratic idea was emblazoned on the title page of the catalogue of the first exhibition, which took place at the Grand Central Palace from April 10 to May 6, 1917: "No Jury—No Prizes." The pictures were hung in alphabetical order, and everyone was welcomed; for a fee you were allotted a certain amount of wall space, and could hang thereon anything you liked.

W. G. was unanimously elected first president of the Society, a position he occupied for one year, to be succeeded in 1918 by John Sloan, who remained president for the life of the Society. The first vice-president was Charles Prendergast, and Walter Pach was treasurer. Among the directors were George Bellows, Marcel Duchamp, John Marin, Maurice Prendergast and Maurice Sterne.

It would be difficult to visualize W. G. in an executive capacity, but nevertheless he proved a very valuable man, especially when an impasse was reached. The story of how he solved a great dilemma that confronted the executive committee was later told by Charles Prendergast, and he laughed so hard telling it that the tears ran down his cheeks.

Now as has been seen, the entire *raison d'être* of the new organization was to do away with juries of admittance, so that the artist could for a fee (I think it was six dollars) display his work, whatever it might be.

But this noble ideal caused problems. No juries of admittance meant no juries for refusing either.

Everybody perhaps knows the story of the "Fountain" signed R. Mutt, a *nom de guerre* of Marcel Duchamp, which the creator of the "Nude Descending a Staircase" submitted as his entry. This object was a urinal, a heavy porcelain affair meant to be a fixture, and it caused a great deal of dismay in the executive committee.

Apparently Mr. Duchamp was not the only one who planned to cause dismay, for, according to Charles Prendergast's story, a chamber pot, tastefully decorated, was also submitted by someone. Could it too have been a creation of R. Mutt? History is silent.

The executive committee stood around discussing the thorny problem. Presumably the best art brains in the country were stumped.

Nobody noticed W. G. leave the group and quietly make his way to a corner where the disputed *objet d'art* sat on the floor beside a screen. He picked it up, held it over the screen, and dropped it. There was a crash. Everyone looked around startled.

"It broke!" he exclaimed.

In May, 1917, both E.'s parents died, and the family went to Hartford to spend several months in the large house, half-deserted with only Ella L. Fiske and E.'s brother Stanley left in residence. W., who did not find life on Vanderbilt Hill particularly stimulating, at least always had his paints, and he made good use of them. He produced a number of canvases during this Babylonian captivity: "In the Conservatory," "King and Kingdom" (Lenna among her toys), and several studies of the garden and the old thatched summerhouse which he had first painted in 1904. These were the last Hartford pictures, for the old house and stables were torn down the following year. But some of the fine trees Ira Dimock planted and W. G. painted remain, and the red sandstone wall and hemlock hedge still overlook Farmington Avenue.

The summer of 1918 was spent at New London, Connecticut. The Dimocks' old house at Pequot was near public beaches, perhaps W.'s favorite subject, and in that more satisfactory summer of 1918 W. had a chance to go fishing. He and E. went for two weeks into the Maine wilderness, to Lake Sardanahunk, sixty miles in a buckboard from the nearest railroad. On their return E. held her children spellbound by a graphic acting out of a sixty-mile ride in a buckboard over rocks and fallen trees.

Beach scenes were always satisfactory subjects for W. G., with their animated and colorful crowds, and for the summer of 1919 a house was found in Gloucester, Massachusetts. It stood in the section of town called Eastern Point, with a rocky bay below, and was covered with wisteria vines.

The artist Charles Demuth was spending the summer at Gloucester. The G.'s saw a good deal of him, and more than once had motored with the Barneses to the old Demuth house at Lancaster, Pennsylvania. Every sunny morning Charles Demuth came in bathing suit and with a blanket

189

to lie on the beach below the G.'s house. The present chronicler used to watch daily from the porch for his approach, and run down to converse with him on the sand. If bored by an eleven-year-old boy, he did not show it, but with his well-known suavity conversed as if with an adult. Those long talks with Charles Demuth are the pleasantest memories of Gloucester.

Once the subject of Shakespeare came up, and I. G. was counseled not to miss seeing, if ever the opportunity offered, Sargent's portrait of Ellen Terry as Lady Macbeth, holding the crown ecstatically over her head. Charles Demuth vividly described it. When, years later, the painting was seen (Tate Gallery, London) one wondered that it was Charles Demuth, of all artists, who had sung its praises.

This was the summer of the Rabbits. Lenna acquired two, Ophelia and White Vine, and she posed with them. The painting was later destroyed in a railroad wreck.

To I. G., soon abysmally homesick in camp in Maine, almost daily letters recorded the saga of these animals. Besides the rabbits there was the family tree toad, Peter Wink. E. wrote on a short trip to New York, "I have some meal worms for Peter in my bag. I got a good supply. We shall give him flies for dessert but the worms will be the chief of his diet."

And then a boy gave Lenna another rabbit, much larger than Ophelia and White Vine, named Zuzu. "She has a flat ignorant face Daddy says."

William and the rabbits of Gloucester. Sketch by E.G.

W. G. to I. G.:

Gloucester,. Mass., Aug. 13, 1919.
We forgot to take the rabbits in last night and I was awakened early this morning by the barking of a dog. I looked out of the window and spied a small yellow dog yelping at the rabbits in their boxes. It didn't take me long to get down stairs and drive the dog away. The little rabbits were all right, but when I looked in the box for Zuzu I found it empty. The lid of the box was only paste board and Zuzu had pushed it off and escaped. Your mother has written a notice offering 50 cts. reward for the recovery of Zuzu and pinned it on the telegraph pole. Lenna does not know that Zuzu has gone yet and when she does find out there will be trouble. However there is no help for that. We have looked everywhere about the yard. I think Zuzu has made for the rocks up on the hill.

With much love,
DADDY

Four days later W. took pen in hand once more. After all, he had a son in camp and something had to be done to relieve Edith from her constant letter-writing.

Gloucester, Aug. 17, 1919
DEAR IRA:
Wait till your mother hears about that haircut! You know how she loathes that kind of haircut. At present she is in Hartford but we expect her back today (Sunday). Lenna is very much interested in the cereal bowl you are making for her. In case she doesn't get her letter to you in time, I shall confide to you the types of animals she wants you to put on the bowl. They are, mouse, toad, groundhog and earth worm. These I am afraid will tax your powers of design to the utmost. She is enclosing a piece of hair ribbon which will give you the color she would like the bowl.

You are getting to be quite an accomplished swimmer. In fact I think you have learned a lot of things in camp. One thing especially I am interested in and that is getting fire by rubbing sticks together. Probably you will be able to do that for us when you get back from camp. . . .

Zuzu has been found. She was picked up on Rocky Neck by a small boy, we got Zuzu and he got the 50 cts."

Though the summer in Gloucester was declared dull, there seemed to be considerable coming and going. Lou Glackens visited, and Charles Prendergast came up to go fishing with W. at Lanesville. Edith, whose tender heart was much concerned over her too-sheltered son away from

home for the first time and hating every minute of camp, made several
journeys to Maine to see him. One of the projected trips was prevented at
the last moment.

"I was all ready to step into bed . . ."

E. G. to I. G.:

Gloucester, July 29. Before breakfast.

DEAREST IRA

I was all ready to step into bed last night having made all arrangements
to go to see you today when the telephone rang and a telegram came from
Dr. Barnes asking if they could lunch here today! Well I was so disappointed
I didn't know *what* to do! I could hardly make up my mind to give up the
plan. It must have been 11 o'clock when the message came. I tried to think
of the things I would say to you. That it would only be a few days later, etc.
I don't want to be a Pollyanna but have decided to be a philosopher.

Pollyanna, who was thankful for everything that happened to her no
matter how dreadful, was the particular hatred of all healthy children in
this epoch. I. G. was no exception, and therefore Edith sprinkled draw-
ings of Pollyanna through her letters to cheer and amuse.

The year 1920 rolled around, and the choice of a summer retreat was
left as usual up to W. He knew what he wanted and how to go about
finding it. He consulted the ads in the old *Boston Transcript*.

Pollyanna. "I am so glad my leg came off, because now I can *hop* home!" Sketch by E.G.

A glowing description of a house on a lake near Conway, New Hampshire, caught his eye. After a trip of inspection which involved wading through drifts of snow, though it was early May, the house was taken. It proved so satisfactory that five summers were spent here.

The country around Conway has been declared by Scotch visitors to resemble the Highlands, though wilder and grander. Conway lies in the foothills of the White Mountains. W. did not care much to paint mountains, as they afford no foregrounds, but the small-mouthed black bass in Conway Lake (or Walker's Pond as the older inhabitants call it) were then prodigious. Most of the fishermen had been off to the wars and given the fish a chance to grow. Only when the autumn colors began and the landscape grew less green were the paints usually brought out.

The section was then primitive. Nobody had electricity or running water. Appetites were enormous, and a Model T took E. and Peppy daily to market, to "forage for food" as E. called it, in the surrounding villages.

Bread was procured from a bakery at North Conway, eleven miles away. The meat was best at Fryeburg, Maine, a distance of seven miles in another direction. The entire morning was devoted to gathering in enough food to last until the next morning.

W. produced a few landscapes and some flower pieces and still lifes when the need to paint grew too great and the out-of-doors was too green and buggy; but on the whole Conway seems not to have provided many paintable places.

The summer colony consisted of families who had been coming to Conway for thirty years, but they cordially welcomed the newcomers. General A. W. Greely, the Arctic explorer, was the distinguished resident. The journalist and historian, Frank Simonds, whom W. had known in Cuba, lived on a hill in the neighboring village of Snowville. Life was simple and neighbors not too near. The country was heavily wooded and very hilly, and there were fine walks as well as some mountain climbing. W. and E. more than once climbed Mount Washington and Mount Chocorua, the most beautiful mountain in the East.

If the painting in Conway was not very good, the fishing was, and W. spent much time making fishing rods and standing on the grass before the house, practicing casting. But when one day he came home carrying a four-pound black bass in his landing net, there was an interested gleam in his eye which not even a fish could inspire. "There is an Angel of Death on the path to the lake," he announced calmly.

These alarming tidings could not dismay the family of an amateur mycologist. All knew he referred to the deadly mushroom, *Amanita phalloides*, also known as Destroying Angel and Death Angel, the merest bite of which causes an agonizing death in a few hours. (Until recently there was no known antidote.) All went forth at once to inspect it, as it stood alone in the middle of the path, a particularly fine specimen, white as alabaster, straight as an arrow on its long stem, and beautiful as a Greek statue—an awesome sight, and one not often seen in that part of the country.

W.'s interest in mushrooms might extend to stinkhorns and Angels of Death, but his real love was concentrated on the edible varieties. Walks in the woods were interspersed with inspections of any that were found. W. always could give the Latin name and announce at once whether the variety were edible or not. To the tyro many of the edible ones en-

countered looked particularly poisonous, but E. would always take a bite. I used to marvel at the faith they both had in W.'s knowledge.

E.'s old friend Lillian Travis—she who was also interested in stink-horns—owned a farm on a hill in South Tamworth, twenty-five miles away, and sometimes the Model T was packed with a picnic lunch and the whole family set out to spend a day in Tamworth, returning home at dusk, exhausted. And W.'s old Pennsylvania Academy friend, Alice Mumford, now Mrs. Stewart Culin, was urged by E. to come to Conway with her daughter, Penelope Roberts, and take a house there. Alice proceeded to joggle the simple summer life by giving a fancy dress ball in her barn, to which the whole community was invited. W.'s costume consisted of a painting smock, and he wore an inverted basket on his head. Two young ladies from Lowell, Massachusetts, the Misses Helen and Isabel Nesmith, admired the costume greatly. "What have you got in there?" Helen said, and spanked W. smartly on the belly. But instead of the dull thud she expected from slapping a pillow, alas! the unmistakable hollow sound occasioned by slapping a bona fide belly was audible all over the room. W. never lived this down, but he had no intention of going on a diet.

In spite of the pioneer existence in Conway, E. did not hesitate to invite friends to visit and share the primitive life. Ella L. Fiske came several times. Used to a commodious mansion and rafts of servants to order around, she suffered in silence. That E., brought up in comfort, seemed happy and contented without any plumbing was a puzzle she could not answer. Dr. and Mrs. Barnes, on a motor trip, spent a day or two. One wonders what they thought about it.

Meanwhile, the G.'s had been looking for a new home in New York, and they settled on an old house, Number 10 West Ninth Street, bought it, and moved there in 1919. The house dated from about 1830 and had few modern improvements. It was lighted by gas, and though it had five floors, the furnace in the cellar was the size of a bandbox. The former owner was said to have owned a valuable library, and heat was bad for rare books. But the house had eighteen-foot ceilings, mahogany doors and handsome carved pilasters on the parlor floor, in the stately Federal style.

When they moved from 23 Fifth Avenue, on the corner of Ninth Street, W. and E. had vowed never to live in that street again. Trucks used it day and night as a thoroughfare to Brooklyn. Their first night

in their new home, as they settled to rest, the trucks began rumbling past as usual, and their forgotten vow was called to mind. "Back on Ninth Street!" they moaned. It was W.'s home for the rest of his life.

In the next nineteen years the house saw many fine times and some anxious ones. A few years later a studio was constructed on the top of it, with a fine north light, until the Fifth Avenue Hotel was built across the street. After that the light was no longer pure, for a pink reflection from the bricks of the giant construction ruined it forever. W. experimented with frosted glass, with electric lamps and with various other contraptions, without much success.

In the winter of 1925 there was a dinner at the George W. Bellows house in East Nineteenth Street that was portentous. George Bellows died a few days later of appendicitis, and W. came home from the party with a chill that rapidly developed into pneumonia. Pneumonia before the advent of the "wonder drugs" was serious. The newest treatment in 1925 was diathermia. Dr. Harry Britenstool arrived in Ninth Street with a portable diathermia machine. Electricians quickly installed new wires capable of carrying the requisite load, and the treatment, then a very new one, began.

Alice Culin, a friend in need, abandoned home, domestic duties, and her husband in Brooklyn to sit by the telephone and answer messages. There was a consultation of doctors, and they told Alice to prepare E. for the fact that W. G. would not live through the night. She refused to do this. All night she sat by the telephone. Before dawn the fever suddenly began to drop, and in the morning W. G. was convalescent.

Stewart Culin, Curator of Ethnology at the Brooklyn Museum, was a remarkable man. A native of Philadelphia, he had been painted in his younger days by his friend Thomas Eakins.[1] He was an authority on the art and culture of the East, and on primitive races. He wrote delightfully on such subjects as ancient Chinese games and many others. "I am sure of my facts," he said in his crisp and decided way, "because I make them up!" He was ahead of his time in his conception of what a museum should be, a living and working rather than a dried and dead institution. It was he who started the costume collection at the Brooklyn Museum which was available to study and even to try on, rather than merely to look at behind glass. The collection of ancient Chinese art and artifacts that he assembled

[1] This painting was later stolen and never recovered.

from many trips to the Orient is perhaps the most fascinating in America, though unfortunately no longer on display.

Sunday nights from time to time the G.'s repaired to Brooklyn, for tea with the Culins in Stewart's musty office in the Museum, amid aromatic packing cases and dusty treasures, and then dinner at their house hard by. Alice Culin was ever a brilliant and understanding hostess. She won Lenna's heart by offering her a box of chocolates and at the same time a wastebasket. "If they're nasty, spit them out," she invited. Could hospitality go further?

After Stewart Culin's death the G.'s saw more than ever of Alice, both in America and in France. When emergencies or tragedies arrived, she continued to be a friend in need, and one whose unvanquishable humor and courage in the face of troubles were beyond price. She was seldom down, whether she could get portrait commissions or not. Alice should have been a millionaire, for she would have had the flair.

"I intend to be the best-dressed woman in New York," she announced one day. "I have two hundred dollars a year to do it on." Then she added, "If I had three hundred dollars, I could do it!"

Alice was short and rather stout, and when she went to buy a pair of corsets she began by stating to the saleslady firmly, "I am a dwarf." Otherwise, she explained, they invariably brought her a pair that closed together over her head.

One day she came in wearing a new dress with which she was very pleased. But everyone in the room cried with one accord, "*Alice!* STRIPES!"

"Why not?" she demanded. "Stripes were good enough for the Ptolemies!"

->>>->>>->>>->>>->>>

CHAPTER TWENTY-FOUR

In the spring of 1925 the New York house was let, and the G.'s, accompanied by the faithful Peppy, set sail for France. The sojourn was to be for at least two years.

W.'s three former trips to Europe had been undertaken in freedom, but in 1925 he had a whole family tagging at his heels, and no Alfy Maurer to help him "lord it over the others" in the smoking room with Monterey cigars.

The Royal Dutch ship called at Boulogne in the dim light of dawn. But then came a beautiful sunny day. The little toy train squealed like a pig when approaching grade crossings, the French countryside looked laid out to be painted, the spires of Amiens appeared—and Paris was as magical as ever.

We set out for our hotel, where rooms were engaged, with our five steamer trunks on the roofs of two taxis. (In those days one still traveled with trunks.) But when we arrived it turned out that the hotel had never heard of us. Someone had tipped someone and taken over our lodgings, including the welcoming flowers left by a friend in our rooms.

All Paris, it appeared, was full, and with horns tooting and trunks swaying we went from hotel to hotel. The seventh took us in. It was called Le Fournet and was in a section of the city both inconvenient and uninteresting. Le Fournet was faded, tattered and dusty, and the food was poor. However, the G.'s had a roof over their heads and hurried to visit the Tuileries, the Place de la Concorde, the Luxembourg—these had not changed.

Leon Kroll was in Paris with his French wife Viette. She took the G.'s under her wing; she went with E. to see house agents and to inspect many a flat. E. was entranced with Viette. She would march into bed-

198

rooms and right in the face of the *propriétaire* sweep the bedding, blankets, sheets and mattress back, and look for bedbugs. No bugs were found, except one or two, but none of the flats suited.

The Krolls had a house at Samois-sur-Seine, near Fontainebleau, and soon the G.'s were in Samois, at the Hôtel Beau Rivage. Then they rented a house on the main street of the town.

The house was called the Maison Daboncourt and had been built in the late seventeenth century. The front door opened directly onto the cobbled street; in the rear was a fine walled garden containing an *orangerie*. On a window pane in a bedroom was scratched the name of a member of the Salut Public, a Butcher of the Revolution who had gone into hiding there after the ninth Thermidor. Madame Daboncourt, who lived next door, had at first not mentioned this historic curiosity, fearing that we would cut the pane out and take it with us for a souvenir. We were tenants, and what was worse, Americans. But we finally passed muster and suspicions were calmed. We had found the signature anyway.

Charles Prendergast was in France that summer, and he came down for a protracted visit. Everyone rented a bicycle, and now when W. was not painting or fishing in the Seine, he, E., and Prendy went on excursions through the beautiful Forest of Fontainebleau and to the surrounding villages and towns. In these villages lunch was eaten at the local inn, and a bottle of wine drunk, to fortify the bicyclists for the return to Samois.

When Yvette Guilbert came to give a concert in Fontainebleau, all the G.'s attended. W. had met her in New York in 1897, when he was on the *Herald*. She had called at the office to see the editor, and entertained the staff by bending over backward and touching her head to her heels.

Now, when the stout, cheerful lady in an eighteenth-century costume of light blue silk emerged onto the stage of the local theatre, it was hard to believe she was the same person who had been immortalized by Toulouse-Lautrec. But when Yvette Guilbert began to sing her songs, no time had elapsed at all.

She sang a song about a woman making a list of her past lovers, with the same practical interest that one would have counting cabbages. My first was a postman! my second was a policeman! and so on. She sang "The Keys of Heaven" in English for the many American students in the

audience. But W. was·most in favor of a song about wine, the refrain of which went:

> Le bon bon vin!
> Le bon bon vin!

and Yvette Guilbert, far from ignoring her ample girth, slapped her stomach appreciatively at each mention of the good wine.

After hearing Yvette Guilbert one could understand more clearly the particular color and savor of the French, their brand of humor and their attitude toward things. Sometimes our humor needed interpretation for them. At Samois-sur-Seine, a good, hard-working woman came every day to clean and wash. She had never known foreigners, and after some time she broke down and confessed how much she enjoyed working for Americans, who were *si sympathiques.*

"*For Americans,*" Edith replied, "we are *very wicked!*"

The honest woman's face assumed a startled and puzzled look. Then it broke into a beam. "Madame is joking!" she cried.

When the South of France was decided on for the winter, Viette Kroll said that at Cavalaire, near Hyères, one could find plenty of studios with a good north light. We went to Cavalaire, which consisted of a small hotel with excellent food for one dollar a day, *tout compris,* one village street with a few miserable huts, and at a distance overlooking the sea, the unpretentious villa of Madame Curie. The hotel was inhabited by all the village cats, and at mealtime they poured with the guests into the dining room. The guests and the waiters fed them, often whirling a chop across the tiled floor. But the only things of interest at Cavalaire were the hotel cats.

So W. and E. set out by train for Vence, which was near Nice, to see what that place afforded. Reports that Vence was arty had discouraged them, but when they got there, they were delighted with it. In 1925 Vence was still an old walled town, large enough to be animated but not yet ruined by a mushroom growth of villas and the exploitation of the Matisse Chapel. There was a small British-American colony, and the peasant women dressed in black from head to toe, with long, full skirts, shawls and curious shovel hats. They came out to fill their jugs at the fountain in the Place du Peyra, they sat roasting coffee in little charcoal stoves in their doorways, and they believed that a toad kept in a pot under a sick-

bed drew the poison out of the patient. They also believed that if a pregnant woman were so unfortunate or so careless as to walk under the neck of a horse her delivery would be delayed two extra months. Vence was a wonderful place.

There was of course the problem of finding a suitable house, and an agent took W. and E. by car from one to another. Finally he described what must be the perfect villa: it stood on a hill with a magnificent view; it had a garden full of orange trees and lilies; it had large airy rooms and *eau courante*. It even had a vineyard, and the farmer made the wine! And the rent was reasonable.

The agent gave the address to the driver. "Route des Abattoirs," he said.

"Oh no," said E., and stepped firmly out of the car. She pictured the little lambs, two by two, trotting daily past the door en route to the abattoirs, and the tragic looks and tear-stained cheeks of Lenna. The G.'s simply could not live, however luxuriously, on Slaughterhouse Road. These crazy Americans! Another villa must be found.

One at last appeared: a Victorian edifice with a cupola overlooking the whole town and the Mediterranean beyond. Behind it loomed the Baou des Blancs, a curious domed mountain with the ruins of a castle

Old Women of Vence

of the Knights Templars, and a road wound by down which black-garmented women came on donkeys, their saddlebags packed with great bundles of roses in the bud, destined for the markets of Paris and London.

Les Pivoines (The Peonies) was the name of the villa. From the garden, the whole town with its ancient walls spread out below—the tower of the cathedral and the great square building called the Vieux Séminaire dominating it like the Alcazar in El Greco's great painting of Toledo. Terrace after terrace, planted to oranges and olives, led down the valleys and up the slopes of the precipitous opposite hills. The Mediterranean was visible five miles off, melting into the blue Midi sky, and once or twice, when conditions were right, the island of Corsica with its high mountains appeared, a mirage on the horizon. The air was filled with the odor of burning olive root.

Yet in this art colony there was no studio with a good north light, and W. had to make shift for a place to paint. E., being a watercolorist, was luckier. She got out her paints, and inspired by the old peasant women, red-faced girls, village shops with their wares oozing into the street, she produced hundreds of watercolors.

Lenna was enrolled in the communal school, and a black bombazine pinafore was acquired so that she would be dressed exactly like her schoolmates. E. urged her to make friends with them. "Oh mother, I can't!" she wailed. "They keep rabbits for pets and then eat them!"

The Krolls had settled at Saint-Jean, Cap Ferrat, on the eastern side of Nice, but it was Viette who arranged the hire of a donkey and cart for Lenna. The donkey was a beautiful soft gray Corsican one, so small that when he refused to get off the road to let a car pass in a narrow place, the driver could step out, pick him up, and set him on the side lines. W. painted him with Lenna on his back. ("The Promenade," Detroit Institute of Arts.)

One day the painter Marsden Hartley called unexpectedly at Les Pivoines. W. had been associated with him in several art organizations, but Hartley had never been a close friend. This in no way prevented him from arriving once at W.'s studio in Washington Square with a large supply of his canvases and the little request that W. store them for him as he was going away. It had not occurred to him that W. might be going away too. When Hartley did not return, the pictures had to be moved from place to place in a studio already crammed, and shipped off to

storage when the studio was given up. Hartley in those days painted thick, with great gouts and points of paint sticking out all over the canvas, and once W. G. received a nasty gouge on the thumb from a sharp pinnacle of paint. He said the picture bit him.

Hartley was a native of Lewiston, Maine, but spent much time traveling about Europe, apparently liking nothing very much and staying nowhere long. In the end he went back to Maine, where his rather cold art seemed more at home than in the South of France.

On the first of May the tenants of Les Pivoines set out for a month's tour of Italy. W. had never been there.

We went straight to Naples and did all the sights, including Pompeii. W. and I. G. were led secretly by the guide while the female members of the family lingered in the background, to see the "paintings not suited for general inspection," as Baedeker puts it, in the House of the Vettii. Had Lenna been a few years older she would have demanded "all the privileges enjoyed by boys," but then she was only thirteen. We went to Capri and the Blue Grotto—it would hardly have been decent not to— and spent a night in Tasso's house at Sorrento. Thence to Rome, the projected sojourn there being cut shorter and shorter, since there were few paintings in Rome that interested W. and he wanted more time for the hill towns.

Rome consisted of church after church, within the walls, without the walls, and in almost every one of them we were obliged to inspect a dead body. The fascinations of Rome, its vistas, ancient buildings, ruins, fountains, bustling streets, verdant gardens, and the graves of Keats and Shelley, call for a long, relaxed visit. When W. was led down a precipitous stair into the crypt of Saint Peter's, protesting all the way under his breath, though a sacred silence was enjoined, to view the marble sarcophagi, ornamented like wedding cakes, of several recently defunct popes, he had had enough of Rome. So we all threw pennies in the Trevi fountain and left for Florence.

A fine Isotta-Fraschini, driven by a chauffeur in a white linen duster trimmed with blue, bore us to the hill towns of Tuscany. George Luks' favorite phrase, "King for a Day!" came to everyone's mind. Orvieto, Perugia, Siena and Assisi were visited. In Assisi the complacency of an English priest at the bad restorations of Giotto's frescoes would have tried the patience of Saint Francis himself. Even W. G. was mildly annoyed.

A week in Florence, where it rained every day, explaining why the English feel so at home there, was slight preparation for the glories of Venice.

Venice begins with a gondola. The G.'s had rooms in the Casa Petrarca on the Grand Canal and across the way from the City Hall, where civil marriage ceremonies take place. Gaily decked gondolas bearing the wedding parties to and from the City Hall were a never-ending spectacle, and so were the funeral gondolas which moved by with their rich black and gold trappings. We all decided that for weddings and funerals, Venice was the place.

The Tintorettos in the Scuola di San Rocco and the Academia, the Titians, the Giorgiones, the Bellinis (all three), the Carpaccios, beloved of Maurice Prendergast ("The work of the grand Venetians," he wrote home to his brother, "makes me ashamed to call myself an artist.") — the canals, the palaces, the bridges, the islands, San Marco, the rebuilt Campanile (which, though a replica, E. said lacked the charm of the old one) — to all this the G.'s surrendered like every other tourist. But W. G. wanted to see Giotto more than any other painter in Italy, and one day of the ten planned for Venice was sacrificed by W. and E. for a trip to Padua to see his frescoes in the old Arena chapel.

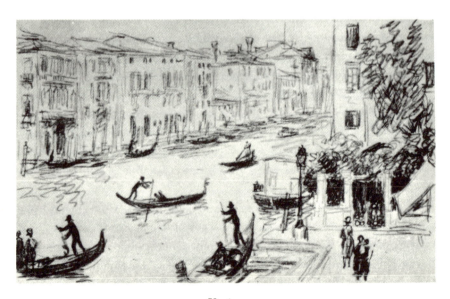

Venice

Charles Prendergast to E. G.:

219 West 14th St.

DEAR EDITH:

I received your nice long letter from Venice dated May 24th some time ago. And also a postal card of the old marble bridge. How well we knew that old spot. I hope you had a drink at the café just the other side. And Orvieto. I wish I was with you. Est Est Est. Did you find the place where the old bishop stayed?[1]

I am still in the same old place. It's not bad. But the last week was quite warm and it still hangs on. It was 98 today (July 21). It's been up to 101.

I went to dinner last week to Lillian Travis's new apartment. It's a great improvement over the old one. Fitz and Irene were there. And Irene simply looked stunning. A blue gown, a fine quality of blue trimmed with a soft white collar opened in the front. And a wide brim hat. I never thought I would live to see the day when Fitz would refuse a cocktail.

——— He did ———

I wonder if Lillian Travis told you of the wonderful buy she bought at an auction room on University Place. I got a call from her one evening asking me to go with her in the morning and look at a painting she discovered. When we got there hanging on the wall was an early painting by George Luks. 18 x 24 canvas. A good one. Perhaps you remember it. A little girl looks as if she was trying to wear her mother's hat with her two hands up to her head, holding on the bonnet. All done in grey tones. The little girl is lost against the background. The first bid was $5. She got it for $30. Thirty dollars. Kraushaar had it on sale for $2,500. Fitz recognized it at once. An old lady came up after she bought it, "Say madame. Did you buy that for the frame?"

Miss Bliss had all her paintings on exhibition at the Brooklyn Museum. They make a good show. She is going to leave all of her paintings to Brooklyn in her will . . .[2]

I am working on some panels. I have five finished and when I get about 8 or 10 I would like to jump on a boat and head her direct for Paris. Your description of that little house just wins my admiration. Did you know that Rehn[3] bought a couple of your drawings at an auction sale at the Anderson galleries last March? He thinks they are great. You ought to make a bunch and have an exhibition.

[1] A reference to the legendary German bishop who, on his way to Rome, was so entranced by the wine of Orvieto that he just stayed there and drank himself to death. Charles Prendergast loved such stories.
[2] But alas for Brooklyn! she left them to the Modern Museum.
[3] Frank Rehn, art dealer.

[Walter] Pach went over to lecture on art in the Louvre. He left here last
June. The family are with him. I met Dan and Grace Morgan at Westport. I
went down there for a few days. They both look very prosperous. Grace had
on the dress I brought over. It gave her quite a Parisian air. . . . That's good
news, Lenna picking up five pounds. Give her my love.

<div align="right">CHARLES</div>

CHAPTER TWENTY-FIVE

Isle-Adam, on the river Oise about an hour north of Paris, was chosen for the summer. The town was one of the most paintable and charming in the region. Here the Oise bends and forms two small islands, on one of which stood an old chateau, the Royal Conti, made into a hotel. On an old stone bridge spanning the river to connect the island with the mainland, the inhabitants stood and fished all day long. A few hundred yards from the bridge was a little bathing beach and a pavilion with bright umbrellas, little tables and a harassed waiter who served the bathers. W. G. painted that beach innumerable times.

A house was rented in the Avenue de Paris, a little out of the main part of the town. It had a garden, several acres in extent, with flowers, vegetables, a greenhouse, a summer house, all surrounded with a high wall. The owners asked if two small dogs, Zezède and Dianne, might be left there until a new home could be arranged. The G.'s said they might be left for the summer, so Lenna had two pets.

Local help was sought, and a widow (grass) of middle age, Madame Maitre, came to serve. Her name was Berthe, and henceforth she was a member of the household wherever we went in France. When she grew to know us, Berthe said one day, "Monsieur is very good. There is not another like him in Isle-Adam." Then she considered, and loyally amended her valuation. "There is not another like him in all of France." She said she was "eating her white bread now." When she arrived, Berthe had a wild look in her eye, and her head shook, which troubled us, but it was found that she had just recovered from a long illness. She wore a pair of bright lemon-yellow shoes, her best, and rushed around the table with remarkable dispatch. The cook was a younger woman with a daughter

207

Isle Adam—The Passerelle

aged five, named Paulette, who also became a member of the household.

May and James Preston came to visit; James spent much of the summer with us. Walter Pach, fresh from his lectures in the Louvre, and his wife Magda came down, and there was a constant stream of guests. Lenna's closest friend Ann Spencer (now Ann Spencer Pratt) and her mother, Mrs. C. G. Spencer of New York, also were with us, and after a while hired a small flat up the street which they called the Spencerian Pen.

W. G. found a studio in the town, overlooking the river and one of the little islands and the bathing beach. It was owned by two maiden ladies of aristocratic lineage and democratic manners. One of them was an ardent fisherman.

Everyone was painting, studying French, and learning poetry—ten lines a day, a pursuit in which W. G. did not join. The weather was consistently beautiful, and we usually had all three meals in the garden.

Besides the dogs, which had come as fixtures, Lenna and Ann each bought a guinea hen in the market, and they wandered about the large

garden and made a nest under the ivy on the wall, in which every day one delicious egg was found. They looked like refined old ladies in gray shawls as they minced up and down the garden paths.

Next door there was a small orphan asylum run by three nuns of the order of the Soeurs de Bon Secours (known in Ireland as "Bonesuckers") —the ones in blue with wide-winged headdresses. There were about twenty orphan girls dressed in black-and-gray-checked dresses, very much the color of the guinea hens. Soeur Marguerite conducted her charges on their outings; they walked in a double line about the village streets. Soeur Marguerite was a small, hard-working woman, and when she smiled her otherwise plain face lit up with an expression that made her beautiful. A life of toil for her children was her happiness. Soeur Philomène was fat and practical, and she had charge of the kitchen. E. G. sent money to the nuns, and Soeur Marguerite wrote that it was to be spent for butter on Sundays and ice cream once a month "for the children." Our relations with our neighbors were most cordial, and when we called and sat in a room bare of everything but a deal table, two chairs, and a holy image, a bottle of wine and a dry *gâteau* were offered.

All was not entirely roses. During the summer of 1926, suddenly the franc fell alarmingly and without warning. Or, the dollar rose, whichever way one wanted to look at it. The G.'s however did not profit, as a considerable number of dollars had been changed into francs previously.

The franc fell so alarmingly, indeed, that France was shaken. The mysteries of international finance are shrouded not only from the common man, but from statesmen as well. It was no wonder that some of the people of Isle-Adam blamed "the pound." In these emergencies anyone who is English-speaking is a *"sale anglais,"* and the G.'s began to hear this unpleasant phrase muttered in the streets as they passed. Next, a couple of stones whirled past our heads and landed at a distance. We retired to the high-walled garden for an indefinite self-imposed exile, like the Pope in the Vatican, and Berthe and the cook were our contact with the outside world.

During this time, one morning we found on the doorstep an enormous envelope with a black border an inch and a half wide. It contained a huge sheet of paper, similarly bordered, which prayed us to attend the funeral next day of a young soldier who had died while on military duty in Algiers, and it listed the sorrowing relatives down to remote cousins and

in-laws. This is the French custom; the announcement is placed at every door in the street, and is not expected to be accepted.

W. G. was confined to his bed, but he observed that, since we were foreigners living in France, and the deceased was a soldier who had died in his country's service, he thought it fitting that in this case the rest of us should attend the funeral. It was so unlike father to make any suggestion about what anyone should do under any circumstances that his pronouncement was weighty and impressive; and of course we felt that he was right.

So, the next morning, as the funeral cortege passed our door with solemn tread, the family swathed in veils and black bands walking behind the hearse, E. G., Lenna, Peppy and I. G. slipped out the front door and fell in behind, with a few other stragglers. It seemed unlikely that epithets (or stones) would be hurled at mourners in a soldier's funeral.

The procession passed down the Avenue de Paris to the church. Most of the dead boy's fellow-townsmen had considered it sufficient to show their respect by standing along the streets to watch the funeral pass, so we were observed by all the town.

At the end of the services, as was the custom, we had to file past the coffin and shake hands with the weeping mother, father, brothers and sisters who stood in a sort of receiving line on the point of collapse.

But after this ordeal we were accepted once more, and as the franc leaped back to its former value within a few days, the clouds were permanently lifted.

When it came time to leave Isle-Adam for a winter in Paris, the problem of what to do with the guinea hens arose. The landlord returned to go over the inventory, and he kindly said that the birds could just as well remain where they were and join the hens in the poultry house; so that was settled. E. G., however, slipped two hundred francs into his not-unwilling palm to pay for the birds' feed.

The next summer the G.'s returned to Isle-Adam, but rented a different and less expensive house. Berthe was sent around first thing to collect the guinea hens, but returned much perturbed to say that our former landlord refused to give them up and said we owed another two hundred francs for their board over the winter. He knew they were pets.

Our faithful Berthe was the most furious of all. She could not see such a *truc* being played on her people, and had she not tended one of the

guinea hens herself, when it caught a cold, and put Vaporub down its throat, curing it in no time? She urged an immediate visit to the *avocat*, and to the *avocat* W. and E. went. But the gentleman was a real estate agent on the side, and one of his clients was our former landlord, so he refused the case. Another lawyer was visited, and he accepted with relish. Lenna, who had a legal mind from the age of five, pointed out that we had boarded the two dogs all summer. Now in France there is a legal price for the board of a dog (then it was ten francs a day), but the French, though they think of almost everything, have never set a legal price for the board of guinea hens. The Glackenses entered a counterclaim for the summer's board of two dogs.

Within a reasonable time the Great Guinea Hen Case was heard at Pointoise, the chief town of the *département* of Seine-et-Oise. In spite of sore temptation the G.'s felt it would be undignified to attend, but nothing could keep Berthe away. On the appointed day she donned her lemon-yellow shoes and left by an early train for the halls of justice. She returned in the evening all agog, having had the time of her life. We had won the case.

Her account of the day's proceedings was, as can be imagined, listened to with rapt attention. Even W. cast an amused eye in the narrator's direction.

The learned judge had been unable to conceal his surprise at the vast sum claimed for the board of two guinea hens.

"What," he inquired, "did these *pintades* eat?"

The defending lawyer, thinking quickly, said, "Wheat."

"Oh no," said the judge. "That is illegal in France. Wheat is reserved for human consumption. I should think," he added, "they had been fed on *biscuits* and *gâteaux*."

One of the *pintades*, moreover, had died of natural causes during the winter—or so the faithless landlord claimed. But dark suspicions (having to do with the guinea hen's well-known succulence) were entertained. The G.'s' lawyer put in a claim for the value of the departed bird; and the foolish *propriétaire* was obliged to cough up to the rich, dirty Americans, or English, or whatever he chose to call us, a whole summer's legal board for two dogs, the value of a guinea hen (one dollar) and the costs of the trial. Which sum E. requested the lawyer to donate anonymously to the Société de Bienfaisance of Isle-Adam. But when it was listed next

week in the local paper, the lawyer had entered it as *"Souvenir d'une Pintade."* The G.'s' opinion of French justice was high.

That autumn better arrangements were made for the remaining guinea hen. She went to join the orphans at the asylum (it was Lenna who observed she looked just like them anyway), and Soeur Philomène said that she intended to get her a mate in the spring and raise a brood. The guinea hen lived long and happily with the good nuns.

At Number 51 rue de Varenne, a *rez-de-chaussée* apartment housed the family for the winter of 1926–1927. It was at the end of a long court or *cité*, and it was pompous, with furnishings in the school of decoration E. termed "gilt chairs and bad art." The flat boasted seven crystal chandeliers, but only one bathroom. A large salon and a dining room overlooked the garden next door, to which there was no access. We were only a few doors from the Italian Embassy, as the agent pointed out, but we had no business with the Italian Embassy.

Here we came under the tyrannical sway of that most awful of French institutions, the concierge. A combination of gorgon, sentry, extortionist and Gestapo, these concierges hold your goings and your comings in the hollow of their hands. They are all descended from Madame Lafarge. They distribute your mail, or not, as they see fit. They tattle to the landlord and the police; they love malice; and they are forever making a salad in their noisome cubicles in the passage. By night they sleep with a string tied to their toes, so that you cannot get into your own home after midnight without waking them to press a button and unlock the great iron gate. On rainy nights they take an extra forty winks before letting their shivering tenants pass. As the French equally hate the institution of these creatures, their continued existence reveals a hitherto unsuspected strain of masochism in this great nation.

W. found a useful studio near the Luxembourg Gardens; it had once belonged to Rosa Bonheur, and it was said that "The Horse Fair" had been painted here.

The Pène du Boises were living outside Paris at Garnes, and were often in town. After the day's work W. could walk from his studio to the Café du Dôme, Boulevard Montparnasse, where they or other friends were likely to be found, and have a fine *apéritif* hour. It was the life he liked best.

Dr. and Mrs. Barnes appeared unexpectedly one day, and as they were on their way to Basle to inspect some works of art, they persuaded W. to accompany them. Otherwise, he painted the whole winter without interruption.

Lenna was sent to a nearby *lycée*, which compared unfavorably with the communal school at Vence. It was an enlightened school and the children were given exercises at recess. They were lined up, and each one jumped once over a rope held one foot from the floor.

Soon to assist Berthe appeared an English maid named Ivy. She looked very Burne-Jones and spoke no French, but she and Berthe hit it off well. Ivy had become engaged to a French boy working in London, and he had inveigled her, with honest intentions, across the Channel. But when his family beheld his choice, who could neither speak the language, cook nor do anything else, Ivy was gently but firmly jilted. The poor girl suffered greatly and would not eat, until E. began feeding her a tonic. In the spring she returned to London by air, which was very expensive then, and E. counseled her to tell Englishmen that she had been engaged to a Frenchman but soon thought better of it, and that Englishmen were good enough for her. E., irrepressible, even demonstrated how to say this, and how to toss her head and give a knowing look, which amused the rest of the family, probably, more than it did Ivy. But all hoped poor willowy, ineffectual Ivy would profit by the lesson, and when she left she appeared to say good-by complete in a Paris ensemble with expensive luggage, and looking very grand.

But Ivy was not the only one to discover that the ways and customs of foreign lands can never really be mastered, and when in Rome one can but hope to *approximate* the way the Romans do.

Several charming Frenchmen and their wives, people connected with art, were invited to dinner. E. was determined to do everything in as French a way as possible, cost what it might, for the French are peculiarly devoted to their own customs and peculiarly averse to trying anything new. Even some ordinary article of food, if prepared in a way unfamiliar to them, is apt to be refused with expressions of horror.

The actual menu offered few difficulties, for Berthe had developed into an excellent cook. The wine was W.'s department, and that offered no difficulties. It was in the matter of *plates* that E. collided with custom and yet triumphed in an unexpected way.

E. had it firmly in mind that the French, though they will eat right through a meal using the same knife and fork, like to have a new plate set before them and the old one whisked away every few moments. There were not enough plates in the house to do this with sufficient frequency, and so a screen was set up in a corner of the dining room, next to the pantry, behind which an underling stood all through dinner madly washing plates for Ivy to exchange for old ones.

The dinner progressed very well, plates came and went with lightning rapidity, and the success of her plan so pleased E. that she suddenly said to the entire dinner table, "Do you know what is going on behind that screen? They are washing plates—we don't have enough!" To divulge such a domestic secret was a thing a Frenchwoman would rather die than do. The revelation was greeted with peals of laughter, and the ice, already broken, melted away entirely. Laughter, conversation and cognac flowed late into the night, and when these gracious people left, they spoke particularly of the pleasure they had enjoyed in experiencing a *typically American* dinner and evening! All that plate-washing had been in vain. But E.'s natural, cordial informality had won them.

E.'s father had perceived that his daughter was a comedienne; she was also a clown. One Sunday morning, about this time, she decided to follow the fashions and cut off her hair, which was thick and brown. It was a momentous decision for a woman to make in those days, but E. took it lightly. She brushed her hair down in two thick locks on either side of her face, entered the room with a pensive, downward gaze, and announced:

"Elizabeth Barrett Browning!"

She then vanished, and returned in an instant with her hair short, but holding one of the shorn locks to her chin to resemble a beard, and with a jaunty air.

"Charles Dickens!" she said. And she had managed to look exactly like the well-known pictures of both.

The Paris winter proved milder than a New York one, but the less adequate heating arrangements made a hot *grog américain* at a café in the evening very popular. There were in Paris several interesting people who appeared now and then for meals in the rue de Varenne, among them Leo Stein, the writer and critic and brother of the celebrated Gertrude, and his wife. Leo Stein thought his sister was crazy, or so W. privately

said. Of course she was as crazy as a fox, even when later she returned
to her native land for a lecture tour and went about informing the
country that there was no American art. (She owned much salable French
art.) The G.'s did not know her, but Dr. Barnes did, and an account
filtered to our ears of a chase around a dining table in the rue de Fleurus,
Dr. Barnes in pursuit, not so much of Gertrude as of a canvas by Picasso
that was in her possession. Dr. Barnes won, at a good thumping price.

Lou Glackens making Philadelphia life bearable by means of a homemade hookah.
Caricature by himself.

If it was damp and chilly in Paris, it was much worse in America,
where the winter was severe, and Lou Glackens kept the family informed
of this and of events, or the lack of them, in Philadelphia. Lou's was a
dreary life in Philadelphia, but it was the year of the Sesquicentennial
there, and this afforded him unexpected pleasure, though not the kind
intended. He wrote to E. G.:

> Still the Sesqui keeps open (at a reduced rate). Most of the buildings
> have been torn down and there is nothing to see but wrecks and wreckers, but
> if it is closed completely the Sesqui Association will not be able to collect a
> new $5,000,000 from the City, which council is expected (and will) turn over
> to it this month.
> The whole affair has been the most stupendous failure on record. Every
> concession was a failure and the City has got itself in wrong with all the
> Foreign Governments who were foolish enough to send exhibits. Wild promises
> were made with no possible chance of fulfillment. I am sending a clipping

which through some oversight got into a Philadelphia paper, and to which I could add considerably more if I did not hate to run down my own town. One fourth of the visitors were deadheads and almost half of the remainder children at half price. Over (how much will doubtless never be known) $20,000,000 was spent on the show. Almost $4,000,000 was spent for the erection of towers that were never completed. The maker of the lenses for the lights (that were to be seen as far as Boston) would not part with them until paid and as he never was there were no lights. The contractors that belonged to the gang will get theirs for the filling in of the ground, building, etc., but the other victims will receive but a small part (if any) of their bills.

Save for students of history this city has no interest for anyone and from now on cobwebs will accumulate faster, the town will be again forgotten by the rest of the world, and Philadelphians will still continue to believe that they live in the center of the universe. . . . With love to all,

LOUIS

In the following autumn, after the second summer at Isle-Adam, the caravan of G.'s invaded England, and spent some weeks at Sidmouth, Devon, to be with Charles and Irene FitzGerald, who had shaken the dust of dry America from their heels and gone there to live after a first move to Dublin. The FitzGeralds were in Paris for a few days in February, and Charles made a tour of the bookstalls along the Seine, as he had so often done in his youth. His eye lit on an ancient dictionary of English slang, and in it he discovered to his joy an old synonym for his native Ireland: "Urinal of the gods." The discovery of this calf-bound tome was worth the trip.

The American Legion convention was to be held in Paris that year, and the G.'s were thankful that they would not be in the city at the time. W., however, was obliged to return to Paris, and wrote E. the news from there:

Paris, Sept. 29, 1927

Isadora Duncan was killed in an automobile accident at Nice. The story is that she was learning to drive a new automobile given her by Bob Chanler who was going to marry her. While driving, a long scarf she was wearing was blown out by the wind and one end was caught in the wheels and she was dragged out of the car under the wheels and killed. A very unlikely story, especially about her marrying Chanler and his giving her a car. DuBois says he has not got enough money to buy anyone a car. . . .

The coast of Devon at Sidmouth. The Art Museum, Princeton University.

The American Legion behaved themselves very well and there was no drunkenness at all. Most people feel a bit disappointed. The procession was very amusing and was more like a carnival parade than anything else. The only ones to carry arms were a lot of girls in khaki. The procession was led by a huge woman in white representing the goddess of Liberty with a torch in one hand and a flag in the other which she waved wildly around. Many thought her pie-eyed.

William Glackens was antipathetic to everything in England. To I. G. in London he wrote:

Paris, Hotel du Ministère, 17 Oct. 1927

I have seen very little of the old places in London. Ned [FitzGerald][1] took me through the slums one night (in 1906), we had a detective with us for protection but I don't think we needed him. It was very sordid. Of course I know there are many fine old relics in London and when it comes to buildings of a past age I think it is just as interesting as Paris but it has no romance to it. That is not like Paris. It doesn't look romantic. Paris does. London is a very dreary old town with its rain and fog. You would have to have lots of friends to stand it.

[1] Brother of Charles FitzGerald and manager of the actor Sir Charles Hawtry.

He had learned that Lenna wanted to make etchings, and said of that:

Making copper etchings is not a very intricate thing but it takes a lot of practice to do it well. I have tried it but it requires more patience than I have. I will be glad to teach Lenna all I know, it won't be much.[2]

Yes it will be less than a week after you receive this letter that we will all be together on the boat.

The romantic appeal of London being mostly a literary one, the city could not be expected to move W. G. Though the only books he never read were art books, his preferred reading was not the English classics but the works of George Moore and the philosophy of William James.

W. G. was at times troubled with headaches, bronchitis, and various other aches and pains. E. was a determined doctor-goer. She thought French doctors geniuses, and the doctors of all other nations little better than medicine men. W. meekly, and even perhaps willingly, underwent all sorts of treatments for the alleviation of his malaise, and several times returned to France from the U. S. early in the season to undergo courses of treatment from this or that Paris doctor who was at the moment high in E.'s books.

The spring of 1928 was one of those times. W. left in March, and E. followed with Lenna as soon as her school let out.

W. was lonely in Paris, except when his favorite Paris friend was in town. This was Tommy Slidell, a painter and a Southerner of the old type, who lived in a comfortable house in Passy. He was a gourmet and a lover of good wines, and his house, furnished with heirlooms, seemed to be a bit out of another world. Tommy was a descendant of Slidell of Mason and Slidell fame, Confederate commissioners whose seizure off the British ship *Trent* in 1861 nearly caused war between the U. S. and Great Britain. Slidell had many fine old recipes which were prepared for him by a genius of a cook. To make him even more congenial, he was a fisherman.

W. G. to E. G.:

Paris, Hotel du Ministère
April 4, 1928

Had lunch with Slidell Monday. He had a little model out there who lunched with us but never opened her mouth except to put food in. He tells me he is going to have an exhibition this Spring. He asked about you and

[2] But the reader is referred to the etching reproduced in this book.

the Prestons and sends his best salutations. He agreed to go fishing for a week down in the Auvergne but on my way home I stopped in at our pharmacien and he told me it was much too early for fishing, that it would be no good before May and even better in June. He said that salmon was the only fish that could be caught at this season. . . .

Slidell is the only person I know in Paris. . . . The duBois [are] at Garne and Maurice Sterne who was here left for Spain last night. However the two men I met on the boat have been around and I have been out to dinner with them a couple of times and they are dining with me tonight. I shall try to get Slidell to come along.

A new Cafe called "La Coupole" has opened quite close to the Dôme. It is huge, looks like a waiting room at Grand Central Station, only much larger. It is crowded every night, largely by the French. It has a roof garden and there will be dancing as soon as it grows warmer. I had dinner by myself there last night, it was pretty good, not wonderful, and then I spent the rest of the evening at the little movie theatre on Boulevard Raspail and saw an awful sloppy French movie just as bad as ours. . . .

W. G. to E. G.:

Paris, April 14, 1928

Have just received a letter from you dated March 31st. Two weeks in crossing and being delivered. Seems pretty slow. Your newspaper clipping about John Sloan's picture I read in the Paris Herald just two days ago. They must get some of their news by mail. I think this unknown man who is buying the pictures is the same one who bought a lot of his work before. You must have met him at that dinner the Sloans gave. I sat next to his wife. You will remember her as the lady with the well marked bow legs who was dancing around there. She told me they were thinking about giving a dinner to the old Eight crowd. I said I thought it would be a fine idea but to wait until next fall as I should like to attend. . . . They are from Philadelphia. She was a music teacher (information first hand) and she married a man who has since made a barrel of money in some way. I think she is the one who is getting him to buy the pictures. . . .

W. had been obliged to leave New York before the opening of a show that John Kraushaar gave him at his gallery.

You seem to think my show looked pretty good. I appreciate Henri's letter very much. If he is not on his way to Ireland tell him so. . . . I hope Lenna is having a good time and is keeping well. The only interesting animal I have seen here is the Dôme cat. An old Tom who occupies always the same chair

and is always asleep. He is the most regular of all the habitués. The Friesekes are back in town. . . . I am sending with this a list of all the pictures I had at Rehn's including those he sold, the prices are the old prices. I have some at Daniel's yet. I send that list too, and one at Montross. . . .

Henri's letter that pleased W. was short but to the point. As it had been since the nineties, Henri's appreciation of other artists' work was given with whole-hearted generosity:

<div align="right">10 Gramercy Park,
March 29, 1928</div>

DEAR EDITH:

Glack's show at Kraushaar's is so beautiful that I paraded down Fifth Avenue stepping high because of it.

It certainly was a joyous sensation I had when I went into that gallery.

I am so sorry he went off too soon to have a glimpse of it himself.

One of W.'s duties in Paris was to house-hunt for the summer. Years of domestic life had taught him what to look for.

<div align="right">Paris, May 5</div>

I have been hunting villas. I have been down the Seine as far as Les Mureaux, visited Verneuil, Vernuillet, Triel . . . couldn't find anything that would do and so I have gone back to Isle-Adam and yesterday I said definitely to Mme. Coulerou that I would take a certain villa if the landlady would do certain things, woolen blankets, a little more furniture, etc. It is on the route to Beaumont, the corner of the rue de Croix Rouge. It is a funny sort of place, plenty of room for us. A nice garden with quite a number of ornamental trees. The place is pretty well appointed, good lavoir, good kitchen, plenty of utensils for the cuisine, clean beds and a good garage with a fine big room over it with a large window that I can use for a studio. The window looks west but it will be a good light in the mornings anyway and in the afternoons I can work in the billiard room, a huge place. The drawback is its distance from the station, a trifle further than the ———— place. . . . I was going to try to make a sketch of it from memory but it is too complicated. It has a corner tower with a candle extinguisher top, winding staircase in the tower. . . . It is in fact two houses joined together with utterly different types of architecture. Nobody but a French architect would have done it. . . .

It will only be about two weeks from now before you start. I am glad of that. I shall take this letter over to the station and mail it there. Let me know what boat you are taking and when it lands. I shall get rooms in town as you will probably want to stay here several days. A double and a single. I don't know Ira's plans.

I am moving today to the Studio Hotel No. 9 rue Delambre. I shall be able to paint there. I am sick of this place and couldn't stay any longer.

> Studio Apartment Hotel
> No. 9 rue Delambre
> Paris, May 8th, 1928

DEAREST TEED:

I received a phone call from Berthe yesterday and she is coming to see me Sunday afternoon. She has a job out at Auteil. . . . I haven't heard from Isle-Adam with respect to the villa. I saw the Coulerous Friday and they said they would write to me as soon as the lease was ready (12,000 francs for the season). I hope it does not fall through as I will have another job hunting for a place.

I am painting at present having taken one of those studios until the end of May, trying my hand at some flowers. I saw Judge ———— at the Dôme yesterday. He seemed a little bit tight to me. He was much interested in hearing about the Shinns.

Maurice Sterne with Mr. and Mrs. Sam Lewisohn have just returned from Spain. Sterne introduced me. They appear to be very pleasant and we spent the evening at the Dôme. He has a couple of my paintings. . . .

I had lunch at Slidell's Sunday again. It seems that I am always there. A Mrs. Havemeyer and a Mrs. Delaney were there, both old friends of Thomas's. We had a very good lunch as usual and then they left. Slidell and myself proceded to St. Cloud in his car. I saw Mrs. duBois for about a half hour yesterday. Guy is on the waterwagon and is very much disgusted with his work. She asked Slidell and myself to drive down and see them next week. Haven't seen duBois since the last of March.

I can amuse myself the rest of the time until you turn up at the end of May in painting. I have a studio at the top of the hotel and the light is quite good. I would have liked to see the Goya show but I can't get down to Spain, haven't the time.[3] My two weeks vacation will be up next Monday when I start another series of piqûres. I won't get any fishing either, unless it is week-end trips. It is too early for fly fishing. It is exactly the same here as around New York. We have had some quite warm weather but yesterday afternoon the wind began to blow and today it is quite chilly. Have gone back to a heavy overcoat. I got Lenna's letter with the lovely little drawing and am very glad her party promises to be such a success.

Your letter April 25 has just arrived and although you mention when the

[3] The great Goya exhibition at the Prado, on the centenary of his death.

Prestons sail and what boat I haven't the slightest recollection of your mentioning what boat you and Lenna take. I think it will sail the 18th but I am not sure; of course I will get information from a later letter. It takes such a long time to get news. I am glad that a few anyway liked the pictures. I would have liked to see how they looked on the walls. . . .

I received a letter from Barnes yesterday. He left for Berlin Monday morning where he will attend an important sale. From there he goes to Belgium. He asked me to come up and join him if I felt like it. Of course I don't. I can't fly around the way he does, and besides I couldn't go anyway. . . .

I will be awfully glad to see you when you get here. I am alright. I had a cold in the head that still lingers on a bit but I haven't been bothered with bronchitis. . . .

I will have to write to Ira to find out when he expects to get to Paris.[4]

<div align="right">Your impatient WM.</div>

And the medical treatment? E. wasn't there, and the year before, concerned over whether W. would follow doctor's orders in her absence, she had asked Mrs. Guy Pène du Bois to check. Floy du Bois, the last person to depend on in such a matter, in time did remember her promise to Edith and asked about the pills.

"Oh, those," said W. G. "I threw them all in the Seine the day after Edith left."

<div align="center">The Seine at Paris, Drypoint</div>

[4] I. G. was in Spain, but planned to spend the summer with the family.

Robert and Marjorie Henri preferred to spend their summers in Ireland. Robert Henri sought his subjects mainly among types of Spanish gypsies or Irish peasants, and so the Henris and the G.'s met only when they were all in New York. But Marjorie wrote a long letter to E. G. at Isle-Adam:

<div style="text-align: right">

Corrymore House, Keel P.O.,

Achill, Co. Mayo, Ireland
</div>

DEAR EDITH:

It was a treat to get your letter. Roberto and I have been thinking of you all a lot, picturing Ira in Madrid, and envying him too, for you know we love Spain very much, and if "The Boss" could be here and there at the same time, all would be happiness. He hated missing the Goya centennial and all the rest of it, and as you know we would have gone there about April 1st if things hadn't gone "all thru other" (as they say here) with our plans last year, so that the Spanish part of the trip would have to be rushed. Also somehow the thought of that extra travel, customs, long train trips—and rush and tickets and hurry—gave the Gov. cold feet—and made coming to Ireland direct, seem like a bus ride on 5th Ave. in the off hours by comparison.

He wasn't feeling top notch when we started but once here the miracle happened. He liked it as well as ever Be God—started in fishing right off—no painting for the first six weeks—just outdoors from about two—until midnight—He and Pat fortified by a fine lunch and a flask of Irish—which according to Pat would make any man fit to row and fish till day light. His joy and happiness when he lands a large white trout give a mere woman like myself a queer little feeling around the heart, so often described by Mary Roberts. He's daft after the fishin' and no mistake is the way Pat puts it.

He blew himself to the finest rod and then of course discovered that there was a still finer one, which he didn't really feel he ought to splurge on. It cost about $80.00. So I broke the going way of twenty long years and gave him a present—feeling very flush from my sale of 3 drawings. I bought him the rod

that looked so nice in the catalogue. He was delighted and said it was a shame I didn't make more drawings. I promised I would. Right from the start my rod has been the winner. So you can imagine how bucked up I feel. Before finishing with the Most High I must report that he feels fine, looks fine and has lost any cushy turn he had.

We have dinner at midnight, then each to his favorite couch to read, I last until about 1:30 and then drop off. It's always three and often later when we mount the stairs to the bedroom. Day is on and great drawings are out the window if I wasn't so sleepy. I'm downstairs at 10:30, but it is usually twelve when Roberto gives the geraniums in the greenhouse the once over. He has his own ideas about the flowers and Mary the housekeeper has hers. You have to be very gentle like when suggesting any changes, and the way Mary pronounces the names of some of the flowers would make even an Irish cow laugh. I leave the spot instantly, it's the only way to hide laughter. The nastursiums (I'm all balled up myself) are "Extrocions"—excursions—and everything else on the map. Mary hates to have anything cut away. Her idea is to have full and plenty—"Shure Sir, 'tisn't often you'll be gettin' your nuff of flowers like, and isnt it a sin to be doing away with even the wuss or thim." Fuschias abound here, the greenhouse being so thick with them that you can hardly pass through.

The hatchet fell the other day however and the place got a good trimming.

The Irish are the greatest natural "Christian Scientists" in the world. They hate doctors, nurses, and as for hospitals, Hell is preferable. They get sick, pay no attention to it until they get tuk bad. Then they go to bed with good drinks of whiskey in them, all the clothes in the house are piled on top of the bed, almost reaching to the ceiling, a huge turf fire is burning always. If they come out of it, "Shure twas the charm like that done it." What is the charm, I asked Mary? "Ah, sometimes it's wan thing and agin it's another. There do be different charms for whativer do be wrong wid you. For the yellow janders now, it's a wee stone that do be put in the hot drink like—and when it's for childer, swellin of the head or chokin—it's werds they do be puttin on em an' it's only certain av the owl people who do have the werds, an' give the charm mind ye." Well, as I said before if they come out of it they're strong husks. Most of them die and then the Fat Sob Priest is sent for but rarely the doctor. There is a district nurse here but then she do be expecting her 10 shillings for bringing a wean into the world—an bilen' wather to hand from wan hour's end to the other—and goes leppin mad if she comes in and finds the child covered up. It's easier wantin her.

A case happened here the other day. A man about 43 had been at work

harvesting in England. He tuk wake in the legs like an' had to come home, and take to his bed—at least to one side of it, for the other was occupied by his wife who was havin' a child like. He lay there, and so did she, but she done her best and was up an' on her feet as soon as you plaze. The neighbors all came in and talked low about the husband's state, "An shure what'll the poor woman be doin' at tall at tall, when he's away—and she wid a houseful of childer," etc. Finally some shopkeeper paid the doctor to come. Dr. ordered the man to the hospital. At the hospital 60 miles away they discovered he was in the last stages of consumption and cancer of the liver. They sent him home as they could do nothing for him. He died about ten days later. I've been thinking it would be a good thing if the new kid followed him. Its bad in color, I hear, and do be throwin' up black stuff the like as tar.

They are always building new churches here, but never a hospital. The nearest is the 60 mile away place. I'm in favor of no religion but I think the Catholic Church is the worst on the map. To get this new kid christened, some friend had to hand over 5 shillings to make the job secure. Away back in the hills here, the most typically forsaken land's end spot, is a small thorny graveyard for children who died before they were baptized, as our Mary says they are shut away for iver from the sight of God. Lucky kids I calls em.

Robert Henri painting the portrait of a Chinese. Caricature by himself.

The Henris' love of Spain equalled their love of Ireland, and so when a letter arrived for W. G. in New York in the spring of 1927, introducing a Mexican mural painter who had come to the U. S., and it seemed polite to invite him to dinner, I. G. suggested that the Henris be invited too. The artist was José Clemente Orozco, and he spoke no word of English.

Señor Orozco arrived before the Henris, and the entertainment that could be tendered him embraced everything but conversation. He was a grizzly, middle-aged man, but in spite of the semisilence enjoined by his lack of knowledge of his hosts' language and their slim knowledge of his, he managed to give an impression so kind, so gentle, and so appreciative of the effort made on his behalf that the awkward situation did not seem so. The conversation picked up a little when the bell rang and the Henris appeared. Señor Orozco was lacking one hand, and it was Marjorie Henri who cut up his dinner for him.

It was not till afterwards—for he had lately arrived in the country—that his powerful art became known to either his hosts or anyone else; and none of us ever saw him again. It was, as so often, difficult to associate the artist with his work.

But Robert Henri would no doubt have given it full understanding. For more than thirty-five years Henri had been inspiring his fellow-artists. He was a quiet man, who spoke quietly, but there was an inner conviction in what he said that brought out the best in all the artists and students who ever came under his influence. His remarkable book *The Art Spirit*—a compendium of informal observations uttered in his classes, and transcribed by one of his pupils, Marjorie Ryerson—continues to do the same, for in it Robert Henri's voice is still heard.

In the late months of 1928 the news arrived that Robert Henri was in St. Luke's Hospital. He was suffering from some acute form of neuritis.

The G.'s were leaving for France again that spring—W. had gone ahead, and the rest of the family followed. I. G. went to the hospital to see "Uncle Robert." Marjorie was with him all day long.

One of his canvases was propped on a chair at the foot of his bed so that he might study and contemplate it, and there were fishing rods in the room, and catalogues of piscatorial equipment lying on the bed. He would soon be out of the hospital and in the country.

I had brought him a book that might interest him, a life of the notorious Claflin sisters by Emanie Sachs, called *The Terrible Siren*, and

this was the last book he ever read. I had the melancholy satisfaction of hearing later that his interest in this book was so great Marjorie had been obliged to read it to him by the hour. When the G.'s were in Paris in July a cable came with the news that he was dead. W. G.'s oldest friend, with whom his whole artistic career had been so closely bound up, was gone.

Marjorie Henri to E. G.:

10 Gramercy Park, July 25th
1929

Dear Edith—

I wanted to get this off to you last week, but couldn't. I know Raymond Lowes has written you, but he said he did not put in the real cause—which is that Robert died from cancer, which had gone through the bones of his pelvis, making millions of little perforations. There was no chance for an operation, and no chance but for him to wait.

When Dr. L —— found that he couldn't operate, and things were as they were, he decided Robert should not be told, and that no one outside of the doctors and myself were to know—that it was true Bob had neuritis, caused by this thing leaning on the sciatic nerve so the thing to do was to make it neuritis. They only gave him the radio therapy treatments to lessen the amount of morphine. I think at your last visit the treatments had been discontinued, and it was then he began to get the morphine in large quantities.

I figured out, Edith, that if no one in the world knew but myself, I could pretend and plan with him, and keep up the lie, but that if anyone else did they would be bound to show there was something serious, and Robert would get it. But when you and everyone else, raised the deuce because he was so slow coming out of it, and should try another doctor—all this was wonderful for Robert. He told me two weeks before he died that he himself was getting fed up with L —— and would like to change to some one new, but would wait until we'd gotten off to the country with Hilda and the two nurses. L —— was to drive me out to look over this place, and though L —— did not think Bob could make the trip, well, even then he expected him to last far into August, still he agreed, that a change would make him happier.

I can't say enough about L ——. He acted up in every way, used to stay with him for a half hour, or longer, talking fishing, Flies, Trout—and convince Bob that he was now at the lowest state, and was on the up grade, convalescing.

When Bob knocked the darned old radio therapy, and blamed it for being the cause of his weakness—and the long delay in his getting well—L ——

agreed and said, Well, Mr. Henri, in our effort to get you out of here in a hurry maybe we have given an overdose, and though it doesn't hurt most people, still, no two people are alike, etc., etc. And I will see that you get no more of it. Often L ———— would just crumple up, when he got outside Bob's door, and say, "My God, I hate to lie to him, but I can't tell him the truth."

Well, Edith, that's the way it's been. Robert was so sure July 6th that we were going some place near a trout stream that he would be able to fish in later, he gave me a million orders about rods, etc. Then suddenly one night he wasn't so strong in his "Good night" or "Take care of yourself." The next morning a slight state of coma, which grew, and from which he never woke up. He died most beautifully, never a sound, or death rattle, or movement, or anything—just a drifting. I was there, and so was L ————. And Bob just went out without knowing a thing, and this was what I was praying for, as I didn't think I could stand it, if he woke up, and realized he was going and would never paint, or see any of us again.

We made the funeral, according to orders made when George Bellows went—no fuss, no church, no tax or strain on friends, just cremation, and that simplified down to nothing.

My sister and I leave for Atlantic City tomorrow to just browse and be pushed up and down in a chair. I need to get fat, and forget the last nine months. All my love.

Brave Marjorie Henri had kept up the terrible strain for nine months, concealing the true facts not only from Robert but from all the world. And before the G.'s came home, so anxious to see her, she fell ill and followed him.

CHAPTER TWENTY-EIGHT

On February 16, 1929, the Glackenses' silver wedding, they were in New York, and E. arranged a fine dinner and invited friends. She ordered little peppermint hearts with "W" and "E" entwined on them in pink icing, for sentiment's sake. Rich food was provided, and candles, flowers, and everything but soft music.

That the evening was a great success was proved by the late hour at which the guests left. George Luks had come bearing as a gift a portrait of Lenna, dashed off with his customary exuberance one afternoon when she had posed for the Luks class. But even he and the beautiful Mercedes had departed, and Ernest Lawson alone remained, deep in conversation with his host. E. finally retired, leaving the two old friends in the dining room, leaning against a tall piece of furniture which was in reality a pile of extra leaves for the dining table, on top of which stood many dozens of glasses—for the evening somehow had required a large number.

Not long after E. was in bed, two flights above, she was startled by a terrible crash. She guessed at once what had occurred, and flinging on a wrapper, she hurried below. There in the middle of the floor sat the two distinguished artists, Lawson and Glackens. They were deep in conversation. The leaves of the dining table lay helter-skelter, having come down in an avalanche; and everywhere were dozens of shattered glasses, standing upright like stalagmites on the floor of a cave. But this catastrophe had not been allowed to interrupt the conversation for a moment.

Hastily securing a broom, E. began silently to sweep up the jagged glass. But though the talkers appeared not to notice her ministrations, W. G. did, for he finally spoke:

"Away!" he said with an imperious gesture. *"You and your broom!"* And he returned to the discussion.

E. completed her task and retired for the second time, nibbling a peppermint heart.

Finally Ernest said he must be going home, and put on his hat and coat. W. decided to accompany his friend to his door, and the two set out.

But they did not progress very rapidly, and later *it was said* that the two artists were seen seated in the middle of Sixth Avenue, under one of the old El pillars, as deep in conversation as ever. What was the subject of their discourse? Life? Immortality? Fishing? Wine? The best way to prepare mushrooms? Even, perhaps, Art? Nobody knows.

It was not that W. G. was without conversation; it was only that a voluble mood came upon him infrequently, and then usually amid old friends in a sociable atmosphere, on a rare occasion like a silver wedding.

For many years W. was accustomed on Sundays to go for a long walk in the country. His companion was always Jimmy Preston, and sometimes William Carman Roberts. A favorite objective was the country around Suffern, New York, which was then particularly wild. Care had to be taken in planning the excursion in order to catch a train back to the city at a reasonable hour. Once W. and Jimmy got lost and came out on a road far from where they intended.

It was growing late, they were several miles from the station, and worse yet, it began to rain. So they pretended to be lame, in fact crippled, and whenever a car approached, they hobbled in pathetic affliction, leaning on each other. But the hard-hearted motorists all whizzed by, leaving them to the darkness and the storm, and they did not reach home until a late hour, drenched to the skin.

May Preston said to Jimmy, "What do you two talk about all day long?"

"We don't talk," said Jimmy.

After W. G.'s death Jimmy wrote to E., "I think of his quietness and his long silences, and somehow peace comes to me as it used to do in the many hours I trudged by his side."

William Carman Roberts, the occasional third companion on these hikes, was the brother of Charles G. D. Roberts, Canada's poet laureate, and for many years an editor of the old *Literary Digest*—a kind, gentle but powerful man who could never do too much for anyone in trouble. His wife, Mary Fanton Roberts, onetime editor of *Arts and Decoration* and several other magazines, was a particular admirer of The Eight from

the start, and gave them much publicity. She entertained the Russian Ballet; and Pavlova, Nijinsky, and other fabulous figures from the great days of Diaghileff were to be found at the Robertses' apartment in East Eighteenth Street.

When I. G., who had been taken to see Pavlova and Mordkin dance in the ballet *Coppélia* before he was four, learned that his father knew the beauteous Pavlova, indeed had met her several times, he asked in childish ecstasy, "What does she look like?"

"She looks like a turtle," was the reply. It was almost as bad as the revelation about the Dead Ophelia. But W. referred to the fact that Anna Pavlova wore a fur coat with a high collar that almost concealed her head.

Isadora Duncan was another of Mary Roberts' enthusiasms, for whom she rendered many services and got few thanks. When Paris Singer (the "Lohengrin" of Isadora's autobiography) bought Madison Square Garden for her to dance in, he asked Billy Roberts to be his agent so that his own name would not appear. The sensation was great when Billy Roberts' friends read in the papers that he had bought the Garden, and one paper printed a cartoon of "Billy Roberts wondering what to do with Madison Square Garden." Isadora wondered what to do with it too; it was too big even for her, and it soon passed into other hands.

While in France, Lenna had developed an overwhelming desire to own a French poodle, but in 1928 they were not in fashion and none was to be found. Rumors that there were poodles in Brussels had sent the whole family there in search, totally without success, and almost a year elapsed before a small black puppy was acquired. Lenna named him Imp.

In no time Imp ruled the whole family, and more particularly W. G. In New York, W. took him for a walk every late afternoon when painting was finished for the day. W. G. with a red wool scarf around his neck, and Imp with a red silk hair ribbon, were familiar sights in Ninth Street. Imp went where he pleased, dragging W. G. back and forth across the street to every hydrant he saw, and people observed, "I saw Imp out with your father yesterday." I spoke to father about this. "It's his walk," he said.

Five times Imp crossed the ocean. He served the bread at dinner, running around the table with a basket in his mouth. He ate tangerines on a paper napkin on the floor, holding the fruit in his paws and neatly

peeling it with his teeth and then eating it in sections. He had a passion for cats, and if a cat showed fear or disdain, he sat up and prayed to it. Imp believed in the efficacy of prayer. When the waves swept his rubber ball out to sea at La Ciotat, he did not dash into the sea after it, but sat up on the edge of the sand and prayed the Mediterranean to return it to him. The ball rolled back on the next wave.

When W. was painting "Lenna and Imp," a large canvas, in Paris in 1929, E. G. put a rubber chop, Imp's favorite toy, on top of her head, and jiggled and jumped in circles to make him pose. This accounts for the alert look in his intelligent eye: he is gazing in astonishment at E.'s curious antics. An artist's wife must labor much for her husband's art.

But it was Berthe, the faithful Berthe, who had brought up Imp and taught him his manners. He slept on the floor by her bed, his head on a little pillow. "I love him better than anyone in the Christian world," she declared. "I love him better than my own grandchildren, the good Lord forgive me!" And when Berthe died, she left the request that Imp's picture, and that of E. G., be put in her coffin.

When the G.'s had returned from their foreign sojourn in the fall of 1927, they found interest in art flourishing in New York. The Whitney Studio Club was soon to open a new gallery at 10 West Eighth Street, around the corner. Juliana Force, the director, was a catalyzing influence for all American art. She was a great admirer of the watercolors of "E. Dimock," and that winter gave her her largest show, which consisted of over fifty watercolors she had made in the last two years. "Some of the People in France," it was called; the *Evening Sun* pointed out it should have been called "Everyone in France." It was a great success, and the whole show went later by invitation to Chicago.

The Whitney Museum, full-fledged, opened in all its glory in 1931. It had a warm, informal air and was a great success from the start. Thanks to Mrs. Whitney and Mrs. Force, American art no longer needed to come in the back door.

Juliana Force, herself a legend now, was responsible for this. Small, vital, with auburn hair, a retroussé nose and a terrifying wit, her extraordinary personality, her electric presence, galvanized any crowd, however large, which she was in. No museum under her direction could help being alive.

Above the museum she had her apartment, and no one was ever known to refuse an invitation to one of her celebrated parties. These often occurred at the openings of new exhibitions in the museum. The apartment was a duplex, whose lower floor contained a long room furnished in a glorified adaptation of the Victorian style, though the gatherings usually occurred on the floor above, in less formal but equally colorful surroundings.

But that Victorian parlor was one of the sights of New York, elegant, handsome and amusing. Papier-mâché blackamoors, inlaid with gold and mother o' pearl, upholding alabaster urns; tufted *fauteuils*; Brussels carpets; music boxes; marble mantlepieces; and curtains of blue satin elaborately looped and edged with large pearls—all gave the room an air at once Victorian, rococo, stylish and amusing.

A socially-conscious artist, who scorned a collar and tie, one day inspected the room unenthusiastically. Its beauty, charm, color and sly humor were all alike lost upon him; he disapproved of everything. (And that is the trouble with the socially conscious.) Finally he came to the curtains and surveyed them with a jaundiced eye.

"What's the idea of the pearls?" he demanded of his hostess.

Juliana Force was not the woman to let such an opportunity slip.

"To cast before swine," she replied promptly in her attractive growl.

About this time W. and E. went for a few weeks to Florida, as both had lingering colds, and while there they received a letter from their old friend and W.'s old collaborator, Harry Grant Dart, once of the New York *Herald*. Harry Dart, who for some reason always addressed Edith as "Ether," perhaps because the name was easier to pronounce that way, was true to form:

DEAR BILLY AND ETHER:

I am in the hospital, due to a collision between a swill truck and a taxi-cab. *I was in the taxi-cab.* At least, I was in it at first, but went right through the window on my way to the truck. They have taken eleven stitches in my chin, but as for my head, they saved time there by using a sewing machine. I haven't any feeling in my head at all, and probably have a bad headache and don't know it. They have been wonderful to me here, doctors, nurses and everybody. For the first three days they wouldn't let me have a drop to drink, not even water. Since then I have tried some of the stuff, and it's really not

bad. They tell me they are going to throw me out of here in another week. Hurry home soon so I can tell you all about my operation.

Harry had succeeded as usual in making light of a serious matter, but he was unable to do otherwise. When Harry's wife had died, long before, he was brokenhearted, and his good friend, the illustrator Wallace Morgan, went with him to help pick out a coffin. Harry mumblingly asked the price of the first to meet his eye. "Fifteen hundred," the undertaker said suavely. Harry hastily asked the price of the second. "Two thousand," said the undertaker.

"Jesus Christ," Harry stammered. "I'm not burying a gangster, I'm burying my wife."

Harry was a friend no one could afford to lose. Shortly after his accident he was persuaded to come and live with the G.'s, and for more than two years he contributed his invariably delightful presence, under which he hid a courageous spirit, to the pleasantness of life in Ninth Street.

Though W. was not a born family man, and a family had been thrust upon him, he was a happy victim of circumstances. Only once did he ever make an overt statement of his opinion of domestic life. On hearing of a fellow-artist who had been divorced, he observed, "A fool and his family are soon parted." E. looked at him in delighted astonishment!

Lenna was very like her father. She too was secretive and contemplative, and equally enjoyed good food. At four she burst into tears because some food she was given "didn't have enough taste," and she wanted spaghetti *marinara* and tasty casserole dishes when other children were content with a lamb chop and baked potatoes. She was W. Glackens' daughter.

But at last Lenna was a young art student, studying awhile with Guy Pène du Bois. Having posed so often for her father, she turned the tables and produced a little study, "William and Imp," a characteristic scene witnessed every day at 10 West Ninth Street. Jerome Myers, gentle painter of street children, taught her the technique of etching, and Lenna's friendship with Jerome and Ethel Myers was close. She often drove with them to their house at Croton-on-Hudson, where the week end was devoted to the etching plate.

Every year through the thirties the du Bois class held a dinner at the

old Lafayette Hotel in University Place. The gathering was called The Rose Madder Club, but its membership regulations were loose, and it included not only the du Bois students but all the old folks and other congenial friends. There were no dues. Reginald Marsh and his wife Felicia Meyer, a du Bois student, Mr. and Mrs. Lincoln Isham, and many more were often present.

At one of these dinners the father of a du Bois student, as he sat watching his daughter, observed sentimentally to W. G., who seemed, as so often, mainly interested in the ash of his cigar, "Isn't it wonderful to see the young people growing up . . ."

Lenna, who overheard this tender remark, later reported with delight what her father's reaction had been.

"What?" he inquired, rousing himself from his reverie. And coming to, he muttered politely but perfunctorily, "Oh . . . Yes . . . Oh, yes . . ." and drifted off again into his own world.

Whether this notion seemed too obvious for remark cannot be ascertained, but he would never have made it. A congenital reticence prevented him from making statements for which even a Trappist monk would be forgiven.

When he returned from a routine visit to the dentist, E. said, "Did you tell him about that tooth that has been troubling you?"

"No."

"Why not?"

"I thought," he replied, dropping instinctively into an old Philadelphianism, "I'd *leave him find that out.*"

He "left others find out" for themselves, but he gathered information of every sort for himself. One cold winter evening Nancy Middlebrook, his future daughter-in-law, arrived in Ninth Street. Having left his studio at dusk, W. G. welcomed her into the living room and sat down contemplatively again with his pipe, gazing at the ceiling or the rug, while Imp rolled his eyes from his usual place on the sofa. Nobody said anything. When W. was present, an agreeable peace seemed to permeate the room, without the need of conversation. They both sat smoking pleasantly. Suddenly W. roused himself a little.

"What *is* a torch song?" he asked.

Nancy obliged him with a demonstration—" 'Why was I born? Why am I living?' " in strangled tones of self-pity. He paid close and amused

Beach Umbrellas at Blue Point, c. 1915

NATIONAL MUSEUM OF AMERICAN ART, WASHINGTON

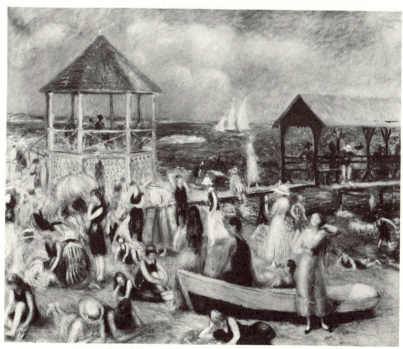

Beach Scene Near New London, 1918

FERDINAND HOWALD COLLECTION, THE COLUMBUS GALLERY OF FINE ARTS

Armenian Girl, 1916

Artist's Daughter in Chinese Costume, 1919

"Temple Gold Medal Nude," 1924

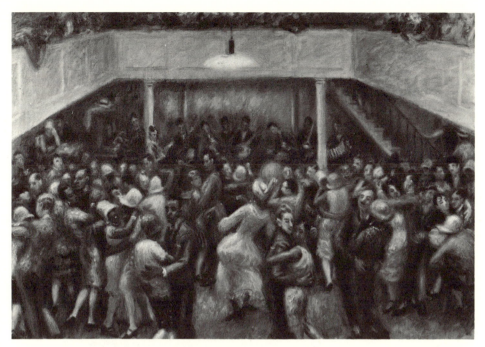

Bal Martinique, c. 1926
KRAUSHAAR GALLERIES, NEW YORK

Beach at St. Jean de Luz, 1929
THE MILWAUKEE ART MUSEUM

Lenna and Imp, 1930

JAMES A. MICHENER COLLECTION, UNIVERSITY OF TEXAS, AUSTIN

Fête du Suquet, 1932

WHITNEY MUSEUM OF AMERICAN ART, NEW YORK

Baie St. Paul, Quebec

NATIONAL GALLERY OF CANADA, OTTAWA

Soda Fountain, 1935

PENNSYLVANIA ACADEMY OF THE FINE ARTS, PHILADELPHIA

Carl Schurz Park

attention. In the middle of the song the rest of the family burst into the house.

"She's showing me what a torch song is," he explained. But he did not explain where he had ever heard of such a thing in the first place.

His knowledge having been enlarged in this field, everyone set out for dinner at Dick the Oysterman's in Eighth Street. Lenna walked ahead and her father: Edith, Nancy, Harry Dart and I. G. followed along behind. W. and Lenna looked somehow so alike, walking side by side, that E. drew attention to them. "See those two funny little people from Philadelphia," was how she referred to them.

"Mama had a sofa just like that when we lived on South Elm Street."

Drawing by Garrett Price. © 1954, The New Yorker Magazine, Inc.

By now W. G. was a celebrity in the art world, but he was perhaps the only one who did not know it. While he had been calmly going his way, uninterested in anything connected with art except the actual act

of painting or looking at other artists' paintings, his reputation had gradually grown. At Mrs. Force's large gatherings, smiling, quiet, pleasant, and surrounded with chattering people, he seemed a little embarrassed at group attention. Always polite, he yet could never feel entirely comfortable at such moments.

At dinner one night, E's sister-in-law, Ruth Bunner (Mrs. Edwin Dimock, daughter of the writer H. C. Bunner), observed that Glack was the only person she knew who *never* showed off.

W. G. looked up in surprise, as though accused of some vicious crime, and defended himself indignantly. He was challenged to cite a single example of showing off.

"I was showing off just now," he said triumphantly, "when I mixed the salad dressing!" And he could not understand why everyone laughed.

W. G. was content to speak in his work, and made very few comments on art. Only one or two seem to have been preserved. At the present time, when significance, social or otherwise, is sought in the work of everyone so avidly, and sometimes so hopelessly, I think of an observation he made to Forbes Watson: "I cannot recollect any great painting that is great for any other reason than that it is a great painting."

From time to time an earnest student brought his work to the house and asked for a criticism. One such occasion was somewhat painful, for the work consisted of indescribably slick and pretty pastels of moving picture actresses, copied from photographs. Why W. G. had been sought out to criticize this sort of "art" is a mystery. He stared at the pastels long and hard, seeking the good to be found in them, some helpful thing to say—and he succeeded.

"They're *skillful*," he said, and proceeded to make a few suggestions that would render them more skillful still.

Yet his patient search for the good that he said could be found in almost every artist's work "if you look hard enough," and that made it impossible for him to say anything harsh when asked to criticize, did not weaken his standards of art in the larger sense. When some paintings were described to him as "pretty good," he made his only severe aphorism: "Pretty good art is like pretty good eggs."

→>>→>>→>>→>>→>>

CHAPTER TWENTY-NINE

In the early spring of 1929 W. G. returned to Paris, and when the rest of the family arrived with Imp from New York, he was well established in a house or *"pavillon"* at 110 rue du Bac under the ministrations of the faithful Berthe. The *pavillon*, an eighteenth-century building, was on a court at the end of a covered alley infested with rats, and next door to Whistler's old studio. One entered on the ground floor, where the living room overlooked a shady garden. The dining room was below stairs and gave directly onto the garden. There were various little flights of stairs here and there leading to bedrooms, and the whole was furnished in the style of the eighteenth century. Rare Chinese *objets d'art* stood about, which E. asked the landlady to remove.

"Ah," said she, "but no! They make the room look so pretty"—with a deprecatory smile. E. was not beguiled, and they were all carefully locked away in a closet. So the house was a jewel box if not a museum; and it was here that "Lenna and Imp" was painted.

The spring of 1929 was the crest of the financial wave. Europe was full of Americans as never before. The Forbes Watsons turned up— Forbes was W. G.'s first biographer. The Prestons were in Paris; Juliana Force blew through the city to fresher fields elsewhere; Margaret Breuning, the art critic, and her husband the late John Anderson, drama critic, appeared in town; almost everyone was in Paris that year.

Beyond the garden wall at 110 were the vast grounds of the Mission Étrangère, where young priests were trained to go forth and preach the gospel in heathen lands. Every evening while we dined in the garden the neophytes slowly moved in procession· through their estate on the other side of the high wall chanting vespers, while bells tolled and blackbirds sang in the tall, umbrageous trees.

In August, however, Paris dies; the breath leaves its body and not

239

a whiff of air blows through the city. The G.'s set out for Hendaye on the Spanish frontier, as it was thought that the Atlantic was more salubrious and bracing than the Mediterranean. But Hendaye proved unpaintable, the *pension* there uninteresting, and the only charms were the wide white beaches and the little town of Fuenterrabia across the Bidassoa river in Spain. *"Face à l'Espagne!"* the instructor ordered when he gave setting up exercises to bathers on the beach; and this phrase, one knows not why, makes for romance.

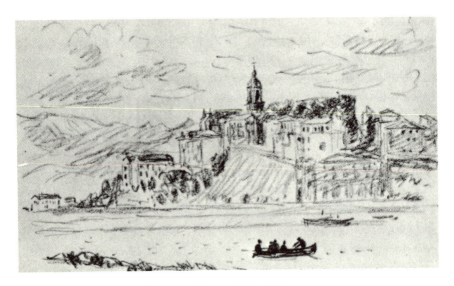

Fuenterrabia and the Bidassoa

But as Hendaye offered nothing to look at, the G.'s moved back up the coast to the little fishing port of Saint-Jean-de-Luz, and there luckily found a small flat owned by a retired English schoolteacher.

The beach was intimate and small, an excellent subject to sketch and paint, and W. produced "Beach, St. Jean de Luz." In the public square, facing the harbor, was a sixteenth-century building called "la Maison de l'Infante," where the Infanta Maria Teresa of Spain lodged before her marriage to Louis XIV, which took place in the town.

The square before this venerable façade was filled with café tables and trees. Every night a band played, and the native Basques danced the

The House of the Infanta, St. Jean de Luz

fandango in little groups which everyone joined, while W. sketched, and the fishing boats in the harbor lit their lanterns; and a man wearing a bull's head mask ran through the crowd with spouting fireworks, and the band played faster, and everyone scattered, and more cooling drinks were ordered. So the days and evenings passed.

The Pyrenees loomed behind the town with their long green slopes, and several excursions were made: to San Sebastian and Pamplona, Spain, where lunch was eaten under the colonnades of the plaza; to Pau; and to Lourdes, where the cripples lying in rows before the sacred grotto with their arms raised and chanting, *"Dieu, faites-nous marcher!"* (which God so seldom did) were too tragic a sight to be borne.

Lenna's friend Ann Spencer and her mother joined the G.'s for several pleasant weeks; and then all returned to Paris in September.

The winter was to be spent in Vence again, at the Villa les Pivoines. Lenna was sent to a *pensionnat* for young ladies at Cannes, twenty miles distant; and in late October the *pavillon* at 110 rue du Bac was given up. The landlady arrived to go over the inventory, always a momentous event in France.

The bell rang and she stood at the door, sheaves of paper under her arm, for a French inventory lists everything on the premises, down to the

panes of glass in the windows and burned matches in the ash trays. The
lady, formerly all beaming smiles and *politesse*, now wore a stern and
scowling look. She meant business.

"*Bonnes nouvelles, Madame!*" E. greeted her with wicked enthusiasm.
"Nothing broken!"

The lady's face slipped down two or three notches. Good news? This
was the worst possible news. Her Ming bowls, her ancient earthenware
Buddhas beyond price—not *one* broken, or even nicked? She had
counted on recovering colossal damages from the rich Americans, and in
her disappointment and dismay she gave herself away by saying bitterly
that she was tired of the eighteenth century anyway and had planned to
do over the whole house modern. And now her hopes were dashed.

After the chill and damp of late October in Paris, it was fine to be
once again at the Villa les Pivoines. Little had changed since the house
was occupied four years before. At the foot of the garden, several terraces
below, an old Provençal farmhouse had been remodeled, and there was
now a tenant in it, an Englishman named Sir Hugo de Bathe. Sir Hugo
was tall and gaunt, the prototype of the aristocratic Englishman, with the
ruins of fine features. He was an old playboy. His one distinction was the
fact that he was the widower of the beauteous Lillie Langtry. The story
circulated that when Edward VII succeeded to the throne and was obliged
to marry off Lillie, he asked her where her choice lay, and she had named
Sir Hugo. The sovereign summoned his subject and broached the matter.

"Sire," said Sir Hugo, "pay my gambling debts, and I shall obey!"

"Done!" said His Majesty—or however these exalted personages
converse.

Now Sir Hugo was living in somewhat modest style at the foot of our
garden. He complained politely that when he gave a party the G.'s' family
washing was flapping on a line outside his back windows. And so when-
ever a party was scheduled we were warned, and no plebeian laundry was
displayed.

This year Vence, primarily an artists' colony, had some distinguished
literary residents. Francis Hackett appeared in town with his wife Signe
Toksvig, likewise a writer, and they rented a villa on the other side of the
valley. Miss Toksvig (she is a Lucy Stoner) was obliged to take some
shots, and E., who was an adept at giving shots, taught Francis Hackett
the technique. Mr. Hackett's biography of Henry the Eighth, now a clas-

sic, had lately been published to wide critical acclaim, and before the Hacketts left Vence he presented a copy to the G.'s, and on the flyleaf wrote:

> To Ireland now we're going back, hence
> This word of sad adieu, O Glackens.
> You never once would let us hire a
> Motor-car—we rolled with Ira,
> Careened with Lenn, with Edith, Willy,
> Dispensing words both wise and silly.
> 'Tis much we owe you: most of all, sure
> The gentle art of giving *piqûres*.

Vence's association with D. H. Lawrence was sadder. He was brought to a sanatorium in the town in the last stages of tuberculosis, where he died in a few weeks: but not before Jo Davidson arrived and made a bust of him. His funeral was attended by most of the foreign colony.

An Englishman named Tyson opened a small bar called Le Rendez-vous, and soon it was the meeting place for all the expatriates in the region. From time to time a soiree was scheduled and everyone reserved a table. These evenings began with dinner and then kept right on into the small hours.

On one such evening, as the G.'s started out for the party, W. said, "Don't tell anyone this is my birthday, because they will all urge me to drink too much."

The secret was carefully kept. At a late hour E. had had enough, and mentioned, *sotto voce*, going home.

"Home!" exclaimed W. loudly. *"Now?* On my BIRTHDAY!"

"It's your BIRTHDAY!" everyone cried, and champagne corks began to pop. The party, which had been going full swing, now reached unprecedented heights. But E. began to droop and drowse, and so a neighbor offered to drive W. home in her car later. "I'm not drinking," she said reassuringly.

E. went home, but W. did not arrive for a couple of hours. Next day he was asked what had gone on after E. left the party.

"The last I remember," he said, "Sir Hugo de Bathe was trying to walk on his hands."

"What were you doing?"

"I," he replied modestly, "was trying to walk on my feet."

In May, 1930, the family motored back to Paris by way of Burgundy. Arles, Nîmes, Orange and Avignon were inspected on the way, as well as Aix-en-Provence and the Cézanne Museum there; and at Avignon the younger members of the family danced on the ancient bridge, or what there is left of it, being not unmindful of tradition.

Over night in Beaune, at the old Hôtel de la Poste, a fine dinner was consumed, and a bottle of Beaune Hospice 1923 which lingers in the memory, and the next morning the journey was resumed toward the hotel of similar name at Saulieu, *"le temple du bien manger"* as it modestly advertised itself. It seems a pity that W. G. had but one journey through the Golden Slope.

A summer spot had been chosen, the Villa lès Cytharis at La Ciotat, a town midway between Marseilles and Toulon. The villa had an enormous flagstoned terrace, eighty feet long, stretching across the front of it and looking out over the tops of olive trees to the bay of La Ciotat. Two large palm trees, one on either side of the terrace, gave a formal touch to an otherwise pastoral landscape.

The G.'s had hired a young native of Vence for a chauffeur. Joseph looked like a carved saint of a primitive period; old wooden images of Saint Sebastian most nearly resembled him. When W. G. and I. G. returned to the Riviera at the end of June, with Berthe and Imp following on another train, it was Joseph's function to meet them in Marseilles. E. G. and L. G. were detained a week longer in Paris.

I. to E. and L. G.:

 Cytharis, La Ciotat, B. du R.
 1 July 1930

DEAREST MA AND LEN:

What a varied scene we have viewed since leaving you! Our Compartiment was at the front of the train, next after the diner, and the dirt blew in fiercely. We chose second setting, as Lenna calls it, at 8:15. Father got up at 5, (next morning) and I at 5:15. We reached Marseilles at 6. It seems to me it had been broad daylight since 3. There was no sign of Joseph and we went to the Hotel Terminus near, in fact connected with, the gare, and drank very bitter coffee and each ate a lemony orange. By about 6:30 I saw Joseph drive up, solemn-faced, where a hundred one-eyed barkers were calling "Le bateau"—I refused the bateau 1000 times during our hour and a half stay in the station. Joseph explained he had *couchéd* in Marseilles, but the concierge of the hotel had neglected to waken him, so he arose himself at 6:20 or so.

Berthe's train was late: father went out to the voie to meet her. I found him long after, Joseph and I having been guarding different exits to weariness. He said he had sent Berthe in to eat, so I went after her, and Imp growled at me. It took some time to get the trunks and the valises where we had deposited them on arriving. By 7:30 we were all packed in the car, the 2 trunks in back with us, Impy looking out the front window. We held Berthe's basket on top of the trunk by means of father's cane, and I prodded the trunks with my knees, or my feet held high above my head so that they would not fall on us, father had his fishing rods tucked into his armpit, and so we made our triumphal way to La Ciotat.

It is a magnificent day. We reached Cytharis about quarter to 9. We felt as if we had been up about two days . . . Coming by the casino I saw two men breakfasting on the terrace, and a raft with a slide is anchored in the bay. It is a most breezy place here, and the terrace is magnificent. The tree tops roar with wind and locusts are squeaking to each other from every bush. If you leave a door open it blows shut like a cyclone, and if you leave it shut it blows open with equal vehemence. All is breezy sunlight. . . .

The town of La Ciotat with its harbor full of fishing boats; the festivities on Bastille Day, in which fishermen jousted with long poles, standing on high scaffoldings erected on their little boats, attempting to push each other overboard, to wild enthusiasm; the evenings now and then at the little casino near the beach; the daily dip into the Mediterranean—all of these diversions combined to make the summer pass too rapidly. Friends motoring through the Riviera stopped now and then for a meal or overnight; in spite of which this was a fine, productive summer for W. G.

At La Ciotat, Berthe continued to preside in the kitchen, and the more mouths there were to feed the more content she was. Her repertoire of dishes was now augmented by several American ones; it was I. G.'s function to translate recipes out of Fannie Farmer's cookbook, with added explanations. The dry white wine of the not-distant town of Fréjus, called Camp Roman, was the daily fare and went well with almost everything. Among the guests who made protracted visits were Commander Wright, an Englishman and an artist, and Blanca Blanco, who came all the way from Madrid bearing a basket of ambrosial fruits called *paraguayas,* a glorified peach such as none of us had ever seen except in Spain. Now and then the tenants of les Cytharis drove to Marseilles, that

disappointingly ugly city, where the famous bouillabaisse was consumed at Basso's restaurant in the harbor. Excursions were likewise made to Toulon, as picturesque as Marseilles is the opposite.

But in September E. G. was obliged to take Lenna back to America to be put in boarding school. I. G., who had a job in New York, accompanied them.

W. G. to E. G.:

 Cytharis, La Ciotat, B. du R.
 Sept. 13, 1930

DEAREST TEED:

The last few days have been unusually exciting for this place. Last Thursday there was a cloudburst at Cassise. The commander had gone over there in the morning on some business connected with his lawsuit [accident] and got right into the middle of it. He couldn't get back that night as everything went out of business including all the lights. He turned up the next morning all bedraggled and damp having gotten soaked to the skin. He said the water came pouring down the main street carrying café chairs and tables along. The doors had to be barricaded against the flood with boards and boxes. It was very bad in Marseilles but here we only had a couple of hours of a pouring rain starting about 8 o'clock in the evening. . . .

The little blonde dog is *en furie* and there has been a great congress of dogs outside our house all trying to get in. Berthe had locked the little bitch in with Imp and for three days he never ate a morsel of food and did nothing but pay court to Zaza. He was like a demon if any other dog came near and would rush out and drive them away. He grabbed Dick by the throat for sniffing around too close and they had to be separated. Now one of the big black lady dogs is *en furie* and I am sorry to say that Imp has abandoned the blonde and is chasing after the brunette. . . . I am getting a bit tired of this dog business, using the house for a dog brothel. . . .

It is beginning to look a little bit like autumn or rather feel like it. There are not so many people about and the evenings are a bit chilly. I suppose I shall be glad to move on. I am counting on leaving here the 28th.

Sunday morning Madame Latil left a large mess of *écrevisse* and we had them for lunch. They were delicious and fresh and made a good dish to go with the civet of hare which Berthe had prepared for the pièce de resistance. . . . The Latils [*propriétaires* of Les Cytharis] are staying at the Hôtel de la Plage at Le Lecque.

Sunday dinner as usual we took at the little restaurant at the port. While we were there a boat put in loaded down with a miraculous haul of anchovies.

The fish were still tangled up in the net and there must have been thousands of them. I had Berthe buy a kilo for ten francs [two pounds for forty cents] and we ate them for lunch and they were delicious. One of the natives standing by us while we were looking on said the haul would bring 5 thousand francs at least to the fishermen.

I seem to be writing about nothing but food, and that reminds me that I got a nice letter from Ira in which he tells me that you are eating meat and that you took two helpings of lamb once. . . .

Your WM.

From the same to the same:

Cytharis, La Ciotat, B. du R.
Sept. 22, 1930

DEAREST TEED:

Well the guests have all cleared out this morning and Berthe has already packed the big brown trunk and Ira's chest of books, a good start.

The ducks have started coming up on the terrace when we are having dejeuner. They are getting quite large now and if you don't throw things to them to eat they will peck you on the legs to remind you. We also have a tame pigeon belonging to the lady farmer. It will come to the kitchen and will climb all over the table while one is eating even getting into the plates. . . .

Berthe found your black silk Venetian shawl which you no doubt forgot. I will bring it along. There is also your cloth cape, one you bought here. I suppose you will not need that in N. Y.

We have found so many things that Berthe will have to get a bigger box than we have to pack them in. What a lot of truck we gather about us.

I don't know whether I shall be able to get any more painting in or not. One gets so upset when packing. It seems an age since you left with the youngsters and you have only been home for a little over a week. Remember me to anyone you meet of our friends . . .

And from Paris he wrote again:

Hotel le Royale, Paris, Oct. 10, 1930

DARLING TEED,

I received a very nice letter from Ira mailed from the top of Mt. Washington. He and Stearns Morse[1] must have plodded pretty steadily to reach the top as soon as they did. I hope the weather permitted them to go over the northern peaks. I don't think I shall ever climb the old mountain again but I would like to go over the northern peaks, making my ascent in the cogwheel train.

[1] Professor Stearns Morse of Dartmouth.

Yesterday a letter turned up from Lenna. She appeared to be quite contented although she had been only there [school] two days.

I find Paris very dull. There are no good picture shows and there is hardly a familiar face at the Dôme.

Slidell and I dined at the Crémaillère night before last. We had an excellent dinner, oysters and partridges. It was to be a Dutch affair but as he had won 400 francs at the races in the afternoon he insisted on paying as a sort of celebration. (He not often wins.) He was quite elated and was passing out largesse in the form of 10 franc notes to the cook for hashing the celery salad the way he wanted it and to other various hirelings . . .

We have had a great deal of rain for a week but this morning it looks as though it wouldn't rain for a month. I am sure before lunch time it will be pouring. I had to buy an umbrella as my trick one collapsed under the strain.

Got a green collar and leash for Imp. They didn't have any white ones but would order one for me. I said I would take the green one.

Mrs. Q. is still here at the Hotel. She is dreadful. She stopped me in the street the other day to introduce me to a French artist, starting by saying I had won a prize at Carnegie. Now if there is anything an artist is not interested in it is hearing about some other artist getting a prize. She is worse than Mae Brooks. I wish I had pushed her over.[2]

Haven't had a chance to get out in the country, weather too inclement but I have walked my legs off here in town between showers . . .

Ira tells me how cheap the fruit is in N. Y. I wish I had some of it here. Eight francs for a pear in a restaurant. Six and seven francs for a bunch of grapes. There seemed to be vast quantities of grapes in the south but they have all been turned into wine by this time as the vendange was in full blast when I left.

I haven't seen the [Walter] Pachs yet. Can't find their telephone number but I know the house. After dinner in the evening it is always too late to visit. Shall certainly see them pretty soon.

I hope you are continuing your diet and Peppy is getting you some tender meat. I take it that you are well. I am Your WM.

The spring of 1932 was spent in Paris again. For Cannes in August and September, since there were five tickets to buy (with Berthe) the travelers reserved a *compartiment* on the Paris-Nice Express and decided to sit up. It proved a terrible night. Imp alone slept comfortably among

[2]As the lady was very large, W.G. *couldn't* have pushed her over!

the feet; the rest nodded in the upright seats or drooped over their own laps. At about 4:00 A.M., when human vitality is reputed to be at its lowest ebb, there was a strange commotion in the *compartiment,* and in the dim lights of the station at Valence, which gleamed palely through the grimy window, Berthe was seen to be going through contortions like Laocoön. It appeared on anxious inquiry that she could endure her corsets no longer and was attempting to struggle out of them without taking off her dress, a feat that might have baffled Houdini. And this the wonderful woman accomplished.

The travelers fell off the train at Cannes more dead than alive, Berthe carrying her corsets in a paper parcel.

On the hill known as Le Suquet, in the old quarter of the town, a most curious little villa was discovered. It was built like an arch, and a gate went right through the middle of it, leading into the grounds of the Pension des Orangers. The living quarters of the Villa des Orangers were upstairs, and vehicles drove underneath. When it came to the choice, the G.'s always found themselves inhabiting the curious house with strange plumbing and lack of conveniences, instead of the new, hideous and convenient one next door. And no country has a greater quantity of both kinds than France.

While the G.'s were in Cannes, news arrived of the death in New York of another of W.'s old friends, Alfy Maurer. This was a tragic death, for the once gay and lively Alfy had hanged himself.

Alfy Maurer, who had begun his career painting with great success in a realistic tradition, had changed his direction about the time the G.'s had visited him at Chezy-sur-Marne, to experiment with newer theories. From then on he had suffered neglect and misunderstanding. His father, old Louis Maurer the lithographer, who had produced the famous "Life of a Fireman" series for Currier and Ives in the middle of the previous century, lived to be a hundred, and died only sixteen days before Alfy followed him. He hated his son's work, and excoriated it, yet Alfy seemed tied to his incompatible parent with a silver cord. The old man preserved a cheerful and unanalytical attitude to life. He got up in summer at 4:00 A.M. to paint his pictures of Buffalo Bill galloping across the plains, explaining that the early light was purest. But the work he produced was not art. In contrast, Alfy, the artist, seemed at last a lost soul.

Every evening the G.'s started out for a walk about the town of Cannes. The evenings, as in all French resorts, were filled with music. The municipal band played the overture to *Zampa* while people ambled along the quays, or dropped into café chairs for a cooling *orgeat* or *cassis à l'eau*. Every night, splendid fireworks illumined the skies over the harbor, where J. P. Morgan's *Corsair* rode at anchor; and entertainers from Paris sang sad songs of love or arias from *Faust* between bursts of skyrockets.

It was from a window of the Villa des Orangers that W. G. painted "Fête du Suquet," now in the collection of the Whitney Museum of American Art. It preserves the spirit of Cannes that summer, the blinding light, the burning heat, and the carefree populace dancing in the street.

-》》-》》-》》-》》-》》

CHAPTER THIRTY

W. and E. G. went abroad together for the last time in 1936. Their companions on the trip were Raymond and Gertrude Brown, their old friends from Bellport, and the object of the journey was to see Charles and Irene FitzGerald. As L. and I. did not accompany them, and L. was all summer in America, several letters from E., who was a nimble letter-writer, recount in lively detail the chief adventures of the trip.

E. to L. G.:

A bord de Paris [May 14, 1936]

DEAREST DAUGHTER,

This is the first day that has been a bit rough. White caps and cold today. The young Russian ballet sits around quietly playing cards most of the time. The Massines are in First. I asked Ray Brown to meet them and present us but he hasn't done it yet. Tell Pep my English governess cape is a complete wash-out. I have cut off the hood and am trying to restrain myself from stuffing the whole thing out the porthole. Better things have gone that way! Think of Agnes Tufverson![1]

Well, I am sufficiently humpbacked even without that hood. It isn't a warm coat neither. Today I am thinking affectionately of the wool underwear tucked in my drawer at 'ome. Papa has been almost free of headaches which is remarkable as we are in a continual draft. He plunged right off his diet the first thing, eating unwisely and swilling down the vinegary white wine so he got a bit upset. Then we dined with the Browns [who were in First; the G.'s were in Tourist] when both he and Ray had to pay slightly for their indiscretion.

I now realize your father's well-being depends entirely on how disagreeable I am in future and I am prepared to frown and point thumbs down and bear everyone's criticism. Dr. —— said *No Ham* but did not think it necessary

[1] It was widely surmised that this lady was disposed of in pieces through a porthole in the S.S. *Olympic* in December, 1934.

251

to say No Salami. I am glad prussic acid is not tasty for if it were and unless he were warned off your father would be guzzling it. . . . In the morning he remarks "That coffee kept me awake" so I must crack his knuckles when he reaches for it the next night.

Miss Brown's fruit came at last and I sent a radiogram. Our room is full of wooden apples and iron pears. Which may ripen come Michaelmas. Ira's telegram was most welcome, "J'ai bonne cabine. Baisers." And I hope you will tell of seeing him off in your first letter. . . . Billie Crawford's[2] flowers are still fresh (on dining table) and the Prendergasts' ditto in our room. . . . We have one full day after today and are due to land Saturday morning at six. If this cold keeps up and I don the cape I may look ever so like the British myself, but expect a long session in the Customs over the kitchen utensils for Irene. I shall not register impatience but rather shall display the calm that marks the Vere de Vere. Somehow I do not warm to the thought of Merrie England, the contrary, but feel the gooseflesh rise, rather. I have no idea what we shall do after a week's visit. To motor or not to motor. So far the oracle has not so much as looked interested. Whether we do or not do I fear it will interfere with the painting. He never blames the overeating. . . . This is going back via the Normandie. Think of that! Love to Peppy and our dear brave Harry [Dart] and kindest regards to George [the furnace man]. A kiss on the upper nose for Imp.

E.'s fear of the cold in England was well founded, but she and W. had gone there to see the FitzGeralds, not for the climate.

From the same to the same:

Narrative continued.

<div align="right">Sunday at Sidmouth
(May 17, 1936)</div>

DEAREST DAUGHTER,

Our last three days on the Paris were Hellish. It had been very cold all the way with a draft on the back of your neck wherever you sat down due to every door and porthole being open all the time. Then we took to rolling. Wednesday was uncomfortable and sleeping that night very poor. My stomach seemed to be like a large melon that would roll over onto one side of me and then onto the other. Thursday afternoon your sainted father and I both got to bed to get warm and I could have sworn I didn't sleep at all. . . . It was calmer Friday night and I kept jumping up to see if it was 4:30 when we had to rise. Breakfast at 5:15 and after inspection of our passports and permits

[2] Mrs. Charles Crawford, daughter of Mrs. L. E. Travis.

to land we got onto the tender, then the customs, then 2 hours by train, and met by Charles and Irene at Sidmouth. Need I state it was raining. I had on two coats and shivered under them. . . . When I got to our lodgings I was sicker than I have been since I had tonsillitis at 23 Fifth Ave. long before your and Pep's time. The ship was still rolling and I had all I could do to get between the sheets where our nice young landlady had put a stout hot-water bottle. By seven I crawled out and ate a bit of supper then managed to get back to bed. This morning I was alright except for a rough throat and boiled eyes, the tough creature. We are very comfortably fixed here. The house was built about two weeks ago, according to your father, taste according, but the bathroom works and boiling water comes out of the pipes. We have a big comfortable bed and use of downstairs living room just for us when we eat and a small but real coal fire in grate. Everything dainty and nice and the coffee while not coffee is 300 per cent better than the hotel stuff.

As soon as Fields is open tomorrow I shall buy the flannel drawers that are more important than ball attire in the British Isles. This morning I was thawed at last and we walked out in the brave sunshine and around the town and by the sea. The place is a spotless town and there are flowers everywhere. Why is it they look like the pictures in seed catalogues? Like Belgium the place absolutely lacks charm. There is no *patine* and the grass is far too green. . . . Everybody here has a cerise face and a purple nose. Father says nature tries to keep people warm by laying on the flesh and of course it is the cold that clots the blood, near the surface of the skin. The FitzG.'s bungalow is very nice indeed, entirely surrounded by flowers which do not look seed cataloguey.

Most of the women look like this ⸻⟶ or worse and I intend to shorten all my skirts. How could Peppy let me wear them so long? My word what frumps there are here! One child about twelve I saw this morning I thought was an old woman from the back, and the teeth! Reminded me of the telegram in "At Home Abroad," "Everybody is a beauty in Europe who has her own teeth."

We have breakfast and supper here and shall lunch at Manstone Cottage. Father pulled through yesterday's grueling experience better than I did. I hope he will feel able to take the motor trip with the Browns who pass this way about Saturday. . . . Now I hope you are having a good time and some people to dinner . . .

God knows where we can put in the time until July 22.

Love to all at 10 West 9.

When the Browns arrived W. decided to go on the motor trip to northern England:

White Hart Family Hotel
Lincoln, May 30, 1936. Saturday

DEAREST LENNA,

It is now 11 p.m. but I can't resist writing to you on this paper. We are in an elegant hotel facing the cathedral but like the other two Saturdays in England it is raining—has been all day. Pleasant weather all the rest of the time. Let me tell you it IS cold here. Ray Brown says he hasn't felt it so much since it was below zero last winter. I wore one of your father's undervests under my dress to dinner. It helped. We played cards (Rummie) in the Browns' room before a cannel coal fire afterwards. Your father has developed into a sharper. Has won several games. I regret to say he had a headache last night (at York) and again tonight. He lays it to the weather but of course it's diet. Cream cheese isn't known here and we have eaten far too much of meat and too few vegetables. They are very limited in diet here. I even thought we might just stay here until Bank Holiday is over—Monday—and then take a train all the way to Sidmouth but evidently your father would rather go on all the way to London in the car. We get too little exercise and it is as well our trip is nearly over.... The Cathedral bells have just gone wild—are cutting up like anything. I shall take father by the hand to show it to him—the C.—as he rested yesterday while I looked it over.... This is not an informative nor interesting letter but just to send love to 10 West 9....

The G.'s returned to Sidmouth on June 2, and E. reported:

Our trip with the Browns was a great success... Gertrude would have been an even match for Ella Fiske for interest and endurance (you remember Irene said Ella's endurance made her eligible as a General in the Battalion of Death). We had no unpleasantness and many a good laugh which is the cream of a trip. One of our best topics was the everlasting chill.... Ray and I have fixed it up that if and when we are here again we are to wear Arctic suits and stride into the hotels insisting that the windows be opened at once— only they will all be open already.

And then (what everyone who knew E. and W. had expected would occur sooner or later) came the news:

Father and I are going over to Exeter tomorrow to see if we could get a visa for France without going to London for it looks as if the only way we

could get warm would be to go there. I should like to try Spain for a change where the peseta is very low but your father feels we should be lost not speaking the language. I don't feel that way. We could afford a fairly good hotel and somebody always speaks French. . . . Did you give my message to Ella Lawson? About Ernest. I wonder if he went South . . .

With the decision made, the whole tenor of E.'s letters changed. She was only sad about leaving Irene, and wondered if she would ever see her again.

Same to the same:

June 7 (I think)

Well, we are frozen out! Your father says we may as well go to France so we shall do so as soon as his new shirts and Harris tweed knickers are delivered. They are promised for Wed. so we shall take the 7 a.m. train Thursday from Sidmouth, breakfast on the train, transport our bags from Waterloo to Victoria Station and check them, then go for a French visa and depart in the afternoon for Paris arriving at 11 p.m. A very hard day but we are anxious to avoid another "Bed and Breakfast" in London. . . . I wish your father would go to Spain but he thinks language and food are against it. The peseta is all *for* it. You can get French food in the hotels and everybody speaks French. But he has the deciding to do. We shall not linger in Paris. It's gloomy and expensive. I shall entertain myself by ordering new clothes for your father anyway. Excuse this stupid letter. I am too cold to have many thoughts.

So they ended up in Paris and did not find it so gloomy after all, and at least they got warm. I. G. met them there, having escaped from Spain at the outset of the Spanish Civil War, and heartily glad that W. had prevailed in spite of the peseta, and had not gone to Madrid.

W. and E. sailed for New York on July 22, as planned, and when they docked they must have been warm at last, for it was over 100 and one of the hottest days of the summer. They fled to Rockport, Massachusetts, where they rented a small house with a serviceable room in which to paint. The faithful Peppy accompanied them from New York to do the cooking, and W. produced a few studies of the beach. Search as one may, not one of his sketchbooks reveals a single thing from his visit to England. It was too cold there to sketch.

The weather was pleasant at last, and W.'s health improved, no doubt in part due to Peppy's cooking.

The house at Rockport was a great success. "Your father and I are happy and having *the best food*. Each day we have a ceremony—we salute the morn. It has to be done on our own grounds which are small but darling. Ornamental shrubs and nooks. Never have I known more lovely air. . . ."

The Max Kuhnes and the Richard Beals had houses at Rockport, and there were thus a few social visits now and then. Rockport is an artists' colony, and the postcards for sale in the shops depict "Motif Number 1" and "Motif Number 2," and so forth—scenes of the town and harbor already selected to save the weary artist the trouble of hunting about for a subject. In spite of which W. G. continued to seek his own!

In September W. and E. were obliged to return to New York for a few days, and left Peppy in the house. The Cape Cod steamers were still running, and the overnight trip was the most painless way of reaching the city, so they set out that way.

A few hours later a repoit came over the radio that the Cape Cod boat had rammed another ship; but there was yet no further news. The G.'s' landlords at Rockport, who were very kind neighbors and occupied a house next door, and knew their tenants were on that boat, hastened over to the house where Peppy was waiting alone in an agony of apprehension. Good news soon came. The ramming of a fishing smack had occasioned no loss of life or injuries, and the Cape Cod boat was being towed back into Boston Harbor. W. and E. had to take the night train after all.

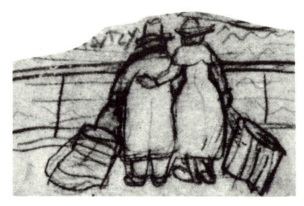

W.G. and E.G. watching the wreck. Caricature by E.G.

I. G. had returned to the U. S., and E. sent a postal card. "I scorn your insinuation," she wrote, "that the life preservers wouldn't go round. They *would—just*. Only we held them nonchalantly watching the wreck." And she made a sketch depicting the scene. (I. G. had made no such insinuation, thinking his parents perfect in size and shape!)

One thing in life distressed E.—her feeling that W. as an artist had not received his due appreciation. Most (but not all) of the critics either called him a mere imitator of Renoir or were politely patronizing. None of this seems to have bothered W. himself, who had long since given up reading the criticisms of his work anyway, for few people at any time have been dowered with the serenity and independence of spirit that made his life so smooth and agreeable.

Then the large collection of W.'s best canvases locked up in the Barnes Foundation was seen by scarcely anyone but the Foundation's two hundred students. "Armenian Girl," one of his most characteristic and powerful works, was among them. E. had longed to get this canvas back.

Dr. Barnes wrote:

<div align="right">Merion, Pa. May 14, 1937</div>

DEAR EDITH:

Yes, I'll sell Willie's girl with red jacket for $85,000 cash and it's cheap for its intrinsic value....

Don't worry that Willie is not yet appreciated: he is in the best company in our gallery and he needs no apology. We talk about him to our students every year, not with emotion as you do, but on the solid rock of permanent place in the great art of all time. A hundred years from now, I'll let you peek down on earth with me and you'll be satisfied with the position he holds with the stars.

<div align="right">Yours, A. C. B.</div>

E. was not much comforted by the thought of "a hundred years from now."

There was also a project, which unfortunately never came to fruition, explained in an earlier letter in lighter vein. From the same to the same:

<div align="right">[No date]</div>

DEAR MADAM:

I am making long distance plans for the educational work of the Foundation and two of the ideas I have in mind are to write small books on two

American painters, W. Glackens and M. Prendergast. If you should happen
to know either of them sufficiently well to obtain from them or members of
their families, published criticisms of their work, I should be glad to receive
such articles. I never knew a New York critic who had even the slightest
conception of the principles of art but even fools sometimes accidently say
something suggestive; for that reason published criticisms are worthy of
examination.

I know what is in my head about those painters and if I can put it on
paper I think perhaps intelligent people will sit up and take notice of what
they have overlooked. The books will be illustrated—very much so—and they
will be published by the Barnes Foundation who have been asked by various
important universities and municipal art galleries to provide an educational
plan in modern art. We shall do it.

<div style="text-align:right">Very respectfully,
A. C. BARNES</div>

24 N. 40th St., Philadelphia

Another and far greater distress to E. was W.'s recurrent ill health.
His headaches continued, and he had some trouble with his eyes. The
light in his studio was not pure; pink reflections from buildings across
the street bothered him, and he found it increasingly difficult to paint.

The summer of 1937 was spent in a house some distance out of
Stratford, Connecticut. It was a beautiful place, surrounded with peach
orchards, lawns and flower beds; and except for the fact that in the
Housatonic valley thunder and lightning storms roared down the river
almost every evening while dinner was being prepared, putting out the
lights as well as the electric stove, life there was very pleasant. It was a
fine, secluded spot, from which the distant city of Bridgeport actually
looked romantic.

However, W. painted little that year. "Bouquet in Quimper Pitcher"
was produced, the best-known and perhaps most gay and brilliant of all
his many flower pieces; and another smaller and more quiet flower piece,
a little bouquet in a glass, standing on a pink lustre dish. It was a bouquet
Peppy had picked and placed in the living room. This proved to be
W. G.'s last completed canvas.

In the winter, back in his studio, his eyes bothered him more and
more, headaches were frequent, and he tried eye exercises, which were
not good for him. He pottered in his studio, painting a single flower or

pear or apple on a scrap of canvas, and finally merely a little study of a half-squeezed tube of paint that happened to be lying on the table beside his easel. This was the last time he ever painted at all.

E., her mind going back to the grand days when W. had been able to produce large canvases—"The Family Group," "The Shoppers," "Nude with Apple" and "The Dream Ride," felt her heart would break to see the artist's strength now equal only to these brilliant but infinitesimal scraps of canvas.

Yet he began to feel better as spring approached, and plans were laid for a return to Conway, New Hampshire, to the little house that had seen such happy summers long ago.

John Sloan was in the hospital, and on May 18 W. G. went to see him there. The two old friends talked of many things, and W. observed that when he could no longer paint, or see his friends, or enjoy food and a glass of wine, he did not want to be alive.

Three days later W. and E. went to Westport, Connecticut, to spend the week end with Charles and Eugenie Prendergast in their charming house on Crooked Mile Road, a glorious bower of Charles' panels and Maurice's oils and watercolors. Eugenie, being French, was an excellent cook; and no doubt there was a bottle of good red wine to go with the repast. Charlie and W. had a fine time talking and reminiscing, with much laughter over many amusing memories.

The next morning was Sunday, and Eugenie provided an excellent breakfast. About eleven o'clock W. was in the living room talking to Charlie; and while he was doing so, the wish he had expressed to John Sloan only four days before was suddenly fulfilled: he lapsed into unconsciousness from a cerebral hemorrhage, and in half an hour he was dead.

A doctor quickly arrived. "I don't think I can save him," he had said.

"If you can't bring him back the way he used to be, please don't bring him back at all," E. said.

And her final comment in a letter to a friend was, "He died as peacefully as he had lived."

Dr. Albert Barnes to E. G.:

Hotel St. Regis, Paris
June 3, 1938
DEAR EDITH:

I left New York the day before your great loss and I heard of it only ten minutes ago in a letter from home. I was shocked; and not only that but

feel a deep sorrow because I loved Butts as I never loved but half a dozen people in my lifetime. He was so *real*, and so gentle and of a character that I would have given millions to possess. And as an artist, I don't need to tell you I esteemed him: only Maurice, among all the American painters I knew, was in his class. He will live forever in the Foundation collection among the great painters of the past who, could they speak, would say he was of the elect. My heart goes out to you in full measure . . .

I cannot think of a happier life than the one my father lived, nor an easier death, which spared him his own regression and the death of his daughter five years later. He had known the best that life has to offer: a peaceful nature, a devoted wife, a happy home, delightful friends, and the contentment that comes from creative work untroubled by anyone's opinion; and he did not leave an enemy, for he had never had one.

AWARDS

William Glackens attached little importance to prizes and believed in the No Jury—No Prize system. He was a modest but gracious recipient. He would not have said, as Whistler did, "My second-class thanks for your second-class prize." *Honos alit artes.* The list is given for the record:

1901 Gold Medal for Drawing, Pan-American Exposition, Buffalo.

1904 Silver Medal for Painting, Bronze Medal for Illustration, Universal Exposition, St. Louis.

1905 Honorable Mention, Carnegie Institute, Pittsburgh.

1915 Bronze Medal, Panama-Pacific International Exposition, San Francisco.

1924 Temple Gold Medal, Pennsylvania Academy of the Fine Arts, Philadelphia.

1929 Second Prize, Carnegie Institute, Pittsburgh.

1933 Carol H. Beck Gold Medal, Pennsylvania Academy of the Fine Arts, Philadelphia.

1936 Allegheny County Garden Club Prize, Carnegie Institute, Pittsburgh.

1936 Norman Waite Harris Bronze Medal and Prize, Art Institute of Chicago.

1936 Jennie Sesnan Gold Medal, Pennsylvania Academy of the Fine Arts, Philadelphia.

1937 Grand Prix for Painting, Paris Exposition.

1938 J. Henry Scheidt Memorial Prize, Pennsylvania Academy of the Fine Arts, Philadelphia.

→»-»»-»»-»»-»»

APPENDIX 1.

In 1967, at the occasion of a large Lawson retrospective at the National Gallery of Canada in Ottawa, an attempt was made to ferret out the true story of Lawson's birth. Indisputable proof set the matter at rest. Lawson was born in Halifax, Nova Scotia, on March 22, 1873. Thus he was a native-born Canadian. The explanation of his San Francisco story must surely be that, when he decided the U.S. was a better place for the furthering of his career, and citizenship useful though entailing red tape, boresome filling out of forms and waiting in dreary courtooms, he declared for San Francisco. That city's vital statistics were destroyed in the great earthquake and fire of 1906. Many must have achieved American citizenship by the same simple process.

APPENDIX 2.

Rowdies frequented that beach, and another explanation is that Lawson was held up, robbed of his wallet, and suffered a fatal heart attack.

APPENDIX 3.

Since Dr. Barnes's death two books about him have appeared. *Art and Argyrol* by William Schack (1960) implants doubts about the good doctor's sole invention of argyrol and plays havoc with the kitchen stove story. The writer takes no sides here. The other book is a whitewash —it must have required gallons.

-»»-»»-»»-»»-»»-

Paintings listed separately at the end

264 WILLIAM GLACKENS

Dimock, Ruth Bunner (Mrs. Edwin), 238
Dimock, Stanley K., 33, 189
Dodge, Mabel, 139
DuBois, Florence Sherman (Mrs. Guy
Pène), 222, 223
Du Bois, Guy Pène, 76, 97, 130, 180-181,
212, 217, 220, 222, 235
Duchamp, Marcel, 187-188
Du Maurier, George, 27
Duncan, Isadora, 135, 217, 232
Dwight, General Henry C., 52
Dwight, Grace, *see* Morgan, Grace Dwight
Dwight, Richard E., 157

Eakins, Thomas, 196
Edward VII, 242
"Eggs Lena" (recipe), 38
Eight, The, 1, 78, 86, 88, 107, 109, 120
Elman, Mischa, 155
Exhibition, Allen Gallery, 29-30
Exhibition, The Eight, 88-89
Exhibition, of Independent Artists, 131

Finn, Elizabeth Cartwright, *see* Glackens,
Elizabeth Finn
Fiske, Ella L., 33, 35, 36, 47, 48, 105, 162,
185, 189, 195, 254
FitzGerald, Dr., 56
FitzGerald, Charles, 29, 47, 48, 49-50, 51,
56-60, 61-62, 89, 92, 94, 102, 105, 108-109,
114, 134, 217, 253
FitzGerald, Irene Dimock (Mrs. Charles),
47, 139, 184-185, 217, 253
FitzGerald, Ned, 61, 218
Force, Juliana, 136, 233-234, 239
Frieseke, Frederick Carl, 221
Fuhr, Ernest, 17, 29, 45, 51, 63, 86, 87,

Garden, Mary, 102
Gauguin, Paul, 160
Giorgione, 204
Giotto, 203-204
Glackens, Ada, 10, 162
Glackens, Daniel L., 9, 10
Glackens, Edith Dimock, as actress, 142;
as art student, 35-36; death, 177; mar-
riage, 33, 45-53; watercolors exhibited,
57-58, 182, 233
Glackens, Imp, 232-233, 246, 248
Glackens, Ira, 78, 80, 100, 118, 120, 126,
137, 139, 182-183, 190-191, 223, 247, 256,
257
Glackens, Lenna, 168, 171-174, 175-176, 177,
179, 180, 190, 191, 211, 214, 232, 235-237,
246, 248, 251, 260
Glackens, Louis M., 10, 11-12, 13, 174, 191,
216-217
Glackens, Nancy Middlebrook, 236-237

Glackens, Samuel, 9, 10, 13, 51, 162
Glackens, Sara Ovenshine, 9, 10
Glackens, William J., awards, 261; birth,
10; comments on art, 181, 238; in Cuba,
23-27; death, 259; in Europe, 14-16, 67-
72, 198-223, 239-250, 251-255; as an illus-
trator, 20, 23-27, 30, 37; marriage, 33, 45-
53; on music, 28, 102; newspaper career,
5-9, 13, 16-19, 23-27; youth, 10, 79, 161
Goldman, Emma, 136
Goya, Francisco, 222, 224
Grapevine, The, 29, 94
Greco, El, 167-168
Greely, General A. W., 194
Gregg, Frederick James, 66, 77, 89, 91, 109,
114, 181
Gruger, Frederick, 31, 45, 46, 132
Guilbert, Yvette, 199-200
Guillaume, Paul, 167
Guinea Hen Case, 210-212

Hackett, Francis, 242-243
Haggin, Ben Ali, 142
Haggin, Mrs., 135
Hals, Franz, 16
Hartford Courant, 33
Hartford Times, 33, 53
Hartley, Marsden, 202-203
Hassam, Childe, 65, 72
Havemeyer, Henry O., 18
Henri, Linda, 63, 64, 65
Henri, Marjorie, 110, 112, 114, 135, 224-229
Henri, Robert, 1, 6, 8, 15, 17, 19, 20, 29, 49,
57, 59, 61, 63, 64, 65, 72, 75, 77, 83, 86-
87, 88, 89, 91, 105, 110, 114, 126, 131,
180, 186, 220, 221, 224-229
Henry, O., 66
Hobart, Garrett A. (Vice President), 18
Homer, Winslow, 65
Huneker, James, 90, 91

Iroquois Theatre Fire, 47
Irwin, Wallace, 112
Isham, Mr. and Mrs. Lincoln, 236

Journal, The, 112

Kasebier, Gertrude, 87
Keene, Charles, 27
Knox, Tommy, 92
Kock, Charles Paul de, 39, 42-43
Kraushaar, John, 205, 220
Kroll, Leon, 198-199, 202
Kroll, Viette (Mrs. Leon), 198-199, 200,
202
Kuhn, Walt, 180, 181-182
Kuhne, Mr. and Mrs. Max, 256

Index of paintings referred to in text. All works listed are by W. Glackens unless otherwise specified.

-»»-»»-»»-»»-»»

ABOUT THE AUTHOR

Ira Glackens, son of William Glackens, was born in New York and hap-
hazardly educated here and abroad as he followed his famous family in
its search for good painting and pleasant living. Thus among other things
he found the opportunity to paint with Robert Henri at the Art Students
League and with George Luks in his studio, attend lectures at the Sorbonne
and art school at Fontainebleau, study the Spanish language and mores
in Madrid, learn the names and vintage years of the best wines from his
father, amass a collection of rare recordings of the Golden Age of Opera,
journey to India, Australia and New Zealand during the War, contribute
articles on music, the theatre and horticulture to various journals, and from
the vantage point of his New Hampshire farm hunt out and grow over one
hundred kinds of old-fashioned apples ("that taste like apples"). Aided
by his wife he founded a humane society. Best of all, he could and did
acquaint himself with the paintings and personalities of The Eight among
whom his childhood was passed. Of that, this book is the result.

The Glackens now divide their time between Washington, D.C. and
West Virginia.